PICTURING WOMEN IN LATE
MEDIEVAL AND RENAISSANCE ART

MANCHESTER MEDIEVAL STUDIES

SERIES EDITOR Dr S. H. Rigby

SERIES ADVISORS Professor J. H. Denton
Professor R. B. Dobson Professor L. K. Little

The study of medieval Europe is being transformed as old orthodoxies are challenged, new methods embraced and fresh fields of inquiry opened up. The adoption of inter-disciplinary perspectives and the challenge of economic, social and cultural theory are forcing medievalists to ask new questions and to see familiar topics in a fresh light.

The aim of this series is to combine the scholarship traditionally associated with medieval studies with an awareness of more recent issues and approaches in a form accessible to the non-specialist reader.

ALREADY PUBLISHED IN THE SERIES

Chaucer in context
S. H. Rigby

The commercialisation of English society, 1000–1500
R. H. Britnell

FORTHCOMING TITLES IN THE SERIES

English society and the Hundred Years War
Ann Curry

The reign of King Stephen
Paul Dalton

Britain in its European context
Emma Mason

The twelfth-century Renaissance
Robert Swanson

Money in the medieval economy
J. L. Bolton

PICTURING WOMEN IN LATE MEDIEVAL AND RENAISSANCE ART

Christa Grössinger

Manchester University Press
Manchester and New York

distributed exclusively in the USA by St. Martin's Press

Published by Manchester University Press
Oxford Road, Manchester M13 9NR, UK
and Room 400, 175 Fifth Avenue, New York, NY 10010, USA

Distributed exclusively in the USA
by St. Martin's Press, Inc., 175 Fifth Avenue, New York, NY 10010, USA

British Library Cataloguing-in-Publication Data
A catalogue record for this book is available from the British Library

Library of Congress Cataloging-in-Publication Data
Grössinger, Christa.
 Picturing women in late Medieval and Renaissance art / Christa Grössinger.
 p. cm. — (Manchester medieval studies)
 Includes bibliographical references.
 ISBN 0-7190-4109-0. — ISBN 0-7190-4110-4 (pbk.)
 1. Women in art. 2. Art, Late Gothic. 3. Art, Early Renaissance.
 I. Title. II. Series.
N7630.G76 1997
704.9'424'09024—dc21 96-36815

 ISBN 0 7190 4109 0 *hardback*
 0 7190 4110 4 *paperback*

 First published 1997

 00 99 10 9 8 7 6 5 4 3 2

Typeset in Monotype Bulmer
by Koinonia Limited, Manchester
Printed in Great Britain
by Biddles Ltd, Guildford and King's Lynn

CONTENTS

LIST OF ILLUSTRATIONS

Engravings can be found in the following publications: *The Complete Woodcuts of Albrecht Dürer*, edited by Willi Kurth, Dover Publications, 1963; *The Illustrated Bartsch*, Abaris Books, New York, 1981. General editor Walter Strauss. Adam Bartsch published first edition of *Les vieux maitres allemandes (Peintre-graveur, vol. VI)* in 1808; *Max Geisberg, The German Single-Leaf Woodcut: 1500–1550*, revised and edited by W. Strauss, Hacker Art Books Inc., New York, 1974; Ernst and Johanna Lehner, *Devils, Demons, Death and Damnation*, Dover Publications, 1971; and Max Lehrs, *Late Gothic Engravings of Germany and the Netherlands*, Dover Publications, 1969.

Photographs of misericords were taken by photographers at the Department of History of Art, University of Manchester.

For my Godchildren
Sabine, Rosalind, Jan and Julius

PREFACE

The literature published on the subject matter of women is enormous, covering both past and present times, for the debate on women is as alive now as it was in the Middle Ages, and misogyny is as old as the world itself, starting with Eve and the Temptation.

Just as books on the history of women assemble a picture of reality from archive material, economic and ecclesiastical reports and literature, so my book attempts to extract from visual representations of women the symbolism and realism, the significance of the illustrations and the motivating factor behind them. It examines the portrayal of women in art – in manuscripts, paintings, engravings and sculpture – and it covers the late Middle Ages and the early Renaissance in Northern Europe, c. 1400 to c. 1540. This period of transition saw the demise of Catholicism and the introduction of the Reformation in many parts of Northern Europe, encouraging a renewed, intensified preoccupation with women and their duties. There was a new emphasis on the individual and on marriage, yet women became less independent, for during the Reformation the patriarch gained in control, the actions and sexuality of women were closely scrutinised, and violent misogynist outbursts against women increased.

Most books on women use images to illustrate the text, whereas it is my aim to put the images first, and glean from them information about a woman's life. Often, however, pictures, like romances, do not tell the truth and meddle with reality; depictions of the lower classes, in particular, can be deceptive, for they were created by middle-class artisans, often intent on ridiculing peasants and labourers. In the marginal arts, above all, i.e. margins of manuscripts, prints and misericords, women are depicted as shrews, fighting men for power over them, destroying their virility and everyone's honour in the process.

While this book concentrates on visual material, other books covering the life of women using documentary evidence were essential to me, and to obtain a more complete picture, the expertise of researchers from many disciplines was of the utmost importance. My greatest gratitude goes to Dr Steve Rigby, whose constructive advice on editorial matters, and on suggestions for reading on specific themes, was invaluable.

1

The history of misogyny

From the beginning, the image of woman was created by man and in the Christian Middle Ages this was the image of Eve. Eve, born from Adam's rib, was tempted by the devil and persuaded Adam to disobey God and eat the forbidden fruit, resulting in the expulsion from paradise, mortality, and life on earth in hardship, tears and sorrow. Since then, female descendants of Eve were held responsible for this loss of paradise and castigated as temptresses and sinners; rebellious and impossible to discipline. Only the Virgin, a woman of absolute purity and humility, born without original sin, was able to redeem humanity, as the second Eve.

The early Church Fathers of the fourth and fifth centuries in particular were responsible for creating the image of woman as temptress, for they fled the world with its temptations and led a life of extreme asceticism in the desert. Evil to them was identified with the flesh. In art, the Temptation of St Anthony[1] best reflected fear of women, showing the holy man in the desert tempted by a worldly woman, beautiful and fashionably dressed, her evil nature often indicated by clawed feet, the snake-like train of her dress or the devilish horns of her headdress, as illustrated in an engraving by Lucas van Leyden (Pl. 1). Hieronymus Bosch's triptych of *The Temptation of St Anthony*[2] depicts all the hybrid monsters of hell that afflict the saint, and the woman temptress is right behind him, in the central panel, and also appears to him in the nude from behind a curtain draped around a tree, in the right wing. Only faith in Christ can save the saint, but Christ is barely visible in the background of the central panel, pointing to the Crucifixion. The story of St Anthony's life as a hermit in the desert was originally compiled by St Athanasius and St Jerome, and it was St Jerome (c. 342–420), above all, who advocated a life of asceticism and whose negative views on women – expressed in his *Adversus Jovinianum*, c. 393 – influenced much of medieval thinking. In his opinion, even

to touch a woman was bad, and the very presence of a wife would distract a husband from his prayers, for women's love was insatiable and deprived men of their vigour. In discussing marriage and virginity, St Jerome considered marriage third after virginity and widowhood on the scale of spiritual perfection. However, marriage was superior to lust, for he agreed with St Paul, who in his letter to the Corinthians (I Corinthians 7:8–9) advised the unmarried and widows to marry, saying: 'But if they cannot contain themselves, let them marry; for it is better to marry than to burn.' In his letter to Eustochium, the daughter of his friend Paula, who had taken up a life of virginity, St Jerome advised her on how to beware of carnal temptations by telling her of his own fearsome struggles against fantasies of dancing girls; in spite of castigating his flesh and leading the life of a hermit, intent on contemplation, burning desire would afflict him.[3] Once more, Hieronymus Bosch most vividly depicts St Jerome surrounded by fantastic creatures, plants and idols, among the crumbling ruins of pagan Rome, which to St Jerome represented all the worldly pleasures of a wanton society, for example, *St Jerome*, Venice, Palazzo Ducale. There are, however, no dancing girls in medieval depictions of St Jerome, and even later they rarely appear.

Few are the writers who wrote positively on women, and some of these will be discussed in Chapter 2. However, another of the early Church Fathers, St Augustine (354–430), in his *The Good of Marriage*, defended women against the extreme opinions held by St Jerome. To him neither the human body nor marriage was all bad, and he saw fidelity as an aid to marriage, which he considered a sacrament. Nevertheless, in his opinion too, woman was the 'weaker' sex, physically subjected to man, although he also says 'In her mind and in her rational intelligence she has a nature the equal of man's.'[4] The source of this view on woman's subjection is Genesis 3:16, where God tells Eve: 'And you shall be subject to your husband, and he shall rule over you.' Although this was said after the Fall, St Augustine commented that, even before her sin, woman had been made to be ruled by her husband and to be submissive and obedient to him.[5] What St Augustine feared most was the force and uncontrollability of sexual arousal, which began with the Fall. Also, he thought that Adam took the apple offered by Eve in order not to make her unhappy, fearing that she might waste away if he refused it, and would die; he therefore accepted it because of his affection for her.[6] St Augustine had met another of the Church Fathers, the Bishop of Milan, St Ambrose (339–97), who had baptised him after his conversion. St Ambrose, too, was much concerned with the nature of women and wrote treatises such as *On Widows* and *On*

Virgins, expressing vehement anti-matrimonial opinions. He equated the spiritual with Adam, i.e. the male, and sensibility with Eve, i.e. the female.

All the early Bible commentators, missionaries and Church Fathers had in common a life of single-minded dedication to asceticism which only encouraged their wariness of women. Their ideas of sexuality must have

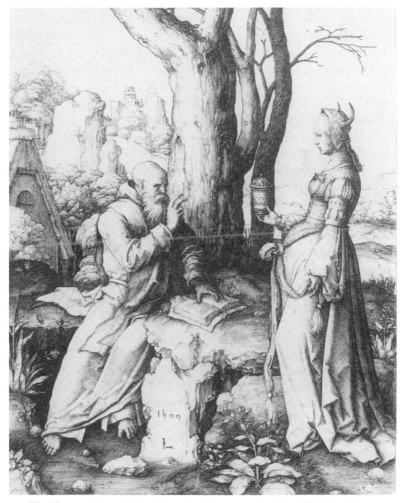

1 *The Temptation of St Anthony* by Lucas van Leyden. The 'Devil Queen' has come to tempt St Anthony outside his hermitage; the saint tries to keep her at bay with the sign of the cross. Her evil intent is clearly illustrated by her horned headdress and the jar symbolising vanity; she is associated with the Babylonian Whore

3

been influenced by their lives in isolation; in their preoccupation with matters spiritual, divorced from the concerns of ordinary people, women would have been a disruptive force. St Augustine was probably influenced by erotic and spiritual experiences, for he had a common-law wife for many years before sending her away after his conversion to Christianity. Much of what these founders of the Church said overlapped, and even if not all of them were anti-matrimonial, they all advocated virginity as the highest goal, and women were most decidedly the 'weaker' sex and temptresses. To Isidore of Seville (d. 636), woman was all body ruled by sexual desires, close to nature and with an undisciplined mind. The only use for women that he could see was procreation.[7] The traditional arguments focusing on woman as Eve were greatly boosted by Pope Gregory VII (1073–85) in his insistence on closer controls on the daily lives of secular priests and a tightening of the rule of celibacy. Women, once more, were seen as disruptive, as a source of disorder, able to lead men astray. Marriage from the turn of the twelfth century was to be monogamous, indissoluble and a sacrament of the Church, and it was from this time onwards that the criticism of women as Eve became ever stronger. In the thirteenth century preachers and moralists, in particular the great theologian Thomas Aquinas (1225–74), based their ideas on Aristotle, whose writings were considered 'scientific' and therefore authoritative. Here, they had their picture of woman confirmed as being weak, irrational, emotional, governed by passion and always receptive to evil influences. Women were seen as imperfect men with an excess of humidity in their bodies which made them damp and thus limp and unsteady, always changing like the moon. That was why women had to be watched over by men, protected, guarded, led, as the power of rational thinking was by nature stronger in men. In his *Summa Theologiae*, Aquinas asks whether woman should have been created in the first place. He answers this in the affirmative because of Genesis 2:18: 'It is not good for man to be alone; let us make him a help that is like himself.' Although he accepts the reason given in the Bible, he reduces woman's help to one possibility: 'it was absolutely necessary to make woman, for the reason Scripture mentions, as a help for man; not indeed to help him in any other work, as some have maintained, because where most work is concerned man can get help more conveniently from another man than from a woman; but to help him in the work of procreation'.[8] Thomas Aquinas also taught that a married woman could be virtuous as long as she had sexual relationships with her husband for the sole purpose of procreation and kept her mind chaste. He wrote that 'Chastity finds its home in the soul, though its nature lies in the body.'[9]

4

From these discussions of women in the eleventh, twelfth and thirteenth centuries, Farmer deduces that their position declined, and misogynistic ideas became more vehement.[10] This interlocking of ideas and reality is debatable,[11] but it can be seen that in this period the Virgin Mary became more and more revered and idealised, while woman remained forever Eve, thus widening the gulf between good and bad. The two polarities, of Mary the Virgin and Eve, of good and evil, came to dominate medieval life and thought in images of Life and Death, of the Virtues and Vices, of Body and Soul, of the Fountain of Life and the Fountain of Love, and of the good and bad women from the Old and New Testaments. In writings and visual images, much is made of the antithesis between the Virgin and Eve. The hymn 'Ave Maria Stella' turns 'Eva' into 'Ave', with which the Archangel Gabriel greeted Mary, the new Eve at the Annunciation. St Jerome created the formula: 'Death through Eve, life through Mary';[12] and St Augustine too said: 'through woman, death; through woman life'.[13]

In the Hours of Catherine of Cleves,[14] c. 1450, the two opposites Eve and the Virgin with Child are placed on either side of the Tree of Knowledge; they thus represent the two mothers of humanity, Eve and the 'new Eve'. The serpent coiled around the tree hands the fruit to Eve, naked apart from her leaf, while the Virgin and Child are well covered. An angel above the tree holds a scroll with the inscription: 'Eve authoress of sin, Mary authoress of merit'. The idea of the Virgin as Life, and Eve as Death, is illustrated in a miniature of the Missal of the Archbishop of Salzburg,[15] c. 1481, for the title-page of the Feast of Corpus Christi (Pl. 2). Again, the Virgin clothed and Eve naked stand on either side of the fruit tree, which on the Virgin's side has Christ on the Cross among the foliage, signifying redemption and life, while the skull of Death looks forth on Eve's side. The Virgin crowned as the Queen of Heaven plucks life-giving fruits like hosts to nourish the faithful kneeling at her feet and protected by an angel, while Eve receives the apple from the snake and hands it to her kneeling flock overshadowed by the figure of Death. Adam sits at the foot of the tree. Mary can also be identified with Ecclesia (the Church) and Eve with the Synagogue, and in art they stand on either side of the crucifix, Ecclesia with a banner of triumph, Synagogue with her staff broken. In an illustrated Bible of c. 1420, the so-called Zittau Bible,[16] Mary and Eve are pictured on the right and left, respectively, of the Living Cross together with Ecclesia and Synagogue; Mary hands out the true bread to members of the Church, while Eve distributes death's-head fruits to people in Jews' hats.

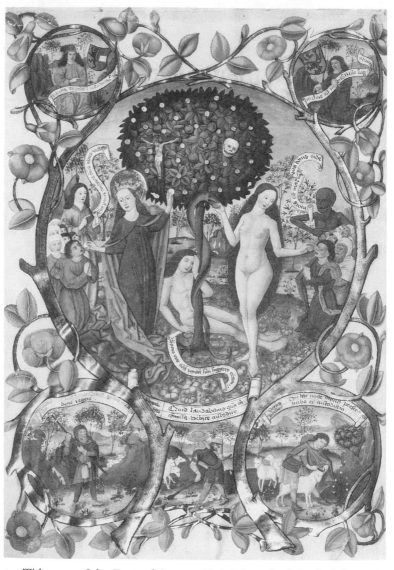

2 Title-page of the Feast of Corpus Christi from the Missal of the Arch-bishop of Salzburg. The Virgin Mary as the second Eve and the original Eve give their respective followers contrasting fruits from the composite Tree of Life and Death

The close association of death with Eve the temptress becomes quite explicit in a fresco in St Nicholas in Klerant (South Tyrol), *c.* 1475.[17] Here Eve is dressed in a very short yellow shift, tied at the shoulders and buttoned on the hip, and exposing her breasts, thus identifying herself as a prostitute. She reaches for the apple in the tree but what she holds in her hand is a skull. The serpent's head is that of a woman, often thus represented in art because the tempter (devil–serpent) in that manner identifies with Eve; they are mirror-images of each other. In a woodcut by Lucas Cranach, both Eve and the serpent have the same face so that the tempter and the tempted become interchangeable. Thus, in order to gain power over Eve, the devil appeared in her own mirror-image. Eve, there-fore, tempted into sin and disobedience, turns temptress herself for the whole of the human race. The image of Death and Temptation has its climax in a painting of Adam and Eve by Hans Baldung Grien from the beginning of the sixteenth century, where the carnality of Eve and her power for evil and death are explored (Pl. 3).[18] In this work, as in many of Baldung Grien's works, Eve or woman, always the temptress and seducer, becomes the victim of Death herself. On view in all her sensuality, she furtively hides the apple in her right hand behind her back and glances suggestively towards the serpent, whose coiling tail she touches daintily. But her soft, white flesh is gripped tightly by Death, who doubles as Adam and who plucks an apple, tempted by sexual desire for Eve the temptress. The flesh on his skeletal frame is rotting, hanging off the bones, and blotches of blood spread across his face and skull. While Eve touches the serpent's tail and Death/Adam grabs Eve by the wrist, the serpent sinks its teeth into Death's/Adam's wrist. Thus, they are all interlocked in their doom, Death being the victor. However, what stands out most is the figure of Eve as an object of sexual desire, and this once more makes Eve, representative of all women, responsible for death. Cornelius Agrippa, who wrote on witchcraft and the magic arts with which Baldung Grien was much concerned in his art, stated that it was the excitement that Eve purposefully aroused in Adam, seducing his body and ego with carnal desire, that was the true cause of original sin and the Fall, and not knowledge in general.[19]

The stark contrast between good and evil also found expression in the theme of the Wise and Foolish Virgins (Matthew 25:1–13). The five wise virgins are humble and patient, and their faith in the coming of Christ is unwavering as the light in their lamps is kept burning, while the five foolish virgins extinguish their lamps and enjoy the pleasures of the world. Matthew linked the theme with the Last Judgement, and in medieval art it

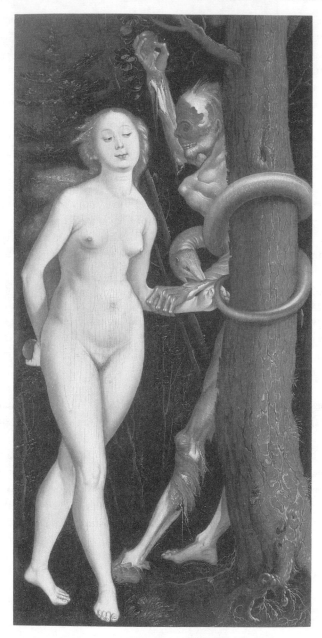

3 *Eve, the Serpent and Death* by Hans Baldung Grien. Eve
tempts Adam who doubles up as Death and Adam; their arms
are irretrievably entwined by the serpent

is often found on and around church doorways, where Last Judgements are usually placed. In thirteenth-century Germany, the Wise and Foolish Virgins were sculpted life-size, most frequently on the Portal of the Virgin (e.g. Magdeburg Cathedral). Usually, they stand on either side of the portal, the wise ones holding their lit lamps aloft, the foolish ones having turned theirs downwards, thus spilling the oil. Generally, the foolish virgins are more fashionably dressed, and their clothes accentuate the shapes of their bodies. In some of the Gothic churches, like Basle and Freiburg Minsters, the foolish virgins are deceived by the beautiful young seducer Satan, who smiles at them and offers them an apple; they fail to notice the evil in him, for it is hidden from their view, in the shape of crawling snakes and toads on his back; in the meantime, the wise virgins walk towards their bridegroom, Christ. Matthew does not mention the seducer, but the close connection with the Last Judgement must have been instrumental in creating this parallel to Satan at the Fall. Ultimate bliss is found in the Paradise Garden to which the wise virgins are welcomed by their bridegroom, and to which all blessed virgins and the Virgin herself withdraw. The Song of Songs (Song of Solomon) is the source for the imagery of the *hortus conclusus*, the enclosed garden, with beautiful flowers and fresh water, in which the Virgin and Child often sit in the company of saints. The *hortus conclusus*, shut off from the outside, earthly world, and surrounded by a wall or trellis of flowers, is symbolic of virginity; all the plants and the fountain of water within the garden refer to the Virgin's purity, her enclosed womb. Well-known flowers associated with the Virgin are the lily and the rose without thorns. In a small, intimate painting of the Paradise Garden, *c.* 1420, from the Rhineland,[20] the Virgin is seated in a flower-strewn enclosed garden, surrounded by saints who repose among the flowers, pick fruit or play with the Child. An engraving attributed to the Master of the Berlin Passion from the Lower Rhine area,[21] 1460s, shows the Virgin and Child with eight female saints in the enclosed garden (Pl. 4). The Virgin is making a wreath of roses, taken from a basket held by St Dorothy; and the Child, who has left her lap, is putting a ring on St Catherine's finger. All the saints are identified by their symbols and the angels sing: 'Gloria in excelsis deo et in terra pax hominibus bone volut' (Glory to God in the highest and peace on earth to men of good will). In contrast to the spiritual peace in the gardens of the Virgin, and yet very similar in composition and setting, are Gardens of Love, where the carnal passions rule in contrast to spiritual love (Pls 39 and 40), to be discussed later in connection with the evil woman.

Another theme of opposites popular in the late Middle Ages, and

particularly in the early Renaissance, was that of famous good and bad women from Scripture and classical antiquity, held up as examples of great heroism or treacherous deeds. Just as the Old Testament preceded the New Testament, so these pagan women were seen as typological parallels to Christian women, capable of good and evil. Examples of good women from the Bible are Judith, Jael, Suzanna, Ruth, Abigail and Esther; examples of bad biblical women are Salome, Delilah, Bathsheba, the daughters of Lot, the wife of Potiphar, and the prostitutes who persuaded Solomon to worship idols. Artists like the Netherlandish Lucas van Leyden and Maerten van Heemskerck did series of printed illustrations, c. 1517 and c. 1563 respectively.

Both Judith and Jael killed adversaries of the Israelites, i.e. Holofernes and Sisera, and by so doing they saved their people. They acted as instruments of God, and were considered heroic, the more so being women. Taking the example of Judith, the most popular in the arts, she entered Holofernes' camp[22] by seducing him, pretending to come and sleep with him, but instead she got him drunk and cut off his head. The moment most frequently portrayed in the visual arts is that of Judith handing Holofernes' head to her servant girl. This is what happens in an engraving by Israhel van Meckenem, c. 1500, where the servant girl holds open a bag to receive the head, and Judith looks the other way; her sword lies by Holofernes' bed and a battle scene is raging round about (Pl. 5). Because Judith achieved her aim through trickery, it might seem inappropriate for her to be classed as a 'good' woman; however, as she acted for the good of God's chosen people, she was praised for her deed and seen as a good example. Paintings and prints of this theme became very popular in the workshop of Lucas Cranach the Elder during the Reformation period, because the reformers saw a parallel between Judith's triumph over the enemies of Israel and their own victory, i.e. of the true, reformed Church over the Catholic Church. Lucas Cranach the Elder also depicted the story on two pendant panels: on the left, Judith at the banquet with Holofernes in the camp, and on the right, cutting off his head and putting it into the bag held by the servant girl.[23]

It is 'women's wiles' which characterise the bad women from Scripture, the best-known being Delilah and Salome. Delilah cut off Samson's hair, the seat of his virility and strength, allowing him to be caught by the Philistines. In art, Samson is depicted sleeping in Delilah's lap while she cuts off his hair, often with enormous shears. Salome delighted King Herod with her dancing, and was rewarded with the head of John the Baptist which she had desired. The scene of Salome receiving the head on

a platter from the executioner is most frequently represented. Sometimes the different moments of the narrative are combined in one panel, e.g. in *The Beheading of John the Baptist*[24] by the fifteenth-century Netherlandish artists Rogier van der Weyden and Hans Memling, the scenes of the Dance

4 *The Virgin Mary and Child Surrounded by Eight Female Saints in a Garden.* The Child puts a ring on St Catherine's finger, thus representing the Mystic Marriage of St Catherine to Christ

11

of Salome and the Presentation of the Head of John the Baptist to Herodias (Salome's mother) are in miniature in the background to the main scene of the Beheading of John the Baptist.

With the advent of the Renaissance came a new attitude to the human body and nudity. Throughout the Middle Ages the emphasis on chastity had generated an obsessive fear of the nude, which was equated with shameful nakedness and, therefore, sin. Some of the good women from the Old Testament and antiquity, however, called for representations in the nude, and in the Renaissance artists took advantage of this; also, a renewed interest in the tradition of classical antiquity may have added to the popularity of the theme. North of the Alps, Albrecht Dürer was the first artist who travelled to Italy (1494–5 and 1505–7), who studied theoretical books on proportions and perspective, and who was able to come to grips with the human body. But even he did not always use real-life models, but turned to classical models, his best-known and most influential example being the 1504 engraving *Adam and Eve*, where Adam is modelled on the Apollo Belvedere and Eve on Venus. From the point of view of the

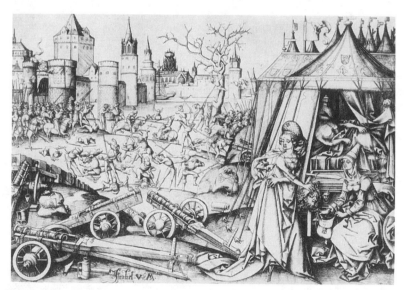

5 *Judith with the Head of Holofernes* by Israhel van Meckenem. Judith is about to place the head of Holofernes into a bag held at the ready by her maid, while the decapitated body of Holofernes can be seen reposing in his tent. The battle between the Israelites (saved by Judith's deed) and their enemies is enacted in German armour and with the use of contemporary cannons

meaning of nudity, it is interesting to note that Dürer had originally planned an illustration of Apollo and Diana, as the preliminary drawings show; however, as nudity was associated with sin, a depiction of the Fall was probably deemed more appropriate to the Northern spirit. The artists who, through the influence of Dürer, made the nude one of their main concerns were Lucas van Leyden and Jan Gossaert in the Netherlands, and Lucas Cranach and Hans Baldung Grien in Germany. Classical and mythological themes now became part of the artists' repertoire. Of the good women, Lucretia killing herself with a dagger could be portrayed full-length, half-length, slitting her dress with the dagger, in the nude or in a piece of flimsy drapery. According to Roman legend, she was the wife of Lucius Tarquinius Collatinus who, having been raped by her cousin Sextus Tarquinius, summoned her father and husband to take revenge, stating that, although without sin, she felt that punishment was inevitable, and thus she killed herself with a dagger. Thereupon, not only the culprit but his whole house and the Tarquinians were wiped out and a republic declared in 508 BC. This illustrates to what extent a woman's honour was essential to the existence of her extended family, and must be guarded at all costs; in this case, Lucretia's suicide was made into an example of the perfect wife, where generally the Church regarded it as a deadly sin. Lucas Cranach and his workshop created many versions of Lucretia, usually standing in the nude, wearing a headdress and a piece of heavy jewellery, her body lithe and of the same erotic type used for other classical beauties such as the Three Graces. In Jan van Scorel's painting[25] Lucretia, nude but for a transparent piece of drapery, looks sideways to the right, while her body is twisted towards the spectator and both her arms are stretched towards the left, to hold the sword that pierces her breast. The Master of the Holy Blood[26] portrays Lucretia in frontal position, three-quarter-length, her dress and bodice open to expose her breast, into which she has plunged her sword; her mouth and eyes are half open, with the glazed look of a pitiful death.

Suzanna in Her Bath is another Old Testament theme, concerning an innocent woman who was wrongfully accused of having had an affair with a young man by two lecherous old men whom she had rebuffed when they surprised her in her bath. Although nudity would be expected for this theme, Suzanna is often well covered up, in particular in Albrecht Altdorfer's example of 1526, although he is one of the young Renaissance artists.[27] She is sitting in a lush garden by a pool of water, her dress pulled up to her knees, and an attendant girl washes her feet in a basin of water, while another combs her long tresses. However, any part of a woman's

bare legs or long hair were considered a source of dangerous temptation, as the Knight of La Tour-Landry taught his daughters in his book of advice named after him (see Chapter 2): a woman should never comb her hair before a man; and even when alone she should not do so for too long, or the devil's bottom might appear in her mirror, as illustrated in a woodcut in the 1493 edition of this book (Pl. 6). As a result of this appearance, the book tells, the woman nearly lost her senses and suffered from shock for a long time afterwards.

As for the bad women of antiquity, their seductive nudity best expressed their women's wiles. Lot and His Daughters (Genesis 19) was a good example. Lot's wife, typical of women's nature, had disobeyed God's command, looking back at the burning city they had fled, and turned into a pillar of salt as punishment. As a result of this, Lot and his daughters were the only people to have escaped from Sodom and Gomorrah, and Lot's family line was threatened with extinction. To ensure continuation, the daughters needed to sleep with their father, which they did after plying him with wine, thus diminishing his responsibility. Once more the women were the temptresses, although in the cause of procreation. In many paintings, the scene of one of the daughters sleeping with Lot, while the other is seen handling the wine, takes place in full clothing; in 1537, however, Albrecht Altdorfer shows them as lascivious nudes,[28] the soft skin of the daughter reclining on her father's body contrasting with his darker, leathery skin. The bodies are offset by the lurid background colours of a vibrant green backcloth and the burning red landscape.

Even in mythological themes, like Paris and the Three Graces, where one would think the female nude could not be avoided, some German artists cover the Graces in dresses and exotic headdresses, as in a woodcut in the style of Lucas Cranach the Elder, c. 1508.[29] If the Graces were depicted in the nude in the fifteenth century, an inability to deal with the nude in general, and female beauty in particular, became especially apparent. In an engraving by the Master of the Banderolles, c. 1470,[30] the three spindly and stiff Graces lack all grace; Paris, in armour, lies at the foot of a fountain and is being roused by Hermes in a long coat. Venus is crowned, and the city in the background across the sea is identified as 'Troja magna'. All the figures have speech scrolls, giving the anonymous Master his name. Lucas Cranach the Elder himself took up mythological themes at the beginning of the sixteenth century, resulting in a large number of paintings of Paris and the Three Graces. The female bodies are serpentine and contorted; they stand on tiptoes, and are seen from different angles; one often looks back at the viewer with alluring eyes, her

head twisted at 180 degrees. They all represent the embodiment of sensuous desire, accentuated by a transparent veil that floats over their bodies. As is the norm in German art, Paris is a knight in armour and asleep. He needs wakening by Mercury and often looks at the Graces with a dazed expression. The three Graces are thus a dream vision, and Paris is not fully responsible for giving in to their temptations and for handing the apple to Venus. So again, even with the Renaissance in full swing, there is great timidity in the North about treating themes of love and passion, for the medieval concern with morals remains.

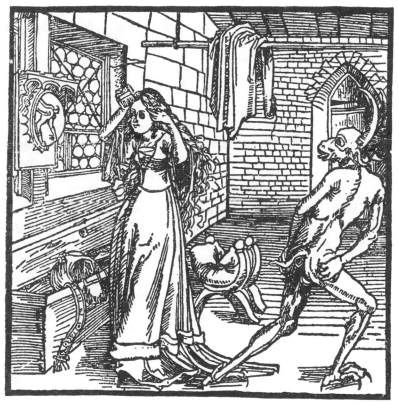

6 A *Young Woman Combing her Hair* before a mirror in which the devil's bottom appears. From the 1493 edition of The Book of the Knight of La Tour-Landry. This woodcut illustrates the dangers of looking into the mirror, and the potency of long, flowing hair, symbolic of pride and vanity, in calling up the devil

As for the human body, only Dürer and Baldung Grien let it speak, and with very different results: Albrecht Dürer's nudes are harmonious, well proportioned, logically constructed, based on classical sculpture; Hans Baldung Grien transformed them into expressions of human passions, as seen in his paintings of Adam and Eve. But even in the Renaissance, virtue remained associated with a female figure clothed and vice with nudity, as, for example, in Dürer's engraving of *Hercules at the Crossroads*, where the peacefully resting nude woman in the lap of a satyr is surprised by the violent attack by Hercules and clothed Virtue.[31] However, when both good and evil women were dressed, their dresses showed little difference in the late Middle Ages and early Renaissance; especially in works by Lucas Cranach, good and evil women often look very much the same, sometimes differentiated only by their symbols, e.g. Judith and Salome. Albrecht Dürer, in a pen-and-ink drawing of a *Venetian Woman*, 1495, has his subject wear the same low-cut dress as he was later to use for the exotic dress of the *Babylonian Whore* in his woodcut of the *Apocalypse*, 1498, but also for a drawing of c. 1500 of *St Catherine*.[32] In the case of the sixteenth-century Netherlandish artist Jan Gossaert, the exaggerated bulging flesh of his mythological nudes is the same as in his portrayals of the Virgin, except that the Virgin is clothed and seems to burst out of her clothes. The female nude had become rounded and weighty by the 1520s and 1530s in the North, but the relationship between flesh and spirit remained problematic, as the medieval tension between content and style remained, e.g. in the late engravings of the *Power of Women* by Lucas van Leyden, where his treatment of erotic nude bodies is aided by gestures and expressions that highlight their evil, sinful nature. The question that remained for Renaissance artists was whether female flesh could be depicted as beautiful, for attractiveness was immediately equated with unchastity; there was always the danger of the triumph of physical beauty over the spirit, of man being tempted into the pleasures of carnal love.

Thus, the visual image of women did not change basically during this period because the mental picture of women in men's minds remained the same. The sharp division between good and bad women stayed in place, and misogynistic depictions proliferated towards the end of the fifteenth and at the beginning of the sixteenth century, increased by the availability of engravings and, in particular, cheap woodcuts. However, the women caricatured in prints were among the weaker, poorer members of society, such as peasants, that became the butt of ribald humour and moralising invective. Choir-stalls are major repositories of satire on women, and in England every large set of choir-stalls has a misericord depicting a woman

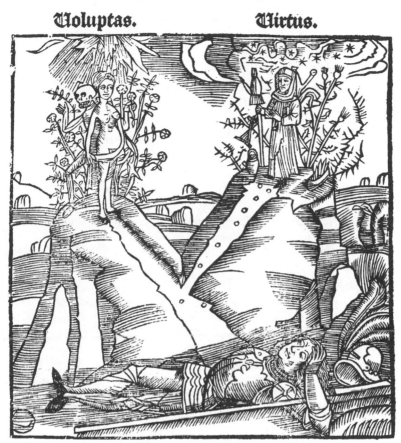

Uoluptas. **Uirtus.**

7 *Hercules at the Crossroads.* From Sebastian Brant's *Ship of Fools.* Hercules has a dream vision of Voluptuousness and Virtue, each standing on a mountain top; he must decide which path to follow: that of vice or of virtue

beating a man, or behaving badly in other ways. Even the universal tool of women in the Middle Ages, the distaff, could symbolise either good or evil, depending on whose hand it was in. In a woodcut by Hans Burgkmair of 1517,[33] *St Elizabeth of Hungary*, crowned and haloed, sits in the midst and above other women and nuns and teaches them to spin. This illustrates the 'spiritual spinner', as in a sermon preached by Geiler von Kaysersberg (Alsace) where cloistered women are addressed and advice is given on spiritual life. In contrast, the ordinary housewife is depicted using her distaff as a weapon with which to beat a man, as in prints by Israhel van Meckenem or on misericords. As will be seen in Chapter 3, the spirit of

17

misogyny is strongest in the marginal arts, where woman does not comply with the norms of society created by man, disregards them, rebels and turns the world upside-down.

To sum up, Sebastian Brant best illustrates the opinions of this age in transition in his *Ship of Fools*. There the woodcut of *Hercules at the Crossroads* shows Virtue and Voluptuousness at the top of two mountains: Virtue on the right as an old woman with distaff, well covered up; Voluptuousness in the nude, but for a headdress, pattens and a ribbon of drapery (Pl. 7).[34] Hercules, in armour, lies stretched out at the bottom of the mountains, having a vision of these choices before him; the road to Virtue is stony and thistles grow on top, while roses frame Voluptuousness. However, on closer inspection, skeleton Death beckons from behind Voluptuousness, and fire and brimstone burst out of the sky above her, while stars light up the sky above Virtue.

Notes

1 St Anthony, born in Upper Eygpt, *c.* 251–356; founder of monasticism.

2 Lisbon, Museo Antiga.

3 Letter 22: Blamires, 1992, pp. 74–6.

4 *Confessions*, XIII.32: Blamires, 1992, p. 78.

5 *De Genesi ad Litteram*, XI.37: Blamires, 1992, p. 79.

6 *Confessions*, XI.42: Blamires, 1992, p. 81.

7 *Etymologies*, XI: Klapisch-Zuber, C., 1992, p. 43.

8 In his *Summa Theologiae*, Ia, q. 92, a. 1: Blamires, 1992, p. 92.

9 *Summa Theologiae*, II–II, q. 151, a. 1,1: Klapisch-Zuber, 1992, p. 80.

10 Farmer, 1986, pp. 520–1.

11 Rigby, 1995, p. 269.

12 Jerome, PL 22, col. 408: Klapisch-Zuber, 1992, p. 23.

13 PL 38, col. 1108: Klapisch-Zuber, 1992, p. 23.

14 New York, Pierpont Morgan Library, Ms. M. 917, p. 139.

15 Munich, Bayrische Staatsbibliothek, Cod. lat. 15710, fol. 60v. The miniature is by Berthold Furtmeyer.

16 Wroclaw, Cod. M 1006.

17 Vavra, 1986, pp. 283–99, fig. 15.

18 Ottawa, National Gallery.

19 Hieatt, 1983, pp. 298, 299.

20 Frankfurt/Main, Städelsches Institut.

21 Name given by Max Lehrs. The beginning of his activity is thought to be the beginninng of the 1450s. Geisberg thinks that he comes from the Arnhem region, close to Westphalia. His stylistic sources are in Netherlandish art, e. g. Rogier van der Weyden.

22 Holofernes was one of Nebuchadnezzar's generals.

23 Gotha, Schlossmuseum, 1531.

24 In Berlin, Gemäldegalerie, Staatliche Museen Preussischer Kulturbesitz, Berlin-Dahlem, and Bruges, St John's Hospital (Memling Museum).

25 Jan van Sorel (1495–1562), Netherlandish; Berlin, Gemäldegalerie, Staatliche Museen, Preussischer Kulturbesitz.

26 From Bruges, early sixteenth century; Budapest, Szépmüvészeti Museum.

27 German, from Regensburg, c. 1480–1538; painting in Munich, Alte Pinakothek.

28 Vienna, Kunsthistorisches Institut.

29 Koepplin, D. and Falk, T. (eds), 1974, vol. I, fig. 116.

30 Koepplin, D. and Falk, T. (eds), 1974, vol. II, fig. 311.

31 The story is related by Xenophon (Strauss, 1972, p. 48) about the young Hercules deciding between Virtue and Pleasure.

32 *Venetian Woman* (lightly coloured) in Vienna, Albertina; *St Catherine* in Berlin, Staatliche Museen, Preussischer Kulturbesitz, Kupferstichkabinett.

33 Stuttgart, Würtembergische Landesbibliothek, Theol. fol. 669.

34 Latin edition, Basle, 1497.

2

The good woman

The Virgin and saints

No woman was higher in virtue than the Virgin Mary, who was both ideal woman and mother, and no other holy figure was so well represented in all the arts; as the mother of Christ she was also the best intercessor, intervening on behalf of human souls at the Last Judgement. The cult of the Virgin Mary was greatly enhanced by the teachings of the Cistercian abbot Bernard of Clairvaux (c. 1090–1153); in the Vision of St Bernard, his lips parched from ardent prayer to the Virgin are moistened with drops of her milk, which in some of the visual representations become fountains of milk streaming towards the kneeling St Bernard from the Virgin's breast, e.g. in a North Netherlandish Book of Hours, c. 1470 (Pl. 8). St Dominic (1170–1221), too, added to the veneration of the Virgin; he was credited with the introduction of the rosary as we know it today, after having had a vision of the Virgin instructing him on its use. Two Dominicans, Jakob Sprenger and Alanus, started the first Brotherhood of the Rosary in Cologne in 1475, where some of the first paintings of the Virgin framed by the rosary were painted. A large number of woodcuts show the Virgin and Child in the company of the faithful, and St Dominic distributing roses. Woodcuts like these, because of their low costs, helped to spread the devotion to the Virgin among the general public. However, the veneration of the Virgin was universal, and in 1506 Albrecht Dürer created one of the most prized paintings of the Madonna of the Rose-garlands for the community of German merchants in Venice.[1] The Virgin with Child is enthroned, and with St Dominic they distribute white and red roses for the joys and sorrows of the Virgin to the kneeling devotees, among whom are Emperor Maximilian I and the Pope.[2] Dürer has included himself, and the whole scene is set into a deep landscape. In a North Netherlandish panel painting of c. 1500,[3] St Dominic and his monks

are lined up in two rows facing down the nave of a church, singing the praise of the Virgin, whereupon the Virgin with Child appears to St Dominic. This demonstrates the power of contemplation and visions; in the same way, the rosary was to be used as an instrument of meditation on the life of the Virgin, helping the devout to call up visions of the happy and sad events in the Virgin's life.

An important movement, the Devotia Moderna, advocating meditation and contemplation, was initiated in the Netherlands by Geert Grote (1340–84), and popularised by Thomas à Kempis (1379/80–1471) in his *The Imitation of Christ*, written during the earlier part of the fifteenth century.[4] This movement had its sources in the mystical tradition of St Bernard of Clairvaux, St Dominic and Pseudo-Bonaventure, and its effects were especially strong in the Netherlands and along the Rhine in Germany. Meditations on the life of Christ and the Virgin were to encourage a personal, inner piety, and art was an important tool in this process, in particular the small devotional panels of the Virgin and Child

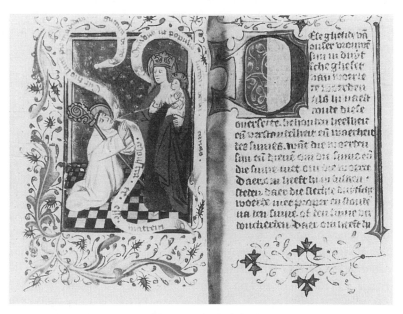

8 *The Vision of St Bernard*, North Netherlandish miniature. St Bernard is kneeling before the standing Virgin and Child. His prayer and the Virgin's response are illustrated by the scrolls. The Virgin's love for St Bernard is made manifest by the milk from her breast directed at the saint

in half-length. The powerful didactic effect of such pictures is demonstrated by St Catherine of Alexandria's question to a hermit, as to how she could best become worthy of Christ as her bridegroom, whereupon she was handed an icon of the Virgin and Child to contemplate. Examples of this scene in art are the Book of Hours of Engelbert of Nassau, c. 1480, and a painting by Hans von Kulmbach from the beginning of the sixteenth century.[5] In order to imitate the life of Christ and the Virgin, as advised in the Devotia Moderna, it was necessary to turn to apocryphal writings, and to *The Meditations on the Life of Christ* by Pseudo-Bonaventure, who himself used apocryphal sources, due to the scarcity of narrative material in the Gospels.[6] Bonaventure's emotional, personal contemplation influenced artists who turned the holy figures out towards the viewer, and depicted the goriness of Christ's tortured body and the Virgin's emotions of sorrow at the Passion. In scenes of the Passion, the frantic pain of the Virgin is that of a mother who has lost her son, e.g. in the *Entombment* by the Netherlandish artist Robert Campin, c. 1420, where she throws herself over the stiff body of Christ laid out on the tomb and kisses his lips, already turned blue.[7] In the *Descent from the Cross* by the Netherlandish artist Rogier van der Weyden, c. 1435,[8] the fainting Virgin is seen as a parallel to the dead Christ being taken down from the cross; their falling bodies and lifeless limbs curve in unison, and both have their eyes closed and the pallor of their faces is a bluish-white hue. In this manner, the artist has given visual expression to the Virgin's role as co-redeemer in the salvation of human kind.

The Devotia Moderna, while preaching the imitation of Christ through meditation and contemplation, also believed in the practical management of life, particularly in help to the poor. Furthermore, there was a new curiosity about the world in the fifteenth century, when every tiny object of creation was considered of importance, as part of God's creation of the world; as the microcosm in the macrocosm. The Netherlandish artist Jan van Eyck was the first to create a real world in panel paintings, so that all the plants symbolically associated with the Virgin were identifiable, as in the *Madonna by the Fountain*, c. 1430,[9] where the Virgin and Child, standing in a *hortus conclusus* (see p. 9) before a backcloth held up by two angels, a floral arbour and the fountain of life, are surrounded by lilies of the valley, strawberry plants, lilies, daisies and roses. It is in scenes of the Virgin of Humility that the Virgin comes closest to life on earth, associating with humans in a literal sense, for she comes to sit on a very low stool, practically on the ground. She is no longer the Queen of Heaven but a humble mother, placed in a bourgeois interior, e.g. an early fifteenth

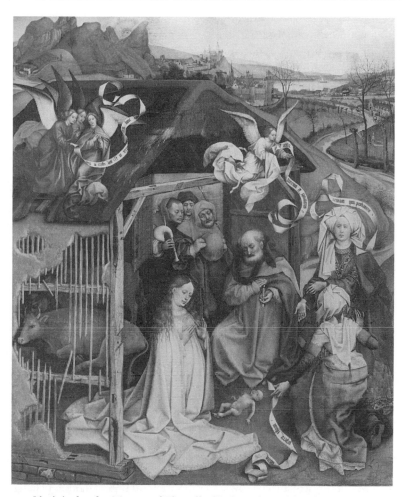

9 *Nativity* by the Master of Flémalle (Robert Campin). The Christ Child, lying on the bare ground, is encircled by the Virgin Mary, St Joseph and two midwives. Angels announcing the birth fly over the dilapidated shed into which the shepherds look, and which contains an ox and a donkey. A golden sun rises above the craggy mountains onto a wintry landscape. The Virgin in white venerating the Child with rays emanating from it corresponds to the descriptions of St Bridget of Sweden

century very small panel from the workshop of Robert Campin, nursing her child by the fire.[10] Scenes like this look quite realistic, in particular in Netherlandish art, where the Virgin rarely has a halo to identify her;

however, the everyday objects are not what they seem to be, because they also function as symbols: for instance, the seamless cloak hanging on the rack above the Virgin points to the cloak worn by Christ on the way to the Crucifixion, and is therefore a premonition of the sad events to come. At the beginning of the sixteenth century, in Bruges, Gerard David invented a close-up, half-figure portrayal of the *Virgin and Child with a Bowl of Milk*.[11] The Virgin looks very young, with soft features and long streaming hair, held in a soft bonnet; she holds the Child on her lap and feeds it from a bowl, while the Child plays with a spoon and spills the broth; an apple and bread are on the table, and under the window can be seen the Virgin's work basket and book. It looks like a picture of an ordinary mother and child.

Although so much like human mothers in pictures of this type, the Virgin, because of her virginity at Christ's birth, was, of course, very different, as was conveyed in depictions of the Annunciation to the Virgin.[12] Generally, the Annunciation takes place in a sacred interior,[13] where the Virgin's reading of Isaiah's prophecy, 'Behold a virgin shall conceive' (Isaiah 7:14), is interrupted by the Archangel Gabriel's greeting, announcing the birth of God's son to Mary; the Holy Ghost in the shape of a dove hovers above. Robert Campin was innovative in placing this scene in a well-appointed bourgeois interior, in the central panel of a triptych, *c.* 1426.[14] The angel steps before the Virgin, who is sitting at the foot of a bench, leaning against it, her eyes fixed on the book in her hands. On the table are another book, open at Isaiah's prophecy, a still-smoking extinguished candle and a vase with lilies; the room is furnished with a fireplace and a niche with wash-basin, kettle and towel. Once more, these objects, painted in all detail, are also symbolic of purity, of the water of baptism and the new Christian faith. Most surprising of all is the apparition of the tiny Christ Child, shouldering his cross and sailing down from the windows on the left towards the Virgin on rays of light, replacing the usual dove. This rather bodily depiction of the conception was popular with Bohemian and Netherlandish artists at the beginning of the fifteenth century, but was frowned upon by the Church, which feared doubts about the virginal birth of Christ.

The Virgin's motherhood was at its most human at the Nativity, when, from the very time of his birth, she had premonitions of Christ's death. It is debatable whether she experienced pain at birth, but in fifteenth-century Netherlandish and German scenes of the Nativity, e.g. by Rogier van der Weyden and Hugo van der Goes, a column often holds up the ruin or shed, and a passage of the *Meditations* of Pseudo-Bonaventure describes the Virgin supporting herself on a column prior to giving birth.[15] St Bridget

of Sweden, in her *Revelations*, mentions the column of the Flagellation in connection with the Nativity, where the Virgin tells St Bridget that she foresaw the Passion as soon as she had given birth.[16] Scenes of the Nativity had apocryphal human details added which reflected the activities of earthly women, such as the midwife adjusting the Virgin's pillow, as seen in English fourteenth-century alabasters, e.g. Holy Trinity, Long Melford, Suffolk. Such details became more frequent around 1400, as seen in a small Nativity panel of *c.* 1410, possibly from Guelders,[17] which shows the Virgin sitting on a brocade mattress, trying to feed the Child from a bowl of broth, while St Joseph at his carpenter's bench attempts to entice the Child towards him with a carnation. The midwife is preparing Christ's bath, while angels fetch water, dry nappies, mend the thatch on the flimsy stable roof, and make the Virgin comfortable. These lively details, surrounding the Holy Family with household objects and busy activity, are placed in an unrealistic landscape; again, this changes with the *Nativity* by Robert Campin, *c.* 1420–25,[18] where the dilapidated stable is situated in a convincing landscape, and the two midwives have become real women, dressed in contemporary dress, although Salome wears rather a rich brocade dress trimmed with jewels (Pl. 9). She, according to the sixth-century Apocrypha, had doubted Mary's virginity, whereupon her hand withered, as seen in the painting. Thus, doubting the Virgin's most important attribute will be punished; however, when Salome came to see the birth, she believed and her hand was instantly healed. In another example of the Nativity from the Paris Hours of René of Anjou, *c.* 1410–20,[19] Mary sits on the ground, suckling the Child, and with her sleeves rolled up tests the bath water in the tub by her side, into which the maidservant, also with her sleeves rolled up, pours more water. Although the water in the bathtub is symbolic of baptism and therewith salvation, the symbolism surrounding the Virgin is now clothed in realism and gives a glimpse of a woman's life. In order to satisfy people's curiosity as to every stage of the Virgin's life, in the desire to identify with it, artists like the South German Martin Schongauer, *c.* 1470, and Albrecht Dürer from Nuremberg, 1504–11, printed whole series of the *Life of the Virgin*. Dürer's woodcut series starts with the life of the Virgin's mother Anne. In the *Birth of the Virgin* the drama of such an event is depicted most vividly (Pl. 10). A large number of women in contemporary dress have come to assist at and after the Virgin's birth. Some bathe the child; some bring food to the exhausted mother, St Anne; while others have dozed off or refresh themselves with a long drink from a tankard after all the excitement and exertion. Dürer was known for his inventive variations on a traditional theme and gave inspiration to many

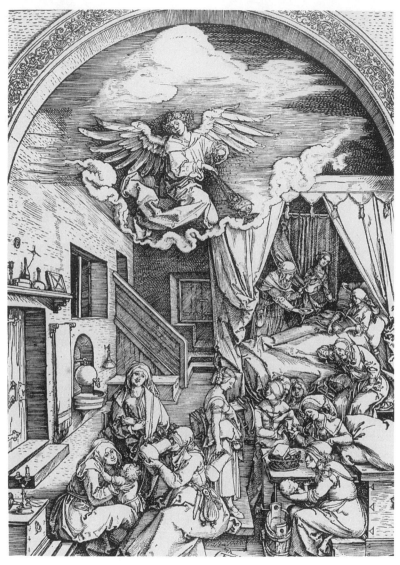

10 *Birth of the Virgin* by Albrecht Dürer, from the woodcut series of the *Life of the Virgin*. St Anne rests in the bed in the background after having given birth to the Virgin Mary who is being bathed. It is a happy scene of bustle, with women having assisted at the birth, resting or busying themselves. That this is no ordinary birth is indicated by the room opening up to heaven

artists. His engravings and woodcuts of the Virgin and Child are very numerous, and in one of his woodcuts he portrays the *Holy Family in Egypt*, in a courtyard surrounded by half-timber buildings and barns; here, the Virgin is seen spinning, an occupation typical of the housewife, while the Child sleeps in his cradle at her side, and St Joseph works at his carpentry. In a painting by the North German artist Master Bertram, from his Buxtehude altarpiece, *c.* 1400, unusually, the Virgin is portrayed knitting, while the Child plays at her feet;[20] it looks like a happy domestic scene, but the coat the Virgin is knitting is the seamless one, diced over at the time of Christ's death, and the objects the Child plays with are the instruments of his future Passion. So, even the joyful moments of the Virgin's life are turned into sadness by her ability to foresee the events to come, indicated by artists through the inclusion of symbolic objects or the sad mien of the Virgin when contemplating her Child. However, the difficulties in her life, the adversity she had to overcome, must have made the links with ordinary humanity even closer, for if the Virgin suffered as ordinary people did, she would be able to be more understanding, teach others not to give up their faith and, above all, have compassion for sinners and act as their intercessor.

In the fourteenth and fifteenth centuries, the Book of Hours, often profusely illuminated, was the most popular devotional book for the laity from which to study and meditate on the life of the Virgin, for the Little Office of Our Lady, composed of certain psalms and lessons, hymns, prayers and antiphons, formed its basic text. Books of Hours are so called because they are divided into eight parts, one for each of the hours of the liturgical day, the so-called canonical hours: matins, laud, prime, terce, sext, none, vespers and compline. They were a shortened version of the Breviary, with its complicated Divine Office, more suitable to monks and nuns. The characteristic components of the Book of Hours are: the liturgical Calendar, the Little Office, the Penitential Psalms, the Litany, the Suffrages or Memorials to the Saints, and the Office of the Dead. The Office of Our Lady began to be detached from the Breviary in the thirteenth century, the first English example of a Book of Hours appearing *c.* 1250 and executed by the monk William de Brailes from St Albans.[21] Because of their expense, illuminated Books of Hours were treasured possessions of the wealthy middle class or aristocracy, and some examples are very personal in the portrayal of donor or donatrix, patron saints and scenes chosen. They were favourite wedding presents to brides, e.g. the so-called Lochorst Manuscript, given to Katrina van Rijswijck from Leiden by her husband Gerard of Lochorst from Utrecht for her wedding

in 1448.[22] Books of Hours were also frequently commissioned by women themselves, e.g. Jeanne d'Evreux, Joanna of Navarre, Catherine of Cleves, Mary of Guelders and Mary of Burgundy.

Apart from the usual scenes of Mary's life, the Book of Hours of Catherine of Cleves shows the Virgin as mother looking after her family in a domestic interior, as part of the Saturday Hours of the Virgin.[23] In the first miniature, she is seen weaving at her loom in her working dress, while the child Christ takes his first steps in a walker and St Joseph planes a beam (Pl. 11). The room has a tiled floor, windows and fireplace, a shelf of silver or pewter plate and other homely utensils. In the other miniature, the Virgin sits on a mat at the foot of a chair and suckles the Child, while St Joseph eats broth out of a bowl seated in an armchair cut out of a barrel. The action of giving suck to the Child is a powerful indication of the Virgin's role as intercessor, of feeding the devout through her son. Also, the Child in the Virgin's lap can be interpreted as the sacrifice on the altar, associated with the Eucharist. In the fireplace between Mary and Joseph one pot is suspended above the fire while another sits on the coals, and the walls are hung with a variety of household utensils. In connection with these miniatures, it is interesting to consider the position of St Joseph as the man in a domestic situation. What one finds is that in medieval art he is seen in a subordinate position: the Virgin is the Queen of Heaven, and St Joseph a well-meaning fool.[24] In most fifteenth-century depictions he is shown doing menial tasks, heating the broth, drying nappies, cutting up his sock with which to cover the Child in his cradle, or having a good drink, and at the Nativity he arrived too late for the birth. Even when doing his carpentry, he cut a beam too short and little Jesus had to lengthen it again, miraculously. Jean Gerson (1363–1429), a theologian at the University of Paris, did his best to elevate Joseph's position, at the beginning of the fifteenth century, but it was not until the seventeenth century that, under the influence of the Jesuits, Joseph attained equal status with the Virgin. The only artist who depicted Joseph as a serious carpenter in his workshop, a father able to support his family, was Robert Campin, in the right wing of the *Annunciation* triptych already discussed.[25]

The humans most closely following in the footsteps of the Virgin were the virgin saints who died for their faith and chastity and thus further contributed to the picture of good Christian women. Saints, generally, are portrayed suffering their martyrdoms with great calmness and fortitude, oblivious to any pain, and eyes turned heavenwards. The symbol signifying martyrdom is the palm branch, and a group of virgin saints walk towards the Lamb in the altarpiece of the *Adoration of the Lamb*[26] by Jan

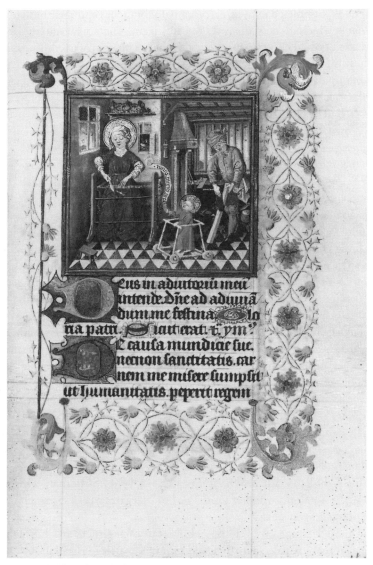

11 *Holy Family at Work*, from the Hours of Catherine of Cleves. In homely surroundings opening into the landscape, the Holy Family is busy: the Virgin at her loom; St Joseph at his carpentry; and the Child in his walker. The text on the Child's scroll says: 'I am your solace.' A shelf with pewter plate is nailed to the wall above the Virgin, a small cabinet behind her contains her weaving materials, and there is a large fireplace and a carpenter's bench with tools on St Joseph's side

van Eyck, completed in 1432, carrying palm branches and their individual symbols which identify them. Like the Virgin, saints were intercessors, and a saint could be found for every ailment or situation of need. The more help was forthcoming from a saint, the more miracles a saint worked, the more popular he or she would be, resulting in donations and pilgrimages to their shrines, and the purchasing of their images. In the case of female saints, much emphasis was put on their chastity. As many refused to marry and vowed to remain virgins, the question of marriage figured in many of their legends, and some of their tortures related to sexual organs – St Agatha, for example, had her breasts torn off with a pair of pincers. She, like St Agnes, had refused her suitors and was thrown into a brothel, but miraculously preserved her virginity. St Agatha is therefore represented carrying her severed breasts on a platter. The lamb which is St Agnes's symbol has its source in the Greek adjective *agnos* (feminine *agne*), meaning chaste, and is also related to the Latin *agnus* for the lamb. The early Christian female saints were mostly of noble birth, and because of their youth and beauty most desirable, so that their dedication of a life in the service of Christ was much resented. Unless they went into the desert, where their long hair covered their naked bodies, as in the case of St Mary Magdalene of Egypt, they were sumptuously dressed, like St Catherine in fur, silk, brocade and jewels. Should their bodies be exposed by heathen torturers, their long hair would hide their bodies, or angels would appear with blinding white cloaks, as in the case of St Agatha. Some of these saints can be seen in the engraving of the *The Virgin Mary and Child Surrounded by Eight Female Saints in a Garden*, already mentioned in Chapter 1 (Pl. 4, p. 11). Behind St Cather-ine being wedded to Christ the Child is St Mary Magdalene with her ointment jar, then St Dorothy with the basket of roses, and behind her is St Agatha, here with the pincers that tore off her breasts; on the right-hand side are St Agnes with her lamb, St Barbara with her tower, St Apollonia with her tooth, and St Margaret with a cross, coming out of the dragon's belly.

Although women were to be obedient to their fathers and husbands, many of these female saints resisted parental marriage plans in order to lead a life of chastity in the service of God. St Catherine of Siena dedicated herself to a religious life as a young girl, and wanted to emulate her namesake, St Catherine of Alexandria, in having Christ as her bridegroom. These women were strong-willed in their dedication to Christ, and St Catherine of Alexandria was also most notable as a scholar, opposing Emperor Maximin II, and disputing her Christian faith with pagan philosophers whom she converts through the strength of her arguments,

as in the Belles Heures of the Duc de Berry,[27] which contains a whole cycle of miniatures on the life of this saint. Mostly, she is depicted at the moment of her mystic marriage, when Christ Child puts a ring on her finger, or with her spiked wheel on which she is to be tortured, when God intervenes and sends down bursts of lightning which strike the heathens and set the wheel

12 *Martyrdom of St Catherine* by Albrecht Dürer. St Catherine is kneeling by the wheel which due to God's intervention is killing her torturers, not herself

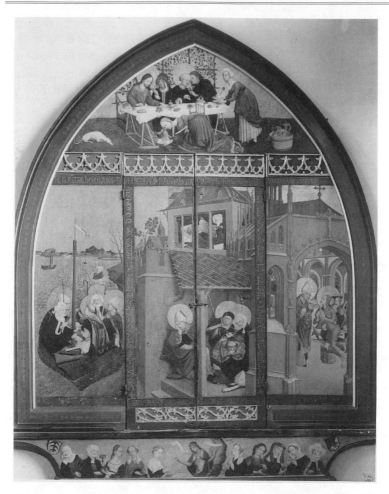

13 *Altarpiece of St Magdalene* by Lucas Moser; signed, dated and with an inscription: 'Cry art, cry, and mourn bitterly, no one wants you any more, so oh woe; 1432, Lucas Moser, painter of Weil, master of this work, pray to God for him.' The life of St Magdalene represented shows: the feast in the house of Simon combined with the feast of Lazarus in the arched top; the miraculous voyage of St Magdalene by boat to Marseille, accompanied by SS Martha, Lazarus, Cedonius, and Maximin, in the left panel; the miraculous appearance of St Magdalene to the pagan prince and princess, while her companions sleep, in the centre; and the last Communion of the Saint, administered by Bishop Lazarus to St Magdalene dressed in her own long hair, and brought from her hermitage by angels, in the right wing. The predella depicts Christ between the wise and foolish virgins

aflame, making it spark, thus giving us the 'Catherine wheel', as in a woodcut by Albrecht Dürer (Pl. 12). In the end she was beheaded with the sword, and her symbols are a book for her learning, the wheel and the sword.

In the case of St Barbara, her father wanted to prevent her from seeing any man according to one version of her legend, and to preserve her from Christian teaching according to another; she was therefore imprisoned in a tower.[28] In spite of all precautions, however, she was converted to Christianity, and had three windows inserted into the tower, representing the Trinity. After many tortures she was beheaded, her own father having dragged her to her place of execution, whereupon he was struck down by lightning. A Netherlandish artist was named the Master of the Legend of St Barbara after a triptych of the story, painted c. 1470, of which only the left wing and the central panel exist.[29] In a silverpoint drawing on a small panel by Jan van Eyck, 1437,[30] St Barbara's symbol, the tower, has become the unfinished, real-size gothic cathedral tower, closely related in style to Cologne Cathedral. St Barbara sits on a mound, high above the workmen scuttling around below, busy with building work; she holds a palm branch and turns the pages of her book, as though she were overseeing the operation.

St Ursula of Brittany, daughter of a Christian king, would only marry a heathen English prince if he and his court would accompany her on pilgrimage to Rome, there to be baptised. Eleven thousand virgins were to travel with her as attendants. On their return journey they stopped in Cologne, which was in the hands of the Huns; the pagan Hunnish prince asked St Ursula to marry him, but she refused, and with all her company was shot to death by arrows. The arrow, thus, became St Ursula's symbol. Many of the fifteenth-century panel paintings of her life and martyrdom were painted for Cologne churches, as she had become the patron saint of Cologne. The most famous painter of her legend was Hans Memling, who, in 1489, painted the shrine containing some of St Ursula's relics for St John's Hospital in Bruges, where it is still kept, depicting the events on the way to and from Rome, with the climactic death of the saint and her virgins before a topographical view of Cologne. The two side panels portray St Ursula protecting the virgins with her cloak and the two nuns who donated the paintings kneeling at the feet of the standing Virgin and Child.

Another way to preserve chastity was to ask God for a slight change of sex, as did a Portuguese princess, St Wilgefortis, also called Uncumber, who refused to marry the King of Sicily. She grew a moustache and beard in order to put off her suitors, but her father had her crucified nonetheless. A statue of her survives in England, in Henry VII's Chapel in Westminster Abbey, and Hans Memling painted her crowned, bearded and bearing a

cross on the left exterior wing of the triptych of Adrian Reins.[31] The name 'Uncumber' points to the saint's help to wives wanting to uncumber themselves of their husbands.[32]

St Mary Magdalene's popularity was based on her humanity as a penitent sinner, redeemed through her faith in Christ. She was really a conflation of three women who were in contact with Christ: (1) the sinner who, during the meal at the house of Simon the Pharisee, washed Christ's feet and dried them with her hair (Luke 7:37–8); (2) Mary of Bethany, sister of Martha and Lazarus, whom Christ resurrected at their request (John 11:2); (3) 'Mary called Magdalene' (Luke 8:2) of the town of Magdala, who was possessed by devils that Christ exorcised, and who was present at the Crucifixion, Entombment and the scene of the *Noli me tangere* in the garden, after the Resurrection. Mostly, she was thought of as the fallen woman, who gave up her sinful ways for a life in the service of Christ, and thus she gave hope to many a sinner. Her life continues after the Ascension, when, according to legend, she travelled with Martha and Lazarus to Provence, where she withdrew to the cave of St Beaume in the Maritime Alps. She lived for another thirty years, and died in Aix-en-Provence, where she had been brought by angels to receive extreme unction. In art, St Mary Magdalene is represented as a beautiful young woman with streaming long golden hair, and with an ointment jar as her symbol. The whole story of her life is told in a German altarpiece of 1432 by Lucas Moser for Tiefenbronn Parish Church, including the rare scene of her receiving her last unction, dressed only in her long hair (Pl. 13). She is often portrayed washing Christ's feet, or meeting Christ after the Resurrection, when she was privileged to be the first to see him after his death; she is best known, however, from scenes of the Passion, where at the Crucifixion she has collapsed at the foot of the cross, winding herself around it, and wringing her hands and tearing her hair. Because of her history, St Mary Magdalene became the patron saint of a new type of order instituted with the specific purpose of saving fallen women and allowing them a life of repentance. These grew up, in particular, in cities which had brothels, such as Nuremberg and Cologne. Pictures most representative of this concept of service in penitence show St Magdalene washing Christ's feet at the house of Simon. Also, Christ had commended Mary Magdalene for sitting by his feet, listening to him, when her sister Martha had complained of having to do all the work. Mary Magdalene thus became an example of the contemplative life, which was rated more highly than the active life. In the middle of the sixteenth century, this scene became popular with the Netherlandish artist Pieter Aertsen, who liked to place

the apostles or *vanitas* still lifes in the foreground, while in the background St Mary Magdalene could be seen sitting and listening to the teachings of Christ.[33]

One of the female saints most prayed to by pregnant women was St Margaret, one of whose duties was to assist women in childbirth. The reason for this was that, having been swallowed up by the devil appearing as a dragon, she pierced his belly with the crucifix, and burst back into life. Many representations, therefore, show St Margaret emerging out of an enormous dragon, as in the *Arnolfini Marriage* by Jan van Eyck, where the

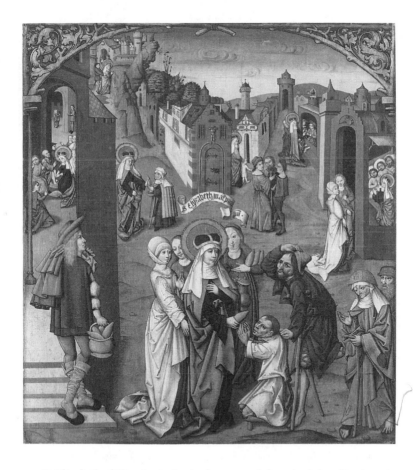

14 *St Elizabeth of Thuringia.* In the foreground the saint is handing bread to cripples; in the background she is washing the feet of the poor, giving them a drink, visiting the sick and those in prison

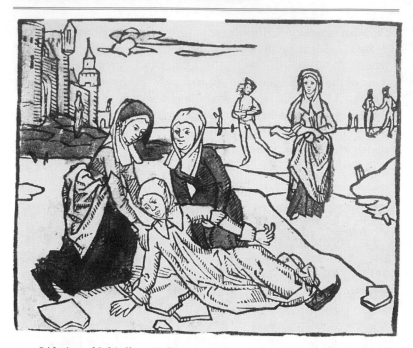

15 *Lidwina of Schiedham Falling on the Ice*, while skating, and helped up by
her friends. This is the first illustration of someone skating in the Netherlands.
People in the background are doing elegant turns on the ice

event is painted as a wooden carving on top of the chair-back next to the
bed.[34]

 Once Christianity had been established, saints no longer needed to die
a martyr's death, except in times of religious upheaval. The emphasis for
female saints remained on chastity, and of great importance were
charitable deeds. An example of a life of dedication to the sick and poor is
St Elizabeth of Thuringia/Hungary (1207–31), who followed St Francis's
teachings to the extreme by starving herself in order to feed and care for the
poor, refusing all her husband's possessions. On one occasion, bearing
food for the poor in her apron, she was questioned by her brother-in-law
about it, and when he looked into her apron, the food had miraculously
turned into roses. Another time, she had allowed a leper into her own bed,
but when her husband drew back the covers, he discovered the figure of
the crucified Christ. A German panel painting of 1495[35] shows St Elizabeth
distributing bread to cripples in the foreground and visiting the poor, the
sick and those in prison (Pl. 14). Like Christ, she is also seen washing their
feet. A cycle of paintings of her life, *c.* 1420, is found in the Holy Ghost

Hospital, Lübeck.

There was a large increase in the number of female saints in the first half of the fifteenth century,[36] and one of these, St Lidwina of Schiedham in the Netherlands (1380–1423), gives us an early insight into the favourite pastime of the Dutch in winter: ice-skating. A woodcut of 1498 of the saint falling on the ice with her skates on is the first illustration of skating in the Netherlands (Pl. 15). She is helped up by two women, one with her upper skirt tucked up, and St Lidwina's headdress is pinned together under her chin for extra warmth. As a result of this fall, St Lidwina spent the rest of her life (thirty-eight years) in bed, and because of her great patience in her suffering, she was already considered a saint in her lifetime. Thus, fortitude in adversity and an unflagging faith in Christ in spite of all suffering still characterised saints, while martyrdoms are often self-inflicted through excessive fasting, mortification of the flesh and exertions in imitation of Christ.

Nuns and mystics

Because chastity was of such importance for a virtuous life, nuns came closest to the ideal of the saints in this world. For strong-willed women, entry into a nunnery was the only accepted reason for not wanting to marry, just as it was for those who could not marry. It could therefore be an escape as well as a prison. A nun was married to Christ, as exemplified by St Catherine. An early-sixteenth-century German altarpiece in How Caple, Herefordshire, shows a Clare nun receiving the ring from the Child on the Virgin's lap, as in the iconography of St Catherine (Pl. 16). Also, when entering a convent, a novice nun had her hair cut off, as illustrated in a German altarpiece of the *Life of St Clare*, from the second half of the fifteenth century, where St Francis himself performs this task.[37] A nun's life consisted of work, study and prayer, based on the rules of St Benedict; and, like the monks, they had to say the eight monastic Offices, as depicted in a fifteenth-century French miniature of the Poor Clares in the Psalter of King Henry VI.[38] They would also do agricultural work, making the nunnery and its running comparable to a manor house with its estate. Most of the embroidery for the Church was done by nuns. The monastery of Lüne, North Germany, still retains a large collection of linencloths and embroideries for altars, chairs and benches made by the nuns. In a tapestry antependium of *c*. 1500 from the convent of the Dominicans in Bamberg, the artist-nun has portrayed herself sitting at her vertical loom, at the feet of the Virgin in a scene of the *Adoration of the Magi*.[39] In general, daughters of

16 *Clare Nun Kneeling Before the Virgin and Child Enthroned,* part of the How Caple altarpiece, Herefordshire. As in the Mystic Marriage of St Catherine the Clare nun receives a ring from the Christ Child

the nobility or gentry, and in the later Middle Ages also of wealthy merchants and professional townsmen, entered convents, where they could improve their learning and discover their talents in scholarship or music. St Clare[40] founded the Order of the Poor Clares in imitation of that of St Francis, with the principal aim of educating poor girls; poor girls of the lower classes, however, never became nuns because they could not afford the dowry required for entry into a convent, and because they were needed by their families for work in the fields or in industry. Art was one of the fields in which nuns could actively participate. For example, it was said that nuns did the wallpaintings in the former Cistercian nunnery of Wienhausen, and although this is not certain, it is documented that they restored them in 1488.[41] Also, they were often involved in the production of manuscripts: for example, Aleyt van Limberghen from Feldwerd nunnery in the Northern Netherlands depicted herself at prayer in the bottom margin of a Book of Hours that she wrote herself, completing it on 24 December 1491.[42] A German version of St Bonaventura's biography *The Life and Miracles of St Francis* was written and illuminated by Sybilla of Bondorff in Freiburg, 1478, under the direction of the abbess Susanne of Falkenstein.[43] The miniature shows a very youthful St Francis, fashionably dressed, with long curly hair and ruddy cheeks, who kneels on flower-strewn ground before an altar with Christ on the Cross, streaming with blood, flanked by Mary and St John. This illustration is an expression of the touching spirituality of many of these South German nunneries, especially those following the rule of St Francis and St Clare. St Clare's nunnery in Nuremberg was well known for its learning and the production of books on the lives of saints, of sermons and of the history of the nunnery.[44] Most of its nuns, although belonging to the Order of the Poor Clares, were of patrician birth, as was Barbara Stromer who wrote down the sermons of her confessor Heinrich Vigilis in 1494 in a manuscript which includes one miniature of St Magdalene appearing to Christ in the garden, probably also by her hand.[45]

Throughout the Middle Ages famous women mystics are believed to have received divine inspiration which allowed them to teach and preach even to leaders of Church and State, for this was no ordinary preaching but prophecy, God using humble women to make his will known. Artists liked to depict visionary events happening to these holy women, as in one of the panels from the St Clare altarpiece in Bamberg which depicts St Clare on her deathbed visited by Pope Innocent IV and his cardinals, an event which did not actually take place, but which refers to the Pope granting her and her nuns the privilege for a life in poverty, two days before her death.

At St Clare's death, the vision of the Virgin with her heavenly company standing around the bed is also visualised both in this altarpiece and in that at How Caple, Herefordshire.

Many female mystics came to prominence in the fourteenth century, and many who went into monasteries had been married or widowed, such as St Bridget of Sweden (1303–73), whose writings influenced the iconography of fifteenth-century paintings.[46] After becoming a widow in 1343 and retiring to a Cistercian nunnery, she experienced the first of her many visions. She moved to Rome in 1349, where she lived a life as laid out in the Gospels; in 1371 she travelled to the Holy Land, where she visited all the Christian sites that were to form the inspiration for her most potent visions. Her renown as a mystic led to kings and popes asking for her advice, and she did her utmost to bring about the return of the Pope from Avignon to Rome.[47] She formed a new order of nuns, the Brigittines, and a woodcut attributed to Albrecht Dürer shows St Bridget distributing the rules of her monastery, presiding over both male and female members (Pl. 17). Often, she is pictured as a Brigittine nun seated in her study writing down her visions, an iconography based on the Vision of St Gregory. Also, St Bridget received visions of St Anne and her family, and she is thus depicted on the exterior right wing of an altarpiece of the Legend of St Anne by a Brussels artist of the end of the fifteenth century.[48] St Bridget's vision of the Nativity most decisively changed the traditional iconography of this scene for the whole of the fifteenth century: where Mary was previously depicted lying in a bed or on a mattress and the Child in a crib, Mary would now kneel adoring the Child lying on the bare ground before her (Pl. 9, p. 23). Most important were St Bridget's descriptions of heavenly light: the rays of light streaming from the Child were stronger than any natural light, and Mary the Virgin was now dressed in white rather than blue. This is most effectively illustrated in the paintings of the Nativity by Robert Campin, where the Virgin's dress and cloak are both white, or by Rogier van der Weyden, where her dress is white and her discarded cloak blue.[49] Rogier van der Weyden also includes caverns in the ground which refer to the caves visited by St Bridget in the Holy Land and associated with the birth of Christ. Her contribution to the iconography of the Passion of Christ is most gruesomely represented in the Isenheim altarpiece by Matthias Grünewald.[50] Her descriptions of Christ on the Cross, mouth open to show his teeth, blue lips, chest sucked in, covered in sores and feet twisted like door-hinges, are literally translated into paint by this artist.

Margery Kempe (*c.* 1373 – *c.* 1439) was a lay mystic of middle-class background from King's Lynn who was greatly influenced by the

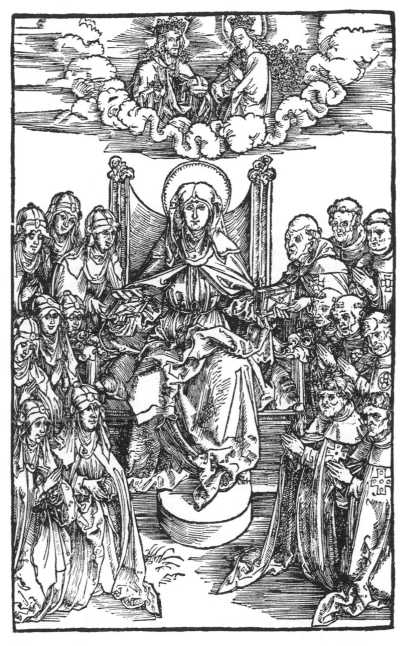

17 *St Bridget of Sweden* distributing the rules of her order among male and
female members, dressed in the Brigittine habit, by Albrecht Dürer

revelations of St Bridget.[51] After twenty years of marriage and the birth of fourteen children, she embarked on a life of pilgrimage to the Holy Land, to Assisi and Rome, to Santiago de Compostela, and very late in her life to Danzig, Wilsnack and Aachen. However, she was not interested in the sights but in emotional and spiritual experiences, in coming face to face with Christ's life and Passion. In contemplation of Christ's Passion, she was constantly moved to tears, even wailing and screaming, for she relived all the events from the betrayal to the Resurrection and saw herself as the repentant, sorrowing Magdalene. She wept for her own sins and for those of other people in purgatory, believing in the power of tears as effective prayers for intercession. These visions she dictated to be written down, because she herself could neither read nor write. She also visited the other famous English visionary of the time, Julian of Norwich, with whom she conversed. There is no picture of Margery herself, but what is of great interest is that her visions are a reflection of art rather than an influence on it. The mystical experiences she had are expressed in the many devotional pictures focusing on the gruesome details of Christ's death, the streaming blood, the discoloured body. Scenes of the Passion in particular showed Christ's suffering at every stage from the Mount of Olives to Golgotha, and the instruments of the Passion were depicted separately for contemplation, as in a manuscript illuminated between 1361 and 1373 in the southeast of England.[52] A major focal point of the manuscript page with the instruments of the Passion is the wound of Christ, held and venerated by angels. Most popular was The Man of Sorrows, a theme with no basis in Scripture but already represented in England by Matthew Paris in the thirteenth century, and showing Christ close-up, covered in blood, pointing to the wound in his side, his head drooping and his eyes closed or gazing pitifully at the viewer. Thus, art was in the service of an emotionally charged religion in imitation of Christ which greatly influenced people like Margery Kempe. Margery also had a vision of the sacrament as it is held between the priest's hands at mass; this illustrates the importance placed on looking on the host as the body of Christ, visualised in scenes of the Mass of St Gregory, e.g. in a painting by Robert Campin, c. 1420, where St Gregory calls up a vision of Christ as The Man of Sorrows on the altar, in order to prove to the unbelieving that the host is in fact the body of Christ.[53] Devotions to the host were encouraged by Church ritual, where the host was held high in a monstrance for all to contemplate, and in about 1450 King René of Anjou had the miraculous host kept in Dijon painted, covered in drops of blood.[54] On her pilgrimages, Margery Kempe saw many relics that would have been contained in beautifully crafted shrines

and caskets, and when she visited Wilsnack in Brandenburg, Germany, she would have contemplated the three hosts sprinkled with blood that had survived, miraculously, the fire of 1383. Margery's visions may also have been influenced by paintings of the Passion closer at hand, such as those at Norwich Cathedral, for she describes having seen in her contemplation 'our Lord Jesus Christ bound to a pillar, and his hands were bound above his head'.[55] Still preserved in Norwich Cathedral is the so-called 'Despencer retable',[56] c. 1380, with scenes of the Flagellation, Christ carrying the Cross, the Crucifixion, the Resurrection and the Ascension; of these the Flagellation is as described by Margery Kempe. The Crucifixion, too, can be compared with her description, where she speaks of the Virgin fainting into the arms of St John. Some of the details in the other panels can also be found in mystery plays.[57]

The art most conducive to the imitation of Christ, because of its ability to portray every detail of Christ's agony most realistically, thus engendering emotional responses, was fifteenth-century Netherlandish art. In Michelangelo's opinion this was an art created to please the devout, causing them to shed tears, and lacking the sense of true harmony of Italian art;[58] in the North, however, it was hailed, for it reflected the souls of all real-life Margery Kempes.

The good housewife

When considering the 'ordinary' woman concerned with the affairs of this world, both literature and art are more likely to be scathing about her character, and only a small proportion of works come to her defence. Mostly, it is the married woman, the housewife, who is being scrutinised, for to the man examining a woman's characteristics, her relationship with her husband and her treatment of him are of the utmost importance. The ideal for the good woman was the Virgin Mary, whose basic characteristics of chastity and humility she might try to imitate. A schematic woodcut of c. 1525 by the German artist Anton Woensam presents us with a picture of *The Wise Woman* (Pl. 18). Her stiff body is laden with the symbols that indicate her qualities, explained in the accompanying text-boxes: eyes like those of a falcon in order to keep clear of shameful behaviour; a key in her ear, referring to her willingness to listen to the word of God; the lock in her mouth, preventing her from using bad language and talking unnecessarily; the mirror to ward off pride; the turtle-dove on her breast illustrating that she will let no other man but her husband near her;[59] the serpent around her waist, demonstrating that she will speak to no one except her husband;

18 *The Wise Woman,* by Anton Woensam. She is dressed in the contemporary dress of a German housewife and carries all the symbolic attributes explaining her virtues, as described in the framed texts surrounding her

the jug she carries representing charity towards the poor; and the horses' hooves symbolising her unshakeable chastity, because with them she stands steadfast and will not be moved. The emphasis, therefore, was on obedience and humility towards her husband, who had complete control over her, as St Paul had stipulated. Before marriage, women belonged to

their fathers, afterwards, to their husbands, whom St Paul (Ephesians 5:25) advised to look after their wives well, saying: 'Husbands, love your wives, even as Christ also loved the church, and gave himself for it.' Anton Woensam's woodcut also shows that the woman stands motionless, for well-behaved women were to act only in moderation, without any show of agitation or abrupt gestures, and their eyes were to be kept downcast in perfect humility; laughter or any demonstrative show of emotion were taboo, and any outward display of dress and ornament was a sign of inward immodesty and immorality. Although this was an image influenced by celibate clergy, who saw chastity as women's greatest virtue, it lived on into the eighteenth century, and was used by the Protestant Netherlandish artist Cornelis Anthonisz. in the second quarter of the sixteenth century.[60] Cornelis Anthonisz. added a wise man to the wise woman, whose virtues can be compared to those of the woman: intellect, honesty, courage, piety and a good reputation, justice, temperance, steadfastness and a sense of duty.

In *Dives and Pauper* (1405–10),[61] an unknown author, probably a cleric, defends women as good, saying that, just as Eve was created in order to be Adam's 'companion in love, and helper', so man and woman are to love each other; nevertheless, Eve/woman is to be humble in the recognition that she was made from Adam's rib, and therefore look up to man, who is the more perfect, 'her principal, and her origin'. In these writings, much of the blame is laid on men, and women are much praised, but this is not because they are good, starting from an equal basis, but because women have to try so much harder to overcome their weaknesses, their lack of strength and intelligence. The anonymous author also criticises husbands who commit adultery but, in contrast to women, do not get punished for it. A panel painting by Wolfgang Katzheimer, c. 1500, illustrates how artists saw the plight of women accused of adultery, in particular of women of the higher classes whose husbands might be away on the crusade.[62] This panel depicts the *Trial by Fire of Empress Kunigunde*, the wife of Emperor Henry II (ruled 1002–24), who has been accused of adultery during her husband's absence. In order to prove her innocence, she must walk on red-hot ploughshears in front of the palace, facing the sword her husband holds at the ready. Adultery committed by a woman would not only damn the woman's soul but it would destroy the honour of the whole family. That is why Lucretia (see Chapter 1, p. 13), who committed suicide after having been raped, became the model for wives, and paintings of Lucretia's action were hung in women's bedrooms, e.g. paintings by Lucas Cranach at the court of Wittenberg.

Admonitions to both men and women to change their worldly ways

were enforced by preaching, in particular by the preaching of the mendicant orders, the Franciscans and Dominicans, since the thirteenth century. There is the sermon story of a lady of Eynesham in Oxfordshire 'who took so long over the adornment of her hair, that she used to arrive at the church barely before the end of Mass'. One day the devil gripped her head in the form of a spider, and could only be dislodged with the holy sacrament. The deadly fright cured the woman of her temptation.[63] A panel painting by an anonymous Bamberg artist of c. 1470–75[64] documents the effect of the visit to Bamberg around 1450 by the Franciscan preacher Capistranus who exhorted people to discard their frivolous lifestyle. As a result, men throw books into the fire, and women their fancy headdresses, intent on leading a pious life forthwith. Sumptuous clothes and outward appearance, therefore, are considered more prevalent among women.

The best-known saintly wife of the Middle Ages, who proved her humility and faithfulness to her husband through unbearable and unquestioning suffering, was Griselda. Her story derives from Boccaccio's *Decameron*, c. 1350, and it tells of the cruelty and inhumanity of Griselda's husband, who not only banished her, telling her that he was marrying another, but also took away her children, pretending to kill them. After she suffers all her trials without protest, her husband takes Griselda back as his wife. In the fifteenth century, the story was illustrated with woodcuts in several editions in Germany, for example in Lübeck, by Lukas Brandis, c. 1478, or in Augsburg by Johann Bämler, c. 1480.[65] The story is contained in rectangular frames, the woodcuts have simple outlines and little shading, and the figures are dressed in contemporary dress. Johann Bämler has nine scenes: (1) Gualtieri fetching Griselda for their wedding; he is on horse-back and she is standing barefoot in peasant dress, holding her distaff. (2) Gualtieri presenting Griselda as his wife to the people; she is still in peasant dress but wears shoes, and he takes her by the hand, and a scroll issuing from his mouth says: 'This is my wife.' (3) Griselda being stripped naked, surrounded by women who help her, while the men look on and Gualtieri points at her. (4) Griselda gives birth to a child, but already a servant is taking it away from her; and on the right-hand side of the woodcut, the child is being put into a basket on a donkey. (5) The forged dispensation of the divorce is being read out to Griselda. (6) Gualtieri sending Griselda home again; she is being stripped of her fine clothes, is in a shift, and the women around her are weeping. (7) Griselda's father handing her her old clothes back on her return to her poor home. (8) Griselda meeting Gualtieri's 'new bride and her brother'; Griselda puts out her arms to welcome them; she is poorly dressed and

barefoot; the 'brother' is very small. (9) Gualtieri revealing to Griselda that the 'bride and her brother' are their own children; Gualtieri presents the children to Griselda, who is still plainly dressed but in shoes, while people dine in the background.

In St Augustine's opinion, woman was physically subject to man in sex,[66] and a helper to him in procreation.[67] The first printed book advocating marriage and treating women as creatures of intelligence and good sense is by Albrecht von Eyb[68] who wrote his so-called *Marriage Booklet*, entitled *Ob einem manne sey zunemen ein eelichs weyb oder nicht*.[69] This question 'Is a man to wed or not?', is answered in the positive, after arguing over all the pros and cons of a married life. Some of the reasons given are still medieval in outlook, e.g. that woman was created to keep man from fornication and for the continuation of the human race; however, novel human touches of married life are included, e.g. when speaking of the children hanging around their parents' necks and being kissed, and of couples thinking and acting in harmony. There is even talk of the 'sweetness of marriage'. Eyb believes that women should be married off young, and that it is better to marry young women than widows, because they can still be moulded like wax. The honour of the family is always a major concern, but what is most surprising is that Eyb considers it reasonable for a young wife to satisfy her sexual desires with another young man in the circumstance of a husband's long absence, as long as the affair is kept secret from society, for the loss of honour would ruin their lives. This book was first printed by Anton Koberger of Nuremberg in 1472, and there were twelve editions printed between this date and 1540; it does not, however, have any pictorial illustrations. A woodcut representative of a contented family living in harmony, busy in their male and female activities, is one published by the Augsburg printer Johann Bämler in 1476 (Pl. 19). Sitting in a cosy room with tiled stove and bottle-glass windows, the daughter turns towards the mother when learning to spin, and the mother rocks the cradle with her foot, while the father does the accounts and the little son reads a book. Thus, the mother sees to the bodily welfare of the family, while the father brings in the money, and both educate their young to follow in their respective footsteps.

Most extraordinary was the existence of a female champion for the cause of women at the beginning of the fifteenth century: Christine de Pizan (*c*. 1364 – *c*. 1430).[70] She was exceptional for the education she had received as a woman, having been brought up at the court of France, where her father was astrologer to King Charles V.[71] Her father encouraged her intellectual pursuits but her mother thought spinning was of more benefit

to a young girl. She was married at 15, to the king's secretary Etienne du Castel. When he died after ten years of marriage, Christine de Pizan was left with three children and a mother to support. This she achieved as the first woman to live by her writing. She gained the patronage of King Charles VI and the Dukes de Berry and of Burgundy, who encouraged her to write the biography of the late king Charles V, but she is mainly known for her staunch defence of women. In the *Epitre au Dieu d'Amour*, she

19 *Domestic Education.* This shows the male and female members of a family, in a late fifteenth-century middle-class interior, performing their respective roles in life

attacked the satirical representations of women by Jean de Meun in *Le Roman de la Rose*.[72] Women deserved respect, not Jean de Meun's slander, and Christine's defence of women made her the first woman to debate this issue in public. Christine wanted women to have a part to play in society and to receive a good education; she was not, however, against marriage, and lamented the death of her husband. Like her, a woman was to 'become a man' and be strong in adversity. In her *Cité des Dames*, women hold high positions in the judicial system and the warriors are women of letters. Contrary to the image put about by Jean de Meun, women were intelligent and could reason logically. But the *Cité* is an ideal, and, although it is set in contemporary surroundings, there is no evidence that Parisian women engaged in ironwork or masonry as depicted in the miniatures; rather the lives of these women, as in Boccaccio, are based on wise women of antiquity such as the sibyls. However, Christine de Pizan selected her own illuminators, often women, and had several copies made of each work which she then sent to patrons and friends.[73] In the *Cité des Dames*,[74] she

20 *Christine de Pizan Presenting her Book to Queen Isabeau of Bavaria*, wife of Charles VI of France. The queen is surrounded by her ladies-in-waiting and Christine kneels before her. The furnishings and dress reflect the luxury at the French court

praised a woman artist named Anastaise for her illuminations, but it is impossible to identify her hand. Many of the manuscripts portray her copying or composing her works, or presenting her manuscript, e.g. to the French queen Isabeau of Bavaria, in resplendent attire and within an interior hung with expensive armorial tapestries (Pl. 20).[75] In the *Proverbes Moraux*, she is seen instructing four men, who listen to her reverentially.[76] Also, Christine de Pizan's concern is for the excellence and virtue of women. In *Le Livre des Trois Vertus*, she is most concerned with women's honour and good reputation in this life.[77] Because most women were married, betrothed or widowed, and not able to live the contemplative life which most ensured chastity, Christine gave them practical advice on how to live a virtuous life within the institution of marriage. Also, she realised that, the higher the woman in rank, the more her life would be scrutinised, and it was of the utmost importance for such a woman to make her virtue visible, i.e. known to all. In this book, Christine de Pizan set out to teach women how to avoid the worst pitfalls of the misogynist stereotype.[78] One of the illuminated manuscripts of *Le Livre des Trois Vertus*[79] can be taken as an example of how the teachings of the three Virtues are visualised. The half-page miniature is divided into two, one half showing the three Virtues appearing to Christine de Pizan in a vision, the other, right side, showing a group of ladies taught in the school of these virtues. In the visions, the Virtues grab Christine by the arm, while she is lying in bed, sleeping; in the School of Virtues, Virtue is raised on a high chair above the encircling women, including queens, whom she faces.

Education

Very few women received the education that Christine de Pizan had had, and Christine herself upheld the traditional belief that woman's role was to nourish children, while the father's was to educate them. In *Le Trésor*, she did however recognise the pedagogical role of high-born mothers, saying that a princess should supervise her children's tutors and teachers, originally selected by the husband.[80] This meant making sure that the children learned a Christian, moral way of life which was set above the study of the arts and sciences. Jacob of Voragine and Gilbert of Tournai, in their sermons, stipulated that moral and religious instruction could be undertaken by a mother if and only if she managed to moderate her carnal love for her children and develop an attitude of spiritual awe.[81] This exemplifies how deep-seated the clergy's mistrust of women was, which had its source in St Jerome, who even warned of excessive ardour in

marriage as adulterous, and the scholars Albertus Magnus, Thomas Aquinas and John Buridan, who believed that women loved their children more strongly than men but that, because this love was irrational and ruled by nature, it was less noble.

St Anne, the Virgin's mother, was the model for women to take an active role in their daughters' education, particularly for middle-class women who were most involved in the education of their children. The scene of *St Anne Teaching the Virgin Mary to Read* is depicted on a panel of the Thornham Parva altarpiece, now in the Cluny Museum, Paris, *c.* 1335, probably made for a Dominican friary, as Dominicans were much concerned with teaching. The Virgin Mary stands at a lectern learning to read from a psaltery, while her mother St Anne towers behind her and, with her arm swinging over the head of the little Mary, points at verses 10–11 of Psalm 45, which Mary is to read aloud and which expresses her acceptance of the divine will. A double page in an early-fifteenth-century Netherlandish illuminated book shows on the left page a group of women learning to read and on the right page the alphabet, first in large gothic letters and then in small. The women reading are on their knees, taught by a woman sitting at the end of a high-backed stall; the woman closest to her has put her hand into that of the teacher, palm upwards, and is about to have it beaten with a flat wooden ladle held in the teacher's other hand, and used on medieval pupils by Netherlandish schoolmasters (Pl. 21).[82]

The daughters of the Knight of La Tour-Landry had lost their mother when young, so that the Knight felt obliged, in 1371, to write an educational treatise for them called The Book of the Knight of La Tour-Landry.[83] He had also written one for his two sons, but as no copies exist we cannot tell how different it was. A large number of the stories are taken from the Scriptures and the lives of the saints, and there are stories adapted from the fabliaux, some of which are quite coarse. Basically, the Knight tried to teach his daughters to beware of evil by giving examples of good and evil women. Above all, they were to beware of men with evil intentions, for he remembered incidents from his own youth of scandalous behaviour. The temptations of vanity are highlighted, set against the great virtues of meekness and courtesy, and a life of deference to the husband is advocated. The Knight used sayings and stories from earlier times exemplifying good and evil which were to act as mirrors for the present. A large number of woodcuts illustrating these stories are in the first German translation printed in Basle by Michael Furter in 1493, *Der Ritter vom Turn*. One of these depicts Emperor Constantine's daughter lying in her bed, on a large chequered pillow, with a chamber-pot underneath; she is naked, and her

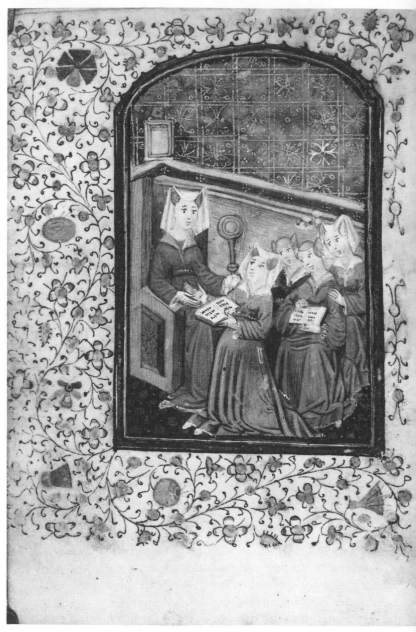

21 *Group of Women Learning the ABC*, page from a Netherlandish manuscript. The women, holding their books, kneel before their seated female teacher. The facing page has the alphabet

thick braids are wound around her head; an army of skeletons come rushing in from the back of the room, causing her young lover to flee, in spite of his large sword. The text tells us that the young man became ill after this shock, and the young woman became chaste. Most of the examples are very Draconian: for example, King Herod kills his wife because she answered back; he stabs her with his sword, and she falls backwards into the arms of her attendant lady. Thus, the punishments are dire for women who misbehave towards their husbands. Many examples have to do with the temptations of the flesh: the woodcut of the young lady combing her hair in front of the mirror, only to face the farting bottom of the devil (Pl. 6, p. 15), has already been mentioned in connection with the biblical Suzanna. Also, women who led a seemingly good life are found out at the hour of death: for example, while the husband prays over his dead wife's body, St Michael stands in the foreground with her soul in the scales, when the devil places her clothes on the other side of the scales and makes them sink, thus damning her because of her love of clothes. The portrayal of a woman who died full of hatred and envy is quite horrific: she has been placed on a bier, and the inside of her body can be seen; there is a large toad sitting where her heart should be, because she had not forgiven her descendants who are standing at her side with hands raised in horror. Although the examples are of historical times, all the figures are dressed in contemporary German costumes, and the book ends with the Knight in armour presenting the book to his two daughters, standing in a walled garden surrounded by a landscape.

Education was also provided at schools, and, especially in Germany, elementary schools were found in the rich mercantile cities such as Cologne, Nuremberg and Augsburg. Women would teach the girls, men the boys.[84] Ambrosius Holbein painted a schoolmaster's signboard, 1516, which shows on one side the schoolmaster instructing a little boy with the help of a birch to write, and on the other the schoolmistress, possibly his wife, teaching a little girl to read; separating them is a bench in the centre of the room with two boys reading.[85] The written text above the scene advertises for pupils wanting to learn to read and write German in the shortest possible time. In case of an unsuccessful outcome, no money would be charged. Anyone could apply, whether burgher or apprentice, woman or spinster. It is difficult to judge what children learned at these schools – probably the alphabet, catechism and religious knowledge.[86] Poor women got no education in reading and writing at all and had to rely on the teachings of the Church for their knowledge of religion and moral behaviour, which they were to transmit to their daughters.

Portraits of women

In an attempt to gain a true picture of women, one might look at representations of them in portraiture. How much do portraits tell us about the individuals portrayed, and who are they? They are members of the nobility and the middle class, because portraits were expensive; individual portraits of peasant women do not exist from this period. Portraits of men far outnumbered those of women, because their public positions in life required public commemoration. In most instances, men commissioned the religious works which portrayed husband and wife or husband and family; and in the case of rulers looking for a wife, artists were sent to paint portraits of prospective wives – for example, Jan van Eyck travelled to Portugal in 1429 to paint Isabella of Portugal on behalf of Philip the Good of Burgundy, and Hans Holbein the Younger painted various women whom Henry VIII had his eyes on. Women were, however, much to the fore as owners of Books of Hours, where they were often portrayed as such, in veneration of the Virgin Mary. Jeanne d'Evreux , the third wife of Charles IV of France, is seen kneeling, crowned as Queen, reading her Book of Hours, in the initial of the Annunciation page in the Book of Hours illuminated by Jean Pucelle and given to her by her husband in 1324–25.[87] Isabella Stuart, the second daughter of James I of Scotland, who became the second wife of Francis I, Duke of Brittany, in 1442, is depicted kneeling before the Virgin and Child, introduced by St Catherine, in a manuscript made in the workshop of the Rohan Master, c. 1417–18.[88] This probably originally belonged to Francis I's first wife, Yolande of Anjou, as a gift from her mother before it passed into Isabella's possession. Isabella wears a heraldic skirt combining her and her husband's arms, a lion rampant gules within a tressure flory counter-flory, and the four corners of the page also bear her coat of arms. Intimacy and devotion are stressed by the prayer Isabella directs at the Child, written on a scroll and received by the Child: 'O Mater Dei memento mei'; also, the Child plays with the rosary Isabella has left on her prie-dieu with the Book of Hours. Mary of Burgundy, the last Burgundian princess and mother of the world-encompassing Habsburg empire, has a complete manuscript page devoted to her portrayal at prayers, in the Hours of Mary of Burgundy, c. 1477.[89] Mary sits reading her Book of Hours, overlooking a church interior from her private balcony chapel window; her finger points to that part of the text in her book beginning with 'O', probably the 'Obsero te' (I beseech thee); a pet dog rests on her lap, and a gold chain with jewelled pendant, red carnations and blue irises in a glass rest on the windowsill. What we see in the church interior down below may be the vision of Mary of Burgundy's

prayer: the Virgin and Child surrounded by angels and Mary on her knees accompanied by her ladies, and on the right a young man swinging a censer. In the Hours of Mary of Guelders, 1415,[90] Mary of Guelders, most fashionably dressed, stands in a walled garden, a *hortus conclusus*, as though she were the Virgin Mary (Pl. 22). She is reading, God the Father sends the Dove down to her, while one of the two hovering angels bears a scroll with the inscription 'O milde Maria' (O gracious Mary). Mary of Guelders, who was childless at the time, thus stands in the mystical garden of her patron, the Virgin Mary, and God blesses her as in an Annunciation in imitation of the Virgin Mary, showing her extremely close, mystical relationship with the Virgin Mary.

The women depicted in Books of Hours are as extravagantly dressed as the Hours are sumptuously illuminated; they were aware of their social position, but splendour in the service of religion and the veneration of holy personages was always appropriate. Generally, such luxurious manuscripts were owned by the nobility, and the noble ladies are depicted as leading an exemplary life. When examining thirteenth- and fourteenth-century penitential manuals, where the wealthy and noble, in particular, are castigated for their pride, Mary Flowers Braswell found that the noble lady is generally depicted as good and as the least sinful.[91] Although many evil queens have been documented, and otherwise the sins of lust and vanity always loom large with women, this is not brought out in penitential literature. The reason for this, Braswell thinks, is that, because noble ladies were under constant guardianship and because medieval women were excluded from public functions, they could not take part in many activities by law, and therefore could not commit as many sins before the law.[92] In this connection one may compare the visual example of the Hours of Jeanne d'Evreux, given to Jeanne by her husband Charles IV of France when she became his third bride at the age of 14. Madeline Caviness argues that the opposites of holy scenes and drolleries in this book were a warning to the young queen to keep her mind on her prayers, after a period full of violence and women's adultery and homosexuality had afflicted the French royal house.[93] Depictions of Jeanne's holy great-grandfather, St Louis, provided a model of charity, chastity and humility, and the half-human/half-animal beasts acted as repellants. Caviness believes that, in spite of the many phallic symbols in the margins, such as erect swords, sticks, horned animals or bagpipes, there is no eroticism. Thus, rather than inspiring pleasure in the grotesques and their sexuality, she sees this book as a control of Jeanne's sexuality by her husband, who had just been cuckolded. This illustrates that Books of Hours, which are very personal

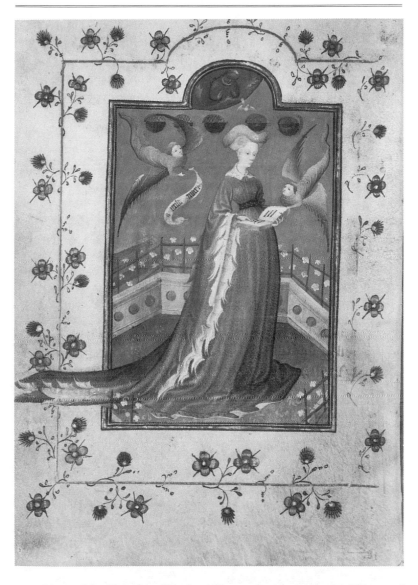

22 *Mary of Guelders Standing in a Hortus Conclusus*, Book of Hours of Mary of Guelders. The very fashionably dressed Mary of Guelders is reading her Book of Hours, the Holy Dove descends towards her and angels hover about her

and are read every day, can guide a young noble woman by subtle means; she would not like to see her own class attacked directly, but hints in an engaging manner were much more effective.

The middle classes were better represented on panel paintings in the fifteenth century. In the Netherlands, in particular, a new class of administrators, of court functionaries, had risen up the social scale, and the prosperous towns had a population of wealthy traders, merchants and

23 *Donatrix Praying at a Prie-dieu*, attributed to the Master of the View of St Gudule. The donatrix is introduced to the Virgin and Child by St Magdalene, whose name-sake she may be. The Christ Child holds the other end of her long rosary

bankers who were seeking to immortalise their public office and wealth. This was most purposefully achieved in the triptych, where the show of worldly concerns and a realistic portrayal were successfully combined with fervent devotion and prayers for salvation. Women's place in such triptychs was on the right, i.e. to the left of the holy figures, on the bad side, as seen in Last Judgement panels, whereas men were on the left, i.e. to the right of holy figures, and thus in the place of honour. An example is the triptych of the *Nativity and Adoration of the Shepherds* by Hugo van der Goes, commissioned by Tommaso Portinari, the representative of the Medici Bank in Bruges, c. 1475.[94] He and his sons, Antonio and Pigello, are kneeling in the inside left wing, while Maria Baroncelli, his wife, with their daughter, Margherita, kneel in the right wing; all are introduced by towering patron saints. In the *Annunciation* triptych by Robert Campin, the wife is squeezed in behind her husband;[95] the reason for this is thought to be that the man married when the altarpiece was already nearly completed. The death of one wife and marriage to another resulted in a novel portrayal in a triptych of the *Baptism of Christ* commissioned by Jan de Trompes from Gerard David of Bruges. The first wife, Elizabeth van der Meersch, who died in 1502, is portrayed, as usual, in the right wing with her daughters, while the second wife, Madeleine Cordier, with her first child, is depicted in the exterior right wing venerating the Virgin and Child in the left wing, thus making the exterior into a devotional diptych. Portraits of women can also be found in religious pictures sharing the same space with the holy personages, e.g. a donatrix praying at her prie-dieu, being presented to the Virgin and Child by St Magdalene, c. 1470 (Pl. 23).[96] A note of mystic playfulness has been added in the Child taking hold of the other end of the woman's rosary, thus physically connecting with her devotions. The most infamous example involving the portrait of a woman in a religious work is a diptych by Jean Fouquet, c. 1450, of the Virgin and Child enthroned and venerated by Etienne Chevalier, accompanied by St Stephen.[97] Not only is the Virgin displaying one bare breast, but she also has the features of Agnes Sorel, King Charles VII's mistress, who wore dresses exposing one breast. Although the portrait and figure of the Virgin are stylised to almost geometric blocks, such portrayal is most daring. The diptych was hung in the Cathedral of Melun, Chevalier's birthplace, and an eighteenth-century inscription at the back of the Madonna and Child claims that the panel was commissioned as a vow by Chevalier at the death of Agnes Sorel in 1450. A seventeenth-century historian, Denys Godefroy, describes the blue velvet frame of the diptych which had the initial 'E' in pearls interwoven with love knots of

silver and gold threads.[98] Thus, by creating the Virgin in the likeness of Agnes Sorel, Etienne Chevalier equated his love of the Virgin with his passion for Agnes Sorel, and woman thus became more spiritual, and the Virgin more human.

The first autonomous portraits of the middle class were painted by early-fifteenth-century Netherlandish artists, such as Robert Campin and Jan van Eyck. Earlier, such portraits were of the nobility only, for purposes of genealogy, and were idealised. As with the new interest in the natural world, already mentioned in connection with depictions of scenes from the life of the Virgin, the human face was now being scrutinised for realistic details, as in half-length portraits of a man and a woman by Robert Campin, 1420s, or the portrait of his wife Margaret by Jan van Eyck, 1439.[99] Rogier van der Weyden concentrated on members of the Burgundian court. His portraits of them are all very much alike: for example, a lady in the National Gallery, London, and another in the National Gallery, Washington, are not only dressed alike, but their expressions, too, are almost indistinguishable. The differences between Rogier van der Weyden's portraits and those by Robert Campin and Jan van Eyck allow one to differentiate between the classes. The most obvious contrasts are in the dress: the ladies of the nobility wear extremely high headdresses, made of transparent materials, and their dresses are low-cut and very decorative; the middle-class women are more covered up, in heavier, duller materials. Because of the high headdresses and the shaven foreheads, the ladies of the nobility are even more elongated, and their pouting lips and lowered heavy-lidded eyes give an impression of aloofness. That is why Rogier van der Weyden's portrait of a woman looking out at the viewer, with a round, shiny face and in middle-class dress, is thought to be his wife.[100] This brings us to the question of truth to life in these portraits. Were all the members of the Burgundian court so much alike because they were closely related, like the later Habsburgs, or were their looks the courtly ideal? Probably the latter, for the etiquette and lifestyle of the Burgundian court were an example to all, and sons from other courts were sent there for their education, e.g. Francesco d'Este, also portrayed by Rogier van der Weyden, looking like the other portraits. Thus, a courtly norm was expected of portraits as of life, and an artistic convention was created. In this connection, it is interesting to note that Jan van Eyck was the official court painter to Philip of Burgundy, yet all his remaining portraits are of people of the middle class, whereas Rogier van der Weyden, the official city painter of Brussels, has left to posterity portraits of the courtiers. The reason for this may well have been that Rogier van der Weyden was more

willing to flatter his subjects, while Jan van Eyck in his obsessive depiction of details did not leave out warts and wrinkles, and the middle class was more prepared to accept this. Flattery was not always acceptable, as is known from Hans Holbein's portrait of Anne of Cleves painted as a prospective bride for Henry VIII; when she arrived in person, Henry was not pleased – he commented on her horse's teeth, and soon divorced her.

From *c.* 1500, there are examples of portraits of man and wife no longer

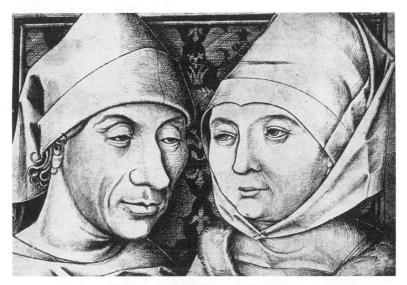

24 *Artist Israhel van Meckenem and his Wife Ida,* by Israhel van Meckenem, *c.* 1490. This is one of the earliest realistic portraits of man and wife. The couple is shown bust-length, in the working-day clothes of the artisan class

on separate panels but joined together in one panel, and these illustrate well the characteristic differentiations between men and women. In Jan Gossaert's bust-length portrait of *An Elderly Couple, c.* 1520, the woman is positioned behind the husband and casts her eyes downwards, whereas the man is assertive, looking outwards with his hands forcefully placed over the edge of the picture frame.[101] An engraving by the Westphalian artist Israhel van Meckenem of *The Artist and his Wife, c.* 1490, shows both of them equal, turned towards each other, their downcast eyes crossing, while the woman's head is held a little higher (Pl. 24). This may illustrate the fact that women of the artisan class were truly helpmates to men, both in the workshop and in the household. A double *Engagement*

61

Portrait of a Young Couple by the Master of the Housebook, *c.* 1484 (Pl. 25),[102] is a rare example of a couple truly in love, in contrast to the usual depictions of unequal couples, where love is bought for money, as

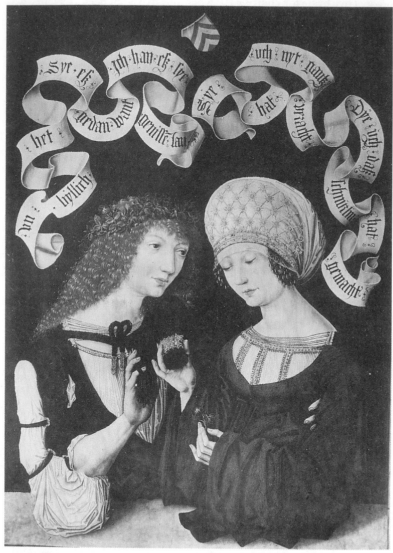

25 *Engagement Portrait of a Young Couple*, attributed to the Master of the Housebook. They are shown half-length behind a balustrade, turning towards each other lovingly, and surrounded by all the attributes of ideal love

discussed in Chapter 3 (pp. 100–1). The young lovers are half-length behind a balustrade, turning towards each other. The young woman looks down at what she is holding in her hands, while the young man puts his arm around her waist and looks at her with tenderness. In her right hand she holds a gold band which encircles the tassels of the man's headdress, draped over his shoulder, as proof of her fidelity, while the wild rose in her left hand is a token of love.[103] The wreath on the man's head is made up of wild roses, too. There are banderolles above the couple which explain that the young woman has presented the young man with the gold band (*Schnürlein*) which he has accepted gratefully. Thus, this portrait expresses the ideals of courtly love: youth, beauty, fidelity and mutual devotion; it is, however, difficult to determine whether it is a real portrait.[104] The German artist Albrecht Dürer, above all others, brought to life the people close to him, such as his wife and his mother. A spontaneous ink drawing shows his young wife Agnes, just after their marriage, lost in thought, with her elbows resting on a table and her head leaning on the hand raised to her chin.[105] Her likeness was also used by

26 *Portrait of Agnes Dürer and a Girl in Cologne Attire*, by Albrecht Dürer. This portrait by Dürer of his wife, on the Netherlandish journey, 1520, seems rather cruel juxtaposed with the features of the young girl. The inscription above Agnes says: 'On the Rhine, My Wife at Boppart', and that above the girl: 'Cologne Girl's Headdress'

Dürer for a depiction of St Anne in a preparatory drawing dated 1519 and the subsequent painting of the *Virgin and Child with St Anne*.[106] On his journey to the Netherlands in 1520–22 he filled two sketchbooks with many portraits of the people he met there. He had taken his wife with him, and one of his bust-length silverpoint drawings shows her ageing features contrasted with those of a young girl in Cologne attire (Pl. 26).[107] Although Agnes Dürer had accompanied her husband to the Netherlands, she did not share his life there; as a woman she was kept apart from the man's world; only on rare occasions did she eat with him, and only once was she invited to a banquet in his honour. Most haunting of all is the charcoal drawing Dürer made of his mother in 1514, when she was 63 years old.[108] She appears with skeletal face and neck, deeply wrinkled forehead, and eyes that stare into a void. The portrait may seem cruel, but we know from Dürer's writings that he greatly admired his mother, and the portrait expresses the woman's hard-working life, in which she gave birth to eighteen children, of whom three survived into adulthood. The upper inscription in charcoal says: 'This is Albrecht Dürer's mother when she was 63 years old'; and a second inscription in ink added below records her death two months later, saying: 'and she passed away in the year 1514, on Tuesday before Rogation Week [May 16], about two hours before nightfall'. Dürer took a great interest in all classes of people, and in particular in different nationalities, resulting in a very sensitive silverpoint drawing, dated 1521, and done in the Netherlands, of the 20-year-old black slave girl Katherina belonging to the Portuguese consul to Antwerp, 1514–21, Joao Brandao.[109]

Having looked at artists painting individual women, the question arises whether there were any women artists outside nunneries. Many names of women are listed as guild members, active as painters, illuminators and scribes, but their work cannot be identified.[110] Mostly, they were daughters or wives of professional artists, who like their assistants were part of the workshop and did not sign their works individually. Also, commissions and any kind of legal document could not be signed by a woman without the witness of a male guardian.[111] Even in the sixteenth century, when mention of female artists becomes more frequent, they are still the daughters of known artist-fathers. One example is Susanna Horenbout (*c.* 1503–45) from Ghent, who travelled with her father to England; her work was well liked there by King Henry VIII. Another female artist whose father was a well-known artist was Catherina van Hemessen (b. 1527/28, d. after 1587), from Antwerp; her *Self-portrait* painting at the easel, 1548, at the age of 20, is the first European self-portrait of a woman (Pl. 27).[112] She

was later in the employ of Queen Isabella of Spain, but no work by her survives from after her marriage in 1554 to a musician. Agnes van den Bosche, from a family of Ghent artists, received many commissions from that city to paint flags, but there is no evidence of her painting altarpieces or other religious works.[113] An example of her work is a *Flag of the City of Ghent*, 1481–82, showing the Maid of Ghent with her hand on the lion of the city, whose tail curls towards the letter 'g' at the pointed end of the flag.

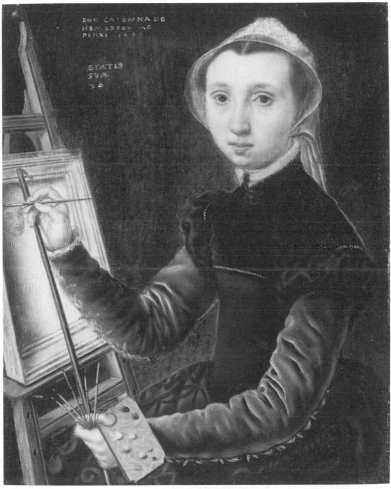

27 *Self-portrait*, Catherina van Hemessen. She is seated in a plain dress and cap at her easel. The portrait is inscribed with the date 1548 and her age of twenty years

Widows could run a husband's workshop after his death, but only until commissioned work was completed or until marriage to another artist. The last method was much favoured by younger assistants, who would thus come into possession of a workshop they could otherwise not have afforded. An example is Dürer's teacher Wolgemut, who married the widow of his master Pleydenwurff.

Many visual representations of female artists are found in manuscripts of Giovanni Boccaccio's *Le Livre des Clères et Nobles Femmes* (De Claris Mulieribus), written between 1360 and 1362, which cites 104 biographies of famous women of all professions, starting with Eve, many of which are based on classical models. Several French manuscripts from the beginning of the fifteenth century depict these women artists in a contemporary setting, such as Marcia painting a self-portrait, 1401–2, using a convex mirror, or Thamar painting a Madonna, surrounded by paints and brushes and a male assistant who grinds the colours for her at a table.[114] Although these are women based on ancient authors, not true to life, they do give us an insight into contemporary workshop practices, for the women dressed in contemporary clothes may well be a reflection of some of the daughters employed in their fathers' workshops. There are also examples of women painting sculptures, and carving them, sketching in a figure for a wallpainting or writing surrounded by lecterns laden with books.[115]

Women at work and play

Having looked at the portrayals of individual women, from which peasant women were excluded, we must now examine the representations of women as they went about their daily lives, accomplishing various occupations or activities. To what extent are women shown in the arts working, and are there differences in the way women of different classes pass the day? What can the depictions of their daily chores and activities tell us about their lives? Calendar pictures at the beginning of Books of Hours give the best illustration of women working, and also show up the differences between the rich and the poor: the peasants are found working the land in those months requiring their labour, while the aristocracy goes in pursuit of riding and hunting in spring and autumn. The best known Labours of the Months are those from the Très Riches Heures commissioned from the Limbourg Brothers by the Duc de Berry; for the first time, a complete page is given to each month, and the labours are depicted with a new sense of realism.[116] The aristocracy is out enjoying the spring countryside in April and May; an engagement scene takes place in April

and two women sit in the grass picking flowers; in May the ladies and gentlemen are out riding, dressed in the fresh green of spring, their hair garlanded with new sprigs of foliage. In August, they go out hawking, sitting side-saddle behind their male riders. In contrast, the peasant women help their men in the fields, rake hay, cut corn, bring in the grape harvest or warm themselves by the fire in February, cold and exhausted from the snow outside. Sometimes, ladies are included in scenes of the grape harvest, but only to taste the grapes and give directions, while the peasant women pick the grapes and help at the winepress, as in a South Netherlandish tapestry from the end of the fifteenth century.[117] The Très Riches Heures must have been known by later artists, for the manuscript influenced many later Books of Hours, especially those produced in Bruges at the beginning of the sixteenth century, where many of the Labours of the Months were copied with slight changes, e.g. to the costumes.[118] At that period, the upper-middle-class woman took the place

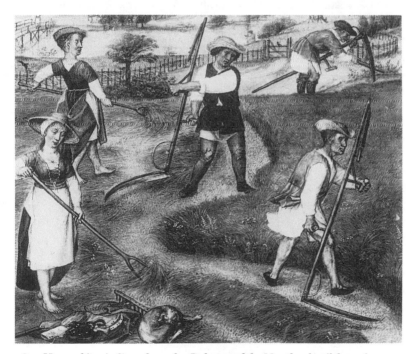

28 *Haymaking in June* from the *Labours of the Months*, detail from the page of a Flemish manuscript. While the men cut the grass with scythes, the women turn it with hay forks. They all wear straw hats and the women have hitched up their long skirts, exposing their legs

of the aristocratic woman, enjoying new life in the countryside or in a boat on the river, decked out with fresh greenery, as a symbol of new life and new love in the months of April and May. Usually these women, accompanied by their lovers, are making music; they carry with them food and wine for a picnic, and represent the ideal of a life without care. The peasant women are seen in the other months, helping in the fields, beating flax and assisting with the killing of pigs, the milking of cows and the general planting and pruning, e.g. *Haymaking in June* in the Grimani Breviary, produced by the Ghent/Bruges school of illumination (Pl. 28). In early spring, usually in March, the lady of the manor may be seen directing the pruning and the new layout of the garden. One of the sports in which ladies could participate was hunting. They would ride side-saddle or astride, and hunt with small hawks and merlins. A fourteenth-century English manuscript[119] shows a woman tending her hawks resting on a perch; another, the so-called Queen Mary's Psalter with text in French, the language of royalty, shows noble ladies hunting on horses and on foot, e.g. hawking on horseback, the hawk having struck a duck (fol. 151v), shooting a fleeing stag with an arrow (fol. 153), one woman putting a ferret into a rabbit's hole, while another nets the rabbit as it comes out (fol. 155v), and even two women clubbing rabbits (fol. 156). It is known that Margaret of Austria, the Regent of the Netherlands (1507–15, 1518–30), would not take a lady into her household who was unable to cut up deer. Women sharing the experiences of the hunt with men is well expressed in the Devonshire hunting tapestries, *c.* 1430, where bears and boars, swans and otters, deer and duck are hunted and killed, and the art of falconry is displayed.[120] The ladies are usually portrayed hunting with their hawks, and in the *Deer and Duck Hunt* tapestry one lady is seen fishing. In a watercolour drawing attributed to Jan van Eyck a group of men and women, members of the court of the Duke of Holland in The Hague, are positioned on either side of a brook, and three of them are fishing, including one of the ladies.[121] Although the activity here is used as an excuse for a group portrait and may have symbolic implications, fifteenth-century Netherlandish artists were well known for combining symbolic meaning with real events or settings. Fishing, therefore, may have been considered a characteristic occupation of both sexes.

All through the Middle Ages (from the early thirteenth century) the presence of ladies was of vital importance at tournaments and jousts, which were often held in their honour, in particular on the occasion of a marriage, e.g. of Richard II to Anne of Bohemia in London, 1382, of Philip the Good to Isabella of Portugal in Bruges, 1429, and of his son Charles the

Bold to Margaret of York, also in Bruges, in 1469. Special scaffolding was erected to accommodate the ladies, and many pictures show them watching from richly decorated balconies, e.g. an early-fifteenth-century manuscript illumination which shows them looking down from a brocaded elevation to a joust in full swing.[122] There are even reports of scaffolding collapsing and injuring the ladies, e.g. the stand at Cheapside in 1331. Dances formed an essential part of the tournaments, thus also requiring the participation of ladies. On such occasions, ladies would shine in all their splendour, but sometimes rules were laid down to curb extravagance: for example, in 1485, ordinances relating to a tournament in Heilbronn, Germany, laid down prohibitions against the wearing of excessively costly dresses: women were only allowed to bring three or four embroidered dresses.[123] The knights fighting in honour of a lady would receive their helmets from her, as seen in an illumination in the *Romance of Alexander*, completed in 1344.[124] In the evening, after the tournament, it was a lady who presented the prize, which in French and Burgundian tournaments was usually a jewel. The illustration of this occasion in King René of Anjou's treatise shows the lady presenting the winner with a large jewel crowned by three ostrich feathers.[125] The scene takes place in a candle- and torch-lit room without windows, and the flickering light casts shadows creating a mysterious, expectant atmosphere. The lady in elaborately high headdress lifts the jewel in a white cloth towards the receiving knight, assisted by two ladies who take hold of the ends of the sheet-like cloth. Noble ladies are also depicted playing games instead of doing serious work: for example, the wallpaintings representing the Labours of the Months in the Torre d'Aquilia, Trento, *c.* 1416, show them throwing snowballs in January; and on the walls of Runkelstein Castle, Tyrol, they play ball and dance. In the Hours of Jeanne d'Evreux, the bottom margins show games such as Blind Man's Buff and the very popular game of forfeits *La main chaude*.[126] An Alsace tapestry from the last quarter of the fourteenth century also depicts this game, which involves a man laying his head in the lap of a lady, while other women touch and slap him, and he must identify them.[127] Another game has the lady sitting on the back of a crouching man, and, using her raised leg like a lance, she tries to dislodge her male opponent who attempts to do likewise while standing on one leg. A large number of French ivory carvings from the first half of the fourteenth century show ladies playing chess, often victorious over their male partners.[128] Images of noble ladies travelling show them sitting in great comfort in their individual chaise suspended between two horses and accompanied by men on foot and on horses,[129]

or in large canvas-covered wagons that transport the royal ladies and their possessions including pet dogs and squirrels, as in the Luttrell Psalter.[130]

All these images of ladies of the nobility represent them as leading a life of leisure and privilege, as though created by a chivalric ideal; but what was the truth of such representations? All the events depicted were part of a lady's life, but not of her everyday life. For example, the court often moved in the Middle Ages, the men went on crusades, but women were frequently left behind, shut up in their castles for long periods of time, and if they did travel, the road was bumpy and treacherous. In the thirteenth-century *Galeran*, the lady expresses her boredom (which must still have applied to life later in the Middle Ages): 'I should do no other work in the day but read my psalter, work in gold or silk, hear the story of Thebes or Troy, play tunes on my harp, checkmate someone at chess, or feed the hawk on my wrist. I have often heard my master say that such a way of life was gentle.'[131] An upper-class household certainly had a large number of servants to do all the heavy work, and the main purpose of the lady was to marry well and produce healthy, and above all legitimate, heirs. Her position as mother, therefore, was of vital importance and organising a large household needed great ability. However, there are no representations of women going about their daily duties, because pictures only catch occasions of special significance, such as festivities or a birth scene, e.g. the birth of St Edmund, king of East Anglia, set in a very rich household of Chaucer's time although the event happened five hundred years earlier.[132] Nowadays, too, private photographs are mostly of festive gatherings such as birthday and Christmas parties or weddings, and official images of royalty on television show them on special occasions such as the races at Ascot. Also, many of the portrayals of life in the late Middle Ages come from tapestries and wallpaintings which are decorative and without moral dimensions. If upper-class women were seen to be working, they went on charitable visits, another parallel with the present. In the Middle Ages, too, they fed and clothed the poor and visited the sick, and Elizabeth of Thuringia was even made a saint for it.[133] Margaret of York, wife of Charles the Bold of Burgundy, is represented doing good works, i.e. the *Seven Works of Mercy*, in a French manuscript of the second half of the fifteenth century (Pl. 29).[134] Thus, she is seen in her brocade dress trimmed with fur and her high, peaked wimple, feeding the hungry with bread, giving the thirsty water to drink, clothing the poor, welcoming pilgrims into the house, visiting prison (she talks to the prisoners through a barred window from the outside), and visiting the sick and dying; and at the end, she is

29 *The Seven Works of Mercy Performed by Margaret of York*, from the page
of a French manuscript. Margaret is dressed in a brocade dress trimmed with
fur and a high wimple, and Christ is always present in the background when
she dispenses charity. The last scene shows her kneeling at her prieu-dieu,
with her patron saint, St Margaret, behind her

seen kneeling at her prie-dieu under a canopy, with St Margaret behind her, gazing at the burial scene. Always, Christ is present in the background of these scenes of mercy, to indicate that all is done in his name. However, it was not until the seventeenth century in Dutch art that ordinary household chores were depicted in paintings, and even then they are edited, have moral meanings and represent the middle class.

Late medieval art, therefore, does not give a picture of the everyday life of the noble lady, which can only be gleaned from records and letters such as the fifteenth-century Paston Letters. These show to what great extent women had to act independently and decisively, especially during the frequent absences of husbands due to wars or business. Women are then seen as politically and socially involved, and Margaret Paston in her letters comes across as a very shrewd and hard-headed English woman. Women like Margaret Paston even had to suffer attacks and sieges during the absences of their husbands. Black Agnes, Countess of Dunbar, defended Dunbar Castle against Edward III in 1338; and there were many heroic women during the Hundred Years War, such as Joan of Flanders or the most famous, a peasant girl, Joan of Arc.[135] Christine de Pizan, in her *Le Livre des Trois Vertus*, c. 1406, expected the lady landowner to be able to replace her husband in all things during his absence: for example, she had to know about feudal law, about the management of the estate and be able to plan and organise the whole household wisely without being extravagant.

The gap between the depictions of noble ladies, already mentioned, and reality is probably due to the ideal view held of a lady, who had to be represented as noble and beautiful, and as an example to all, in particular in her religious devotions. The higher up she was in society, the more inactive and disciplined life became, as reflected in depictions of noble ladies reading their Books of Hours. Defending castles was considered to be men's business; noble ladies could only do so in courtly romances, throwing down roses. Mostly, they would be seen playing their parts at grand ceremonies, watch tournaments and go hunting, all activities associated with life at court as an ideal, with that side of it that was truly representative.

Similarly, the depictions of peasant women in illustrations of the Labours of the Months are only half-truths. They did, for example, help to harvest the hay, but they are shown cutting it with a sickle, never a scythe. They were dairy maids, milking cows and churning milk for butter; but always they look well-fed, healthy and clean. They are simply but never poorly dressed, usually with a white apron or else their upper skirt tucked into their waist, and with a straw hat or kerchief to protect them from the

summer sun. They may not wear any shoes in summer, but there is never any indication of real poverty, and they go about their work with vigour. In real life, however, there was much suffering, with famines recurring, and labours like beating flax were back-breaking.

Thus, with art creating an idealised and deceptive picture of aristocratic and peasant women, how did the upper-middle-class women fare, the wives of functionaries, merchants and bankers, already mentioned in connection with portraiture? As a norm, the life of a middle-class woman was that of a housewife in an urban environment, in contrast to the land-owning aristocracy. The best visual depiction of a wealthy woman is at the side of her husband in the *Arnolfini Marriage* by Jan van Eyck, repre-senting the ideal upper-middle-class couple.[136] They are the merchant banker Jean Arnolfini and Jeanne Cenami, both from very successful Italian families, who had settled in the Netherlands. Leaving aside the arguments about whether the painting commemorates their marriage or their engagement, the couple are united in acceptance of each other and stand in humility before the viewer. Jean holds up his right hand as though in blessing, while Jeanne lifts the heavy material of her dress to form a bulge in front of her stomach, thus creating the ideal shape of a woman, as also seen in figures of female saints and Eve, e.g. on the Ghent altarpiece by Jan van Eyck, 1432. Both Jean and Jeanne lower their eyes, she towards him, he towards the viewer, and both are illuminated by the natural light from the window and symbolically from the one candle burning in the chandelier above, indicating supernatural, heavenly light. A convex mirror on the back wall reflects the back view of the couple and two visitors entering the room; above the mirror, Jan van Eyck signed the painting with: 'Johannes de eyck fuit hic [Jan van Eyck was here], 1434'. Jean stands closer to the window, i.e. the outside world; Jeanne is more closely surrounded by the domestic atmosphere, in particular the bed. A pet dog by her feet faces the viewer. Jean has taken off his outdoor clogs; Jeanne has left her slippers at the foot of the armchair in the background. Every object is depicted in great detail, resulting in numerous symbolic interpretations, leaving the exact purpose of the portrait uncertain. What, however, is certain is that the couple must have been extremely well-off to be able to commission a full-length portrait from Jan van Eyck, the foremost painter of the age; also their sumptuous clothes, the richly appointed room and luxury articles such as the oranges by the window indicate great wealth. The painting exudes a sense of well-being, harmony and humility before the eyes of God and of the world. The picture represents the desire for a successful marriage, which must include

legitimate offspring, and for that purpose the man accepts the woman, putting up his hand in blessing, and the woman, emphasising the curve of her stomach with her stance and bulging drapery, offers herself to him.

In class, appearance and attitude towards each other, the Arnolfini couple can be seen as a visual equivalent to the man and wife in the book of instruction of the *Ménagier de Paris* (1392–94). This was written by an elderly French bourgeois, probably a court official, for the edification of his 15-year-old wife. This book, in its detailed advice on behaviour and the practical running of a household, does, of course, give a much clearer insight into the life of an upper-middle-class woman than the painting can do; yet the main concern for the proper behaviour and attitude of a wife towards her husband is the same – she must be perfect in manners and morals and cater to all the husband's needs. In the book, because the *ménagier* is much older than his wife, he expects her to marry again after his death, so that instilling the right housewifely qualities in her, and

30 *Pieter Jan Foppesz. and his Family*, by Maerten van Heemskerck. The family sits around a table, before a cloudy sky. The food and objects on the table, such as the drinking vessels, have symbolic meanings

teaching her to treat her second husband well, will reflect well on him. The instructions to his wife are extremely practical: in order to make a husband comfortable, the wife must have a good fire ready for him in winter, and keep his bed free from fleas in the summer. Also, there is a section on cookery and on recipes for the sick. As the upper-middle-class woman did not have to do any physical work in the kitchen and around the house, but had to organise others to do the work for her, advice is given on how to choose servants and how to look after them. The *ménagier's* wife is also encouraged to observe her religious duties and love God, and she is even told how to say her morning prayers, how to behave at mass and how to go about her confessions. This can be compared with the religious associations in the *Arnolfini Marriage*, where the mirror frame consists of ten medallions with scenes of the Passion, prayer-beads hang on the wall next to the mirror, and a carving of St Margaret escaping from the belly of the dragon is found on the back of the chair. As for women seen at their devotions, the best examples are in religious panels, already discussed in connection with portraits.

As seen so far, art was orientated towards religious works in the fifteenth century, and in order to gain an impression of middle-class women surrounded by their possessions, it is best to look at depictions of the life of the Virgin. The Reformation in the sixteenth century brought about a shift in direction;[137] the Church lost power to the secular authorities, and trading and financial centres such as Antwerp in the Netherlands, and Nuremberg and Augsburg in Germany, added to the overall prosperity. Art became more secular, necessarily so in Protestant parts of Europe, concentrating on portraits, landscapes and genre scenes. However, even in the sixteenth century, genre scenes did not simply represent ordinary life, but were always accompanied by a moral meaning underneath the surface. This can be illustrated by the painting of *Pieter Jan Foppesz. and his Family* by Maerten van Heemskerck, c. 1530 (Pl. 30).[138] The family sits round a table laid for a meal, the father on the left, the mother on the right, holding the youngest child, while two laughing children are wedged between them. What is immediately striking is that the mother and baby are in the image of the Madonna and Child, for the baby is nude, it clings to the mother, yet looks back out at the spectator, and it fingers the cross from the mother's rosary. The painting is full of religious associations: the mother, with eyes lowered, sits on the right, the father on the left, as in fifteenth-century triptychs, and the food on the table has Eucharistic connections, with an emphasis on the wine which the man lifts up in a glass, while looking at the viewer. Furthermore, the back-

ground of the painting is a cloud-laden sky. Thus, the painting reminds one of the Holy Family Resting on the Flight to Egypt; there, too, the Virgin sits at Joseph's side, holding the Child, her eyes lowered, and food of symbolic value is spread out illusionistically on a parapet before them.

In Lutheran Nuremberg, prints of the family at table, illustrating the role of the middle-class woman, became popular. One example is a wood-cut by Georg Pencz, *c*. 1534. Again, the associations with the Eucharist are strong: everyone gestures towards the food; large pieces of bread are lying on the table, and the wine is raised in a glass by the man sitting in the place of honour on the left, while in the foreground the glasses are being refilled from a large wine-cooler; the young son stands with hands folded in prayer. It is the woman's job to see that the whole ceremony of the meal runs smoothly; she directs the food being brought in by the servant, while touching the large dish in the centre of the table which contains meat, reminding one of the lamb on a platter in pictures of the Last Supper.

A painting of the *Banker and his Wife*, by Quentin Massys,[139] 1514, illustrates well the underlying meaning of a genre picture, and of the expec-tations of women as wives of money-wielding husbands.[140] The viewer looks straight at a couple sitting behind the windowsill of their shop. While the man weighs coins on his scales, the woman turns the pages of her Book of Hours, which is prominently displayed, open at a picture of the Virgin. This is a warning against the obsession with worldly goods, as also indicated by the mirror on the windowsill, the symbol of pride and vanity. Reflected in the mirror is an older man seated at a table, and turreted buildings, possibly the world of commerce and business, outside. Furthermore, the original inscription on the frame said: 'Let the scales be true and the weights equal.'[141] In the prosperous Netherlands avarice was the deadly sin most feared, and the painting illustrates the con-cern over the blinding influence of money, against which the woman was to guard. It is interesting that the situation is very similar to that of the eleventh and twelfth centuries where, in a money economy, morally persuasive wives were to spiritually influence their avaricious or usurious husbands.[142]

These paintings of the woman as part of the family reflect the discussions about woman's place in society, especially in Lutheran circles. Women's behaviour had to be exemplary, for the sake of the family's honour; and in order to keep the household prospering, much depended on a sensible, thrifty wife. Generally speaking, the middle-class woman had more freedom and independence than the aristocratic woman, and the lower the class of a woman, the more actively she was able to participate in a craft, either through desire or necessity. Visual representations of

women in a trade enable us to gain some insight into their lives.

One of the professions unique to women was that of the midwife. In art she is most often represented in this capacity in scenes of the birth of the Virgin and of the birth of Christ, as already seen in the *Life of the Virgin* by Albrecht Dürer and the *Nativity* by Robert Campin (Pls. 9 and 10). In the scenes of the Nativity, the midwife is usually seen arriving after the birth of the Child, having been fetched belatedly by Joseph; she then occupies herself with the after-care of the Child, such as bathing it.

From the ninth century onwards there are illustrations of real births probably based on classical patterns, especially the gynaecology of Soranos of Ephesus (d. *c.* 129 AD), but it was only from the beginning of the sixteenth century that prints with this subject matter became more accessible to the wider public, e.g. woodcuts from *Der swangern Frauwen und Hebammen Rosegarten* (The Rosegarden of Pregnant Women and Midwives) by Eucharius Rösslin.[143] The book is illustrated with woodcuts, mainly of natural and abnormal positions of children, of complications and advice on the last months of pregnancy, premature births, etc., as well as on drugs that might prevent stillborn children and on the care of babies. According to the author, the birth of a boy was considered easier than that of a girl, possibly because the weight of girls at birth was generally higher. In an illustration of the *Use of a Birthchair* the midwife stands behind the woman and supports her under her armpits.[144] The woman giving birth has bare feet and her dress opens up down to her stomach. Another woman sits before her with a sheet, ready to catch the child. A miniature from Jean Bondol's *Histoire ancienne jusqu'à César*, 1375, even shows a woman performing a Caesarian section:[145] the woman having performed the operation stands holding a big knife, another woman catches the rather large baby girl issuing out of the mother's side, and a third one stands in the background, ready to wrap the child up in a sheet. All responsibility for a smooth birth was put on the midwife in this time of very high rates of child mortality. Because it was feared that unbaptised babies would go to everlasting limbo, the *limbus puerorum*, described as a place of darkness underneath the earth, they were baptised as soon as possible after birth and lay people such as midwives were given authority to carry out emergency baptisms, as illustrated in a picture from a cycle of votive pictures in Grossgmain Parish Church (near Salzburg, Austria), 1513, where the midwife lifts the child over a bath-tub and baptises it, while two other women act as godparents and a third holds a baptismal candle. The painting records the miracle performed by the Virgin of Grossgmain, who revived the child just long enough for it to be baptised, after it and its

mother had died in childbirth. Excavations in 1993 in Switzerland uncovered evidence of as many as two thousand stillborn babies up to 1486, at the pilgrimage site of Oberbüren, where, as in Grossgmain, an image of the Virgin worked miracles as above.[146] Women designated by Oberbüren civic council would place the dead children within a ring of glowing coal and burning candles to warm them up; then a feather was put on their lips, and if it moved, the children were declared alive and immediately baptised; thereafter, dead again, they could be buried in sacred ground, as they were now Christian, for Catholic dogma stated that any person unbaptised was not a Christian, could not be buried in sacred ground and would not find salvation on the Day of Judgement. It can easily be imagined how such activities of women dealing with life and death could make them vulnerable in times of intolerance and persecution, when scapegoats were needed.

As women were not permitted to study, professions such as that of a physician were denied to them;[147] they were, however, active as healers and were certainly expected to provide health care in the home. An image often used to illustrate this side of woman's activity is from Petrus Comestor's *Historia Scholastica, c.* 1470.[148] A man lies sleeping on a panelled bed covered with a fur rug, while a woman, seated on a low stool by the open fire, prepares a healing brew or some kind of potion from directions in a book on her knees, and a second woman, wearing an apron over her dress, walks across the room carrying a basin. Women were also shown brewing healing remedies, as seen in the title woodcut of Michael Puff's little book on how to distil waters, *Ain guts nutzlichs büchlin von den aussgeprenten wassern*, printed in Ulm by Johannes Zainer the Younger in 1498.[149] Here, a woman is seen standing in front of the furnace fanning the fire with bellows; the distillation apparatus is on the furnace and distilled bottles rest on a shelf, while leaves and flowers are scattered on the floor.

Illustrations to books such as Boccaccio's *Le Livre des Clères et Nobles Femmes* or Christine de Pizan's *Cité des Dames* show women in all types of professions and work, including building work.[150] However, they do not correspond to the reality of women's daily lives, for represented in these stories are allegories of famous women of virtue and strength from classical antiquity. Another source for the depiction of professions is a set of coloured woodcut playing cards, the *Hofämterspiel* (Court-office Game), *c.* 1460, among which is a female steward, standing with her wimple flying and bearing an enormous rosary that reaches down to her knee, and a female potter, sitting facing and raised on a wooden platform.[151] She turns the wheel between her bare legs with her left foot, shaping a vase and

incising rills into it with a wooden scraper. A lump of brown clay lies by her foot and finished vases and a jug are left to dry on the shelf above. The job must have been a hot one, for the woman is dressed in a sleeveless pinafore-type dress, a turban round her head, and her dress is pulled up to expose her bare legs, and thus her lowly status. Scenes from the margins of manuscripts, such as the Luttrell Psalter, *c.* 1325–35,[152] are often used to represent life, but apart from the physical labour done by women in the fields there is little indication of women being employed in a trade, except for a woman spinning wool with the help of a large spinning wheel, which was a new invention at this time. An occupation in which women are often represented visually is the selling of produce such as fish and vegetables at market, mainly in manuscripts or in the backgrounds of paintings, e.g. at the bottom of the manuscript page representing the *Presentation of a Book to Philip the Good*, in *Les Chroniques et Conquetes de Charlemagne*.[153] The *Chronicle of the Council of Constance*, published by Ulrich von Richental in 1465, has a woman sitting by a portable oven selling the pies being baked by men. It was only in the middle of the sixteenth century that market-stall pictures became independent scenes in their own right, but even then they carried moral messages.

From the visual examples given, it transpires that women were more likely to be helpmates to men than to be carrying out a professional trade on their own. Women of the artisan class, in particular, were actively employed on their husbands' behalf, an example being Albrecht Dürer's wife, who travelled to Frankfurt fair to sell her husband's prints; many other women would take their wares to centres of important events, such as the Council of Constance, *c.* 1435, as recorded by the example above. Artisans' wives not only had to look after their own families but also cater for the physical and moral welfare of the apprentices who would join a master's workshop at a very young age. This meant that it was very difficult for a master to set up a workshop and take in apprentices without being married. Apart from the women artists, already discussed, many of the women living in cities were employed in a craft industry, often in the workshop of father or husband. However, once more, it is only from documents, in particular from guild lists, and not from visual representations, that the real picture of women's professions becomes known. Many women worked as spinners, weavers and seamstresses without membership of a guild, and spinning wool is most frequently depicted as a woman's occupation, creating the term 'spinster' for a single woman. Gold-spinning too was an unregulated profession for women before 1526, when they appear for the first time in official records in

Nuremberg.[154] There are documents of women setting up as brewers, bakers, spinners and in other trades, but, generally speaking, towards the end of the Middle Ages women worked increasingly within the confines of their families, as independent female-led workshops were suppressed in the guild ordinances.[155] They were always in competition with men, were restricted in the size of their workshops, and thus could not make as much money as the men, often being unable to pay their guild dues. In the textile industry, in particular, women were forced to turn to work as day- and cottage-labourers; and, due to new markets and economic situations, by the end of the Middle Ages they were excluded from virtually all guilds.[156] Records show that brewing was often in the hands of women, especially in England,[157] but in art the most popular pictures are not of women in this profession but satirical and moral condemnations of the alewife (see Chapter 3, pp. 99 and Pl. 36, p. 101). This may tell us something about how women who were independent and free were immediately associated with loose morals, particularly in cases where beer was involved, conjuring up the deadliest of sins. Brewing had been a home-based industry dominated by women, which during the fifteenth century was gradually becoming a factory-based industry controlled by men.[158] The satirical depictions of alewives as prostitutes and cheats would have tarnished their image in society even more, and reinforced public prejudice against women brewers, whereas the men who cheated equally were not lambasted.[159] In general, whether at work or at play, the picture of woman is dictated by convention, by the attitude of the audience, and not by reality. Possibly, a combination of documentary evidence and visual representation can give the most complete picture of women at work: the documents recording their presence and numbers at a certain time and place, i.e. the statistics, and the visual examples supplying the details of tools used and how they were applied to specific jobs.

Wild women

Because of the popularity in art of wild women and men, who had lost their demonic associations in the later Middle Ages, and came to be seen as the ideal family in tune with nature, the wild woman well deserves to join the band of good women.

Both the wild man and woman are covered in fur, including their genitalia, leaving their hands and feet bare, as well as the breasts in the case of the wild woman. The wild woman is included among the Eastern races in *Hartman Schedel's World Chronicle*, also called the *Nuremberg*

Chronicle, printed by Anton Koberger in Nuremberg in 1493, with woodcuts by Michael Wolgemut. She appears in one of a number of woodcuts showing the *Wonders of the East*, and sits on the ground, her feet crossed and gesticulating with her hands, covered in fur, except for her hands, feet and breasts, and her long hair flows down her back.[160] She is the only human creature among the hybrid beasts, half-human and half-animal, illustrated above and below her. According to Lucretius and Vitruvius, these exotic races came into existence at a time when human beings still lived in harmony with the animals, before the invention of fire, and they were thought to have come from India, Ethiopia and Lybia. St Augustine in his *De Civitate Dei* (Book XVI, Ch. 8), speaks of monstrous races as also true men deriving from Adam's seed.[161] Wild people were therefore accepted as human, although they were opposed to all civilised behaviour and did not believe in God. Their humanity was also expressed in their upright walk, for the depiction of human beings walking on all fours like animals signified the loss of all senses, as in the madness of King Nebuchadnezzar (Daniel 4:27–9; 5:21). As wild people, in tune with nature, their lives were governed by their instincts, and they lacked all self-control. The wild woman derives from Maia, the Roman goddess of earth and fertility.[162] In the art of the late Middle Ages, the wild woman cannot be divorced from the wild man, who was known for his sexual prowess and strength.[163] She is often portrayed nursing their children while he goes out hunting for food. However, she can also be seen helping him in the woods during the hunt, and she too rides wild beasts, although they are the less ferocious ones such as stags and deer, symbolising faithfulness, as in a drypoint by the Master of the Housebook, where she rides a stag and carries two children, one under her arm, the other behind her. Thus, the wild woman combines the female tasks of child-rearing with those associated with the earth and the woods, but she leaves the fighting to the wild man. She is a faithful and loving wife and, above all, a helpmate to her wild husband. The uncivilised wild woman who is supposed to act according to her impulses is now portrayed as an ideal, living harmoniously among her family and within the bosom of nature.

From *c.* 1450 patterns of wild men and wild women were disseminated through engraved playing cards, e.g. by the German Master of the Playing Cards, who depicted wild people dressed either in fur or in leaves, thus associating them with wood sprites, with moss and lichen. However, the engraving of the hairy wild woman sitting cross-legged and holding her distaff is very human, because the distaff is the tool and symbol of every ordinary housewife; the wild men around her carry clubs and bows and

arrows for hunting. The South German Master E.S., too, created a series of engraved playing cards for his *Small Game of Playing Cards, c.* 1460, which included a suit of *Wild People*. The wild woman in the face card sits cross-legged on a rock and embraces a unicorn. The unicorn is a symbol of chastity, and its wildness can only be tamed by the spiritual and true love of a virgin; most representations therefore show the unicorn laying its head in the lap of the Virgin Mary. Here, however, it is the wild woman, the opposite of all courtly and spiritual ideals, who has taken the place of the Virgin, and gained power over the wild, ferocious beast. On a cushion cover made in Strasburg, *c.* 1500, a *Wild Woman with a Unicorn* shows even stronger parallels with the Virgin, for she sits in an enclosed garden of paradise, including a fountain of life and animals and birds, all symbolising youthful chastity and purity with which she is in tune.[164] On a scroll surrrounding her, however, the wild woman laments being isolated from all worldly pleasures, and she desires to be released from her loneliness. There is hope that her wish may be granted because all the animals around her are paired. Thus, the unicorn, by laying its head in the lap of the wild woman, gives up its strength to her and its erotic passions are curbed. The wild woman, like a noble lady or the Virgin, is able to turn the unicorn's wild erotic drive into docile faithfulness. However, the wild woman is earthbound and represents fertility, and she cannot live alone but is happy only in the companionship of wild men and as mother to her children. Her female role is passive compared to that of the wild man, who is more actively engaged in taming wild animals or riding on them, thus becoming master over them, as in several misericords in Chester Cathedral. The harmonious family life of the wild people is represented in an engraving by the Master bxg, *c.* 1480, where the wild family sits around a spring welling up from the ground, playing with their two children (Pl. 31). There is a strong feeling of togetherness between them, and a tree like the Tree of Life grows in the centre of the rocky and grassy landscape. In the distance, on top of a rock, an owl is being mobbed by birds, thus keeping evil away, and a rabbit, symbol of fertility, escapes from a bird of prey. The same idea of happy life is expressed on a misericord in King Henry VII's Chapel in Westminster Abbey, *c.* 1509, where the wild man and woman sit before a trellis of grapevines, playing with their children.

A love casket of *c.* 1460–70 from the Upper or Middle Rhine, its designs taken from engravings, not only shows the characteristic hunting scenes of wild people's life but also includes scenes of wild beasts threatening them.[165] On the lid, the wild men move through the woods with falcon and dogs; one blows a hunting horn, another carries two dead rabbits on a staff

31 *Wild Family* by the Master bxg. A wild woman and man sit around a
spring, happily playing with their two children

over his shoulder. In the centre, a wild woman sits regally on a unicorn led by a wild man.[166] The back of the casket shows wild couples among ornamental foliage; in the centre is a wild woman suckling her baby, while the older child looks on over her shoulder, and a wild man sleeps in the foliage, his legs crossed; on the left are a wild man and a wild woman embracing, and on the right a wild man shooting a bird with bow and arrow. The other sides of the casket deviate from the happy scenes of family life and instead show wild animals threatening the wild people. The front side of the casket copies an engraving by the Master of the Banderolles; it depicts wild men fighting a bear and a wild woman with a child pointing at the griffin that has already captured the other child and is being pursued by the wild man with a club. The narrow left panel shows a wild man fighting a dragon which turns back towards him; the right panel has him face a lion armed with club and shield, while the wild woman holding her child watches anxiously from the edge of the panel.[167]

In the fifteenth century, Basle and Strasburg were centres for the production of long, narrow tapestries depicting scenes of the life and love of wild men and wild women. These were commissioned by the urban middle class, often as wedding presents, and were used as wall-hangings at the back of wooden benches. Many show hunting scenes, hunting being a most important part of a wild family's life. However, in most cases the scenes are allegories, the hunt symbolising the hunt for faithfulness in love, and the trophy of food that the wild man brings home to his wild woman is an offering in exchange for the favour of her love. In a Strasburg tapestry of c. 1440, wild men courageously slay wild beasts, while the women care for the children, often surrounded by rabbits, symbols of fertility.[168] Another tapestry made in Basle, c. 1468, depicts a *Staghunt*, but the wild man is courting the other sex rather than trying to catch the beast of prey.[169] The scene begins with the wild woman in blue, lifting a ladle as she bids farewell to her wild husband leaving for a deerhunt (Pl. 32).[170] Further along, a wild woman helps her mate to prepare for the hunt, then a young wild huntsman gets more interested in the wild woman falconer than in the hunt itself, and at the end a wild man offers up his bird to his female companion, promising her more. In contrast to amorous scenes between ordinary human couples where the women are depicted as lascivious, firing men's passionate desires, the wild women here reprimand their wild men, telling them to keep their eyes and attention on the hunt, and on the prey. Whereas ordinary women were considered insatiable in their sexual desires, it is the wild men who are thus characterised, and they are the ones who have to be tamed. Wild men, in contrast to chivalrous knights, rape

and carry away women, but the spiritual, 'high' love of a lady will discipline them, illustrated by ladies leading wild men on chains. In scenes of wild men and wild women as in the tapestry above, wild women behave like medieval noble ladies, and take over their function of taming the wild men, while remaining wild women nevertheless. It is interesting to note that the above tapestry was commissioned by the Basle mayor Hans von Flachsland, who was marrying his second wife, and it was most probably a wedding present, demonstrating his love, his desire to gain her favours and to be tamed by her.

Scenes of this type illustrating hunting, love scenes or the storming of love castles were a playful imitation of the life of the nobility. Again and again the emphasis was on love and faithfulness, as illustrated in another tapestry made in the same Basle workshop, c. 1470,[171] which includes a scene of wild lovers meeting by an elderberry tree, a favourite meeting place for couples because of its magical properties, for love potions could be made from its juice. Depictions of wild people as inhabitants of woodlands also served as foliage-strewn ornamental engravings. In one such by the Master E.S., c. 1460, wild men climb up the tendrils of plants while the wild woman rides on the petal of a flower, her hair streaming behind her. Israhel van Meckenem created several such ornamental designs, with wild men and wild women engulfed by and frolicking among exuberant foliage with flower heads abundant with seeds, and prints like these could have been used as models for marriage chests.[172] The seeds would point to the fertility of the wild woman, and, as a symbol of procreation, the wild woman was given the role of arms-bearer, as seen in an engraving in the shape of a roundel by Martin Schongauer, c. 1470; there, she sits on a rock, supporting with one hand a large coat of arms which stands on the ground by her side, while breastfeeding the babe nestling against her other side.[173]

However, not all visual representations of wild women were totally positive. The general increase in satire on women throughout the fifteenth century also affected wild women, but in their case humour, not biting misogyny, came into play. A tapestry made in Alsace, c. 1390–1410,[174] includes among the usual hunting scenes and the wild woman nursing her children several humorous scenes: wild people play games such as Quintain, a balancing game where opponents try to dislodge each other by pressing against each other's soles; a wild woman leads a deer, usually the wild woman's beast, on which sits a wild man in the riding position of a woman; a wild woman slings a wild man over her shoulders, and wild women storm a love castle. These are scenes of the world upside-down,

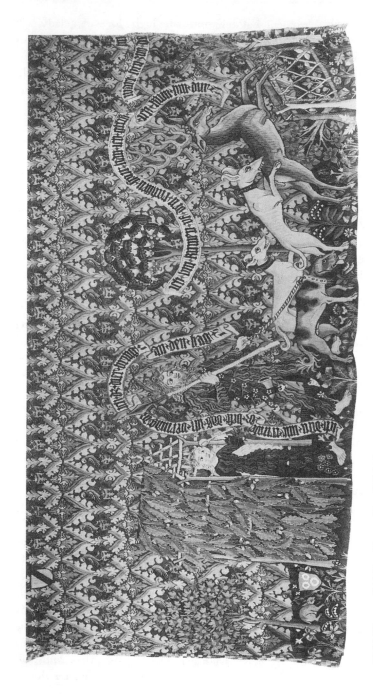

32 *Wild Woman Bidding Farewell to Wild Man*, tapestry. The wild woman stands in the entrance of their leafy abode and lifts a ladle, for she will cook, while he is on his way out to provide the food

where the wild women have brought the wild men to submit to them through their temptations of love. However, the narrative ends in the idyllic, bonded family life of the wild woman delousing her son and the wild man laying his hand on her shoulder. Satire is also found in an engraving of a *Tournament* by Master E.S., *c.* 1460, enacted between a wild man on a unicorn, with a rake as his lance, and a wild woman on a deer, directing a distaff against her opponent.[175] Although they are not covered in fur they are wild people nevertheless, riding on wild beasts, and their nakedness carries erotic connotations. In this battle of wild woman against wild man she has taken on the aggressiveness of the evil housewife satirised in the theme of the Battle for the Trousers (see Chapter 3), but it is a satire as much of wild woman battling against wild man as of the mocking of the old ideal of chivalry represented by the tournament.

The popularity of the wild woman and her wild man was a phenomenon of late-medieval urban society in German cities such as Basle and Strasburg, Nuremberg and Regensburg.[176] The narrow tapestries, in particular, were commissioned by the middle class; and not only the patricians, but those intent on improving their status in life, desired coats-of-arms with wild people as motifs. An ever-increasing admiration for the family life of wild people became a utopian fantasy divorced from real life, because the middle class found itself constrained by laws and regulations; its organised society and its arranged marriages stood in stark contrast to the carefree relationship between wild men and wild women, unfettered by conventions of morality. In a society where marriage and passionate love were incompatible, representations of wild people became like a lucky charm on prints, household chests, platters, tapestries, embroideries and love caskets. The middle class saw them as representatives of the Golden Age, as illustrated in a woodcut of 1530 by Hans Schäufelein, with text by Hans Sachs, printed in Nuremberg. A wild man and woman stand facing each other, protectively putting a hand on the head of each of their two children, one of whom is playing with a dog. In the text, Hans Sachs laments the passing of innocence and the breakdown of morality in civilised society. Furthermore, the wild woman was depicted like a noble lady and was not subjected to the biting satire levelled at ordinary housewives, as will be seen in Chapter 3. Usually she was depicted bound to nature, mated and taking care of her children; content with life and fertile. Thus, the desire for a simple and free life in the late Middle Ages had brought about the transformation of frightening hairy demons into playful wild human people dressed in coloured furs, and the forest no longer held any awe or fear for the bourgeois citizen.

Notes

1 Prague, Narodnie Galeria.
2 It is not certain whether a particular Pope is portrayed; it might be Julius II or Alexander VI.
3 Utrecht, Rijksmuseum het Catharijneconvent.
4 All the books were known by 1427: Knott, 1978 [1963], p. 22. Thomas à Kempis calls himself 'scriptor', not 'auctor', implying that he compiled and edited earlier writings: Dinzelbacher, 1989, p. 496.
5 Oxford, Bodleian Library, Ms. Douce 219–220, fol. 40, by an artist of the Ghent/ Bruges school of illumination, and a German painting in Cracow, St Mary's, as a fragment of an altarpiece of the *Life of St Catherine*.
6 Apocryphal writings were transmitted more widely by the Golden Legend of James of Voragine, thirteenth century. Pseudo-Bonaventure was the anonymous writer of the *Meditationes Vitae Christi*, translated into many vernacular languages. In the Middle Ages the author was thought to have been Bonaventure. Probably written *c.* 1300 by a Franciscan, in Italy, for a Clare nun.
7 Campin is also known as the Master of Flémalle; painting in London, Courtauld Institute Galleries.
8 Madrid, Prado.
9 Antwerp, Koninklije Museum der Schone Kunsten.
10 London, National Gallery.
11 One example in Brussels, Musées Royaux des Beaux-Arts, *c.* 1520.
12 In the Gospels, only St Matthew (1:25) and St Luke (11:34) refer to Mary's virginity, and in the Old Testament Ezekiel's verse (Ezra 44:2): 'This gate shall be shut, it shall be opened, and no man shall enter by it.'
13 According to Pseudo-Bonaventure, the Annunciation takes place in a 'room in the house of Mary': Duchet-Suchaux, G. and Pastoureau, M., 1994, p. 35.
14 New York, Metropolitan Museum, The Cloisters.
15 'Bladelin Altarpiece' in Berlin, Preussischer Kulturbesitz, Staatliche Museen, and 'Portinari Altarpiece' in Florence, Uffizi. On the column: Male, 1984 [1898], p. 44, who thinks that this motif was also used in French mystery plays.
16 *Revelations*, I, 10: Panofsky, 1971, p. 277, n. 3.
17 Berlin, Preussischer Kulturbesitz, Staatliche Museen.
18 Dijon, Musée des Beaux-Arts.
19 Paris, Bibliothèque Nationale, ms. lat. 1156a, fol. 48.
20 Hamburg, Kunsthalle.
21 London, British Library, Add. Ms. 49999.
22 Münster, Westfälisches Landesmuseum, Ms. 530; workshop of the Master of Catherine of Cleves, Utrecht, *c.* 1450.
23 New York, Pierpont Morgan Library, Ms. M.917, pp. 149 and 151.
24 There is also the meaning of the 'holy fool', being a fool for Christ's sake.
25 Also called the *Merode* triptych. New York, Metropolitan Museum, The Cloisters.
26 Ghent, St Bavo Cathedral.
27 New York, Cloisters Museum.
28 Her cult only reached the West in the fifteenth century, and she was especially

popular in Germany.

29 Bruges, Museum of the Brotherhood of the Holy Blood, and Brussels, Musées Royaux des Beaux-Arts.

30 Antwerp, Konijklije Museum der Schone Kunsten.

31 Bruges, Sint-Janshospital, Memlingmuseum.

32 D. H. Farmer, 1978, p. 404; it is thought that the depiction of St Wilgefortis derives from early crucifixes where Christ was clothed and bearded.

33 Rotterdam, Museum Boymans-van-Beuningen, and Vienna, Kunsthistorisches Museum.

34 London, National Gallery.

35 Cologne, Wallraf-Richartz Museum.

36 Almost 30 per cent: Klapisch-Zuber, 1992, p. 41.

37 Bamberg, Staatsgalerie; Flemish, first half of the fifteenth century.

38 London, British Library, Ms. Cott. Dom. A XVII, fol. 74v.

39 Munich, Bayrisches National Museum.

40 St Clare was canonised in 1255, two years after her death.

41 Schraut, E. and Optiz, C., 1983, p. 40.

42 Belle, Musée Depuydt: Ms. s.n., fol. 25.

43 Schraut, E. and Opitz, C., 1983, pp. 28–34 and fig. 31.

44 Schraut, E. and Optiz, C., 1983, p. 31.

45 Bamberg, Bibliotek des Metropolkapitels.

46 Bridget was of noble birth and married at 13, but persuaded her husband to remain chaste for two years; then she bore him eight children.

47 The papal court was at Avignon 1308–78.

48 Frankfurt/Main, Stadtgeschichtliches Museum.

49 Dijon, Musée des Beaux-Arts, and Berlin-Dahlem, Staatliche Museen, Preussicher Kulturbesitz.

50 Colmar, Unterlinden Museum.

51 She visited the Brigittine House of Syon Abbey.

52 Pommersfelden, Graf von Schönborn Schlossbibliothek, Ms. 348, fol. 9v.

53 Brussels, Musées Royaux des Beaux-Arts.

54 London, British Library, Egerton Ms. 1070, fol. 110, and Add. Ms. 31240, fol. 20v.

55 Kempe, 1985, p. 231 and n. 1.

56 On the original frame are the arms of Bishop Despencer (1370–1406), and of six well-known Norfolk families: Alexander and Binski, 1987, p. 516.

57 Kempe, 1985, pp. 232 and 233, nn. 4, 5, 6.

58 Michelangelo speaking to Vittoria Colonna, as recorded by Francisco de Hollanda in his *De Pintura Antigua*, 1548; Snyder, 1985, p. 88.

59 Ozment, 1983, pp. 66 and 67. A turtle-dove is considered faithful to her one mate, for ever; also mentioned in Chaucer's *The Merchant's Tale*.

60 Veldman, 1986, p. 114.

61 Blamires, 1992, pp. 260–70.

62 Bamberg, Staatsgalerie. In practice, trial by fire no longer existed; the examples depicted are of historical figures, as warnings. Kunigunde died in 1033, and was made a saint in 1200. Henry II was the last emperor from the Saxon House.

63 Owst, 1926, p. 170.

64 Bamberg, Staatsgalerie.

65 The translation into German had been done by the Ulm physician and author Heinrich Steinhöwel, 1461.

66 *Confessions*, XIII.32: Blamires, 1992, p. 78.

67 *The Literal Meaning of Genesis (De Genesi ad Litteram)*, IX.5: Blamires, 1992, p. 79.

68 Had a clerical career, but was also a political agent in the service of the Hohenzollern Markgrave Albrecht Achilles.

69 'Is a man to wed or not?' [Introd. Helmut Weinacht, Darmstadt, 1993.]

70 In her *Cité des Dames* she was influenced by Boccaccio's *Le Livre des Clères et Nobles Femmes* and also by St Augustine's *City of God*.

71 In her biography of Charles V, Christine calls her father 'philosopher, servant and counselor to the king', and elsewhere 'astronomer and mathematician': Willard, Charity Cannon, 1984, p. 21.

72 Started by Guillaume de Lorris, *c.* 1236, written *c.* 75 years earlier than the continuation by Jean de Meun.

73 *The Secular Spirit*, Husband, 1975 (intro), cat. 177, p. 161.

74 *Cité des Dames*, 1.41.4. Willard, Charity Cannon, 1984, p. 45.

75 London, British Library, Ms. Harley 4431, fol. 3.

76 London, British Library, Ms. Harley 4431, fol. 259v; French, fifteenth century.

77 Brown-Grant, 1994, pp. 269–92.

78 Ibid., pp. 276, 282 and 292.

79 Boston Public Library, Ms. 1528; follower of the Bedford Master, *c.* 1435–40.

80 Klapisch-Zuber, 1992, p. 125.

81 Ibid., p. 124, n. 51.

82 London, British Library, Ms. Harley 3828, fols. 27v–28r.

83 The book was originally compiled in 1371 by the Knight of La Tour-Landry whose first name only, Geoffrey, is known. It was first printed in Basle in 1493. Twelve copies of the original text, some incomplete, exist in manuscripts, one or two from the beginning of the fifteenth century, and two have illustrations.

84 Women are mentioned as teachers in German towns in Eckenstein, 1896, pp. 328ff.

85 Basle, Oeffentliche Kunstsammlung.

86 Power, 1975, p. 85.

87 New York, The Cloisters, Ms. 54.1.2, fol. 16.

88 Cambridge, Fitzwilliam Museum, ms. 62, fol. 20; Harthan, 1977, p. 117.

89 Flemish; Vienna, Oesterreichische Nationalbibliothek, Cod. 1857, fol. 14v. Mary of Burgundy was the daughter of Charles the Bold and wife of Maximilian I; she died in 1482 as the result of a riding accident.

90 Berlin-Dahlem, Staatsbibliotek, Stiftung Preussischer Kulturbesitz, ms. germ. quart. 42, fol. 19v.

91 Braswell, 1986, p. 82.

92 Ibid., pp. 92 and 93.

93 Caviness, 1993.

94 Florence, Uffizi Galleries.

95 New York, Metropolitan Museum, The Cloisters.

96 Liège, Musée Diocésain; the composition derives from Jan van Eyck's *Madonna with Chancellor Rolin*.

97 The so-called 'Melun Diptych'; panel with donor in Berlin, Staatliche Museen, Preussischer Kulturbesitz, Gemäldegalerie; panel with Virgin in Antwerp, Museum voor Schone Kunsten.

98 Ring, G. (1949), cat. no. 123, p. 210.

99 London, National Gallery, and Antwerp, Museum voor Schone Kunsten.

100 Berlin, Staatliche Museen, Preussischer Kulturbesitz, Gemäldegalerie.

101 London, National Gallery.

102 Gotha, Schlossmuseum.

103 Kok, 1985, p. 270, cat. no. 133.

104 Ibid.

105 Vienna, Albertina. Inscribed 'Mein Agnes'.

106 Drawing in Vienna, Albertina; painting in New York, Metropolitan Museum of Art.

107 Vienna, Albertina; inscribed 'Cologne headdress', and 'My wife on the trip near Bopard'. Fifteen sheets of the sketchbook, started at the beginning of October 1520, survive in various collections.

108 Barbara, née Holper; in Berlin, Staatliche Museen, Preussischer Kulturbesitz, Kupferstichkabinett.

109 Florence, Galleria degli Uffizi, Gabinetto Disegno e Stampe. The sitter, named 'Katharina, 20 years old' in the inscription, has been identified from an entry in Dürer's diary between 16 March and 6 April 1521.

110 A list of patronesses and female illuminators and scribes, given in Schraut, E. and Opitz, C., 1983, pp. 46–7.

111 Ibid., p. 33. This applies to women on the Continent; single women in England could have signed documents (information from Steve Rigby, History Department, University of Manchester).

112 Kunstmuseum, Öffentliche Kunstsammlung, Basle.

113 Harbison, 1995, pp. 21 and 65; *Flag* in Ghent, Bijlokenmuseum.

114 Paris, Bibliothèque Nationale, Ms. fr. 12420, fols. 101v and 86.

115 Paris, Bibliothèque Nationale, Ms. fr. 599, fols. 58 and 53v, and Ms. fr. 598, fol. 43.

116 Chantilly, Musée Condé, ms. lat. 1284, *c*. 1416.

117 Paris, Musée de Cluny.

118 Examples are the Hennesy Hours, Brussels, Bibliothèque Royale Albert I, Ms. II.158, or Munich, Bayrische Staatsbibliothek, Cod. lat. 23638.

119 British Library, Ms. Roy. 10 E IV, fol. 80.

120 London, Victoria and Albert Museum; from Tournai.

121 Paris, Musée du Louvre, Cabinet des Dessins.

122 London, British Library, Ms. Harley 4431, fol. 150.

123 Barber and Baker, 1989, p. 190.

124 Oxford, Bodleian Library, Bodl. Ms. 164, fol. 101v.

125 Paris, Bibliothèque Nationale, Ms. fr. 2692, fol. 70v.

126 New York, Metropolitan Museum, The Cloisters.

127 Nuremberg, Germanisches Nationalmuseum.

128 In Paris, Louvre, and London, Victoria and Albert Museum; see: Koechlin, R., 1968, Pl. CLXXX, nos 5 1046 and 1053.

129 London, British Library, Ms. Harley 4431, fol. 153.

130 London, British Library, Ms. Add. 42130, fol. 33; c. 1325–35.

131 Evans, J., 1969, p. 27.

132 London, British Library, Ms. Harley 2278, fol. 13v.

133 She was a Hungarian princess who married a Thuringian prince and was therefore also known as Elizabeth of Hungary.

134 Brussels, Bibliothèque Royale; style of Philippe de Mazerolles.

135 Power, 1975, p. 45.

136 London, National Gallery.

137 Luther nailed his 95 theses to the door of Wittenberg church in 1517.

138 Kassel, Staatliche Kunstsammlungen.

139 Also called Metsys; in Paris, Louvre.

140 The picture is thought to be modelled on a lost painting by Jan van Eyck, which may have looked like the painting of St Eligius by Petrus Christus (New York, Metropolitan Museum of Art), because of Eyckian characteristics, such as the mirror and the still-life objects; also the dress is from the Eyckian period.

141 The text derives from the laws of righteousness cited in Leviticus 19:35.

142 Farmer, 1986.

143 He was an apothecary in Freiburg (Black Forest) 1493–98, town physician of Frankfurt am Main 1506–11, in Worms 1513–17, and then back in Frankfurt.

144 Kühnel, 1986, fig. 189. Also, see Rowland, 1981, p. 43.

145 Spikkestad, Martin Schogen Collection.

146 Jezler, 1994, pp. 192 and 193.

147 See Klapisch-Zuber, 1992, p. 299 for exceptions.

148 London, British Library, Ms. Royal 15.D.I., fol. 18.

149 Brandy was first distilled in the Middle Ages, initially as a remedy, then as a drink.

150 A Boccaccio manuscript: New York, New York Public Library, Spencer Coll., Ms. 33, French, c. 1470 ; a Cité des Dames manuscript: London, British Library, Ms. Add. 10698, Dutch, 1475.

151 From Austria or the Upper Rhine region; in Vienna, Kunsthistorisches Museum.

152 London, British Library, Ms. Add. 42130.

153 Brussels, Bibliothèque Royale, Ms. 9066, fol. 11.

154 Klapisch-Zuber, 1992, p. 302.

155 Ibid., p. 303.

156 Ibid., p. 304.

157 Power, 1975, p. 67.

158 Bennett, 1991, p. 169.

159 Ibid, pp. 179 and 180.

160 On folio XII, woodcut 16 (out of 21).

161 Knowles, D. (ed), 1972, p. 662.

162 Bernheimer, R., 1952, p. 42.

163 Wild men and wild women are presented singly in the epic poetry of the twelfth and thirteenth centuries; Bernheimer, R., 1952, p. 39.

164 Basle, Historisches Museum. The wild woman with a unicorn derives from an engraving by Master E.S.

165 Vienna, Kunsthistorisches Institut.

166 This scene is probably based on a lost engraving by the Master E.S.

167 After an engraving by the Master of the Nuremberg Passion.

168 Boston, Museum of Fine Arts.

169 Basle, Historisches Museum.

170 All wild men and wild women in these tapestries are dressed in different colours of shaggy fur.

171 Madrid, Thyssen-Bornemisza Collection.

172 Master E.S. in Shestack, 1967, fig. 63; Israhel van Meckenem in Shestack, 1967, fig. 245.

173 The medallion shape points to the fact that such an engraving was a model for a stained-glass window.

174 Regensburg, City Museum.

175 Copied by Israhel van Meckenem.

176 The misericords in Westminster Abbey, e.g. the *Wild Family,* show strong Continental influences.

3

The evil woman

The evil woman, as the direct descendant of Eve, has all the latter's characteristics: she is rebellious, vain, lustful and a gossip. It was her disobedience in the Garden of Eden that led to the expulsion from paradise, and her gossiping with the serpent that resulted in her failure to recognise the devil's deception. The source for negative opinions on women is to be found in the writings of early Christian ascetics, such as Tertullian and St Jerome. Their views were picked up by later preachers, who spiced their sermons with misogynistic stories in order to make them more memorable. In this chapter, the representation of misogyny in art will be examined, with its ramifications in the world of men.

The close relationship between Eve and the devil, which caused evil to enter the world, is aptly expressed in a woodcut of c. 1500, entitled *La Nef des Folles de Eve*.[1] Eve and Adam are standing in the Ship of Fools, where devils in fools' dress, with fools' ears added to their own horns, row the boat (Pl. 33). The Tree of Knowledge is the mast and the serpent with a woman's face winds itself around the stem and hands the apple to Eve. Adam's gesture is one of rejection, but it is too late to prevent foolishness and sin, and the banner at the back of the boat has the emblem of hell's dragon, an indication that the boat is in the possession of the forces of evil, and heading towards catastrophe. The accompanying text says: 'Eve our first mother is the mother of all foolishness', implying that original sin is the product of foolishness, as believed by the humanists.[2] A fifteenth-century misericord in St Martin-aux-Bois, near Paris, expresses the misogynistic, albeit unorthodox, view that already at woman's creation the devil had a hand in it, for a woman is seen sitting between God and the devil, and both are busy sculpting her body with chisels.

According to medieval medical opinion, a person's physical and mental qualities were determined by the four humours, blood, phlegm, choler

and melancholy, but the harmonious flow of these body fluids before the Fall had been unbalanced by it. Women's dominant humour was considered to have the qualities of coldness and dampness, which meant that they were weak and pliant, and therefore easily influenced, in particular by evil, lustful thoughts. This is illustrated in an embroidery for a cope of *c.* 1430 showing the influence of vices, especially those associated with lust, on the beautiful St Magdalene before she had embraced a virtuous life. She sits on the ground, and looks like a beautiful courtly lady surrounded by her suitors, but they wear animal masks that personify the vices, and while encircling her they ensnare her.[3] In contrast, men's humours were thought to be warm and dry but very inflammable in youth so that it was dangerous to fan their fires of passion. However, those who believed that women's sexual passions were insatiable could defend their acts of adultery by accusing women of having bewitched them.[4] In a fifteenth-century Netherlandish carving (Bruges, Gruuthuse Museum), a woman's passionate, lustful nature is made quite explicit: she is bent over, exposing her bare bottom, and the fire of passion inside her is doused with the help of a large clyster. Many were the examples given of women leading

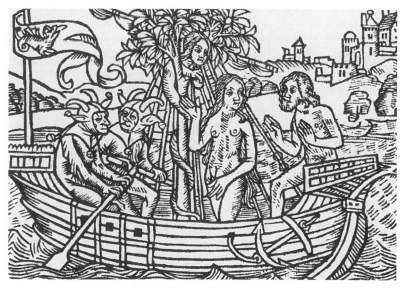

33 *The Ship of Fools of Eve*. Adam and Eve stand in the Ship of Fools, which is being rowed by devils in fools' dress. Eve, the instigator of original sin, is also the mother of foolishness

men astray by their sexual allure, and as Sebastian Brant in his *Ship of Fools* says (Chapter 32): 'to guard women is useless'. A woodcut by Vogtherr the Younger, *c.* 1540, shows that even the chastity belt will not keep women under control. Facing the viewer is a woman, nude apart from her chastity belt with padlock, flanked by an old and a young man, and it is to the latter that she hands the key.

In a woodcut to Brant's *Ship of Fools* (Chapter 13), woman is personified as Lady Venus, instigating foolish love by men, for she is seen with all her fools, i.e. men, at her beck and call (Pl. 34). Her large wings are outspread, and blindfolded Cupid with bow and arrow is at her side. She holds a donkey, an ape and men in fools' costumes on leashes, while behind her lurks the figure of Death, thus pointing to the deceptive nature of love and the transience of all worldly pleasures.

Woman's great weakness, her susceptibility to the whisperings of the devil, was a specific theme in art, the devil in question being Tutivillus, who was active in the choirs of churches, where he would target women and priests, inciting the women to gossip and the priests to drop words and syllables while rushing through mass. Tutivillus would record the gossip or words dropped in order to present them to God as evidence against the person's soul on the Day of Judgement. The source for Tutivillus is Jacques de Vitry, whose sermons were used extensively by sermon compilers who wrote pulpit manuals for the benefit of priests in the thirteenth century. Jacques de Vitry does not mention women in his exemplum but restricts himself to warning priests; however, the story was much elaborated on in Robert of Brunne's *Handlyng Synne*,[5] and in good misogynist spirit, women were now included as the well-known gossips. The story now went that a deacon reading the Gospel let forth a great laugh because he had seen two women engrossed in idle talk while a fiend noted down their every word. Needing more space, he extended his 'rolle' by tugging at one end and gnawing at the other. But it burst and the scribbler hit his head against the wall. Noticing that he was being laughed at, he smashed up his remaining 'rolle' with his fist and left.[6] Tutivillus gloating over gossiping women was very popular in the carvings of English misericords, such as those in Ely Cathedral, 1339–41 (Pl. 35). Two women sit next to each other in church and Tutivillus's wicked face appears between their heads. One woman holds a rosary which points to her hypocritical piety. In the left supporter, Tutivillus pulls at the already over-filled scroll he is writing on with his teeth, in order to stretch it. On the misericords in the Foundation of St Katherine, London, *c.* 1365, and at New College, Oxford, 1390s, women are the target again, the devil

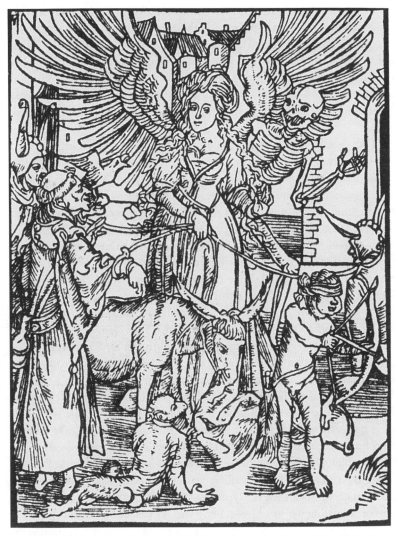

34 *Lady Venus*, from the *Ship of Fools*, by Sebastian Brant. Blindfolded Cupid is at her side, while she holds captive a donkey, an ape and men in fools' costumes. Skeleton Death threatens from behind her

appearing as a bat-winged overpowering menace in New College, putting the women's heads together. The story was also used by the Knight of La Tour-Landry to warn his daughters. In the woodcut of the German edition of 1493 it is St Martin, assisted by his deacon St Brice, who has the

vision of the devil taking down the women's gossip. St Martin then preached to the women of the peril of their sin, saying that it was better not to come to mass at all than to talk so much during it. Mystery plays too treat the subject of women and Tutivillus. In the *Towneley Play* a devil says that he carries more rolls describing the evils of womankind than he is able, and a long satire on women follows.[7] Thus, sermons, mystery plays and visual illustrations all helped to create a popular tradition which kept misogyny alive.

The deadly sins associated with women were manifold, and in a woodcut from a 1487 Louvain edition of Boccaccio's *De Claribus Mulieribus*, the seven deadly sins growing out of the Tree of Knowledge give a good indication of which were women's prime sins in contrast to those committed by men. The Tree of Knowledge stands between Adam and Eve at the Temptation; Eve passes the apple to Adam, and the serpent has a woman's face with hair plaited into horns. The sins harboured by the tree are half-length figures, bearing their symbols: Wrath swings a sword; Envy eats his heart out; Avarice counts the money in his chest; Pride is a woman admiring herself in a mirror; Lechery is an embracing couple; Gluttony is a monk guzzling from a tankard; and Sloth rests on his elbow, his face against the palm of his hand. This woodcut, therefore, demonstrates in very simple imagery that all the vices derive from Eve at the Temptation, that all are guilty of sin, but that the sin specific to women is pride.[8] In the misogynistic tales of John of Bromyard's *Summa Predicantium*, Ruth Karras has found that particular sins are attributed to women because of their femininity, whereas the sins of men are specific to their trade, rather than to their masculinity; men sin not because they are men but because they are human.[9] This can also be exemplified in the round tabletop painting of the *Seven Deadly Sins* by Hieronymus Bosch.[10] Here, Bosch created more realistic settings, almost making the sins into genre scenes; nevertheless, typically, the woman is standing before a mirror, adjusting her headdress, her jewellery casket on the floor, and her young lover is waiting in the room next door. Intent on her reflection in the mirror, she fails to notice that the devil, wearing the same wimple as herself, is holding the mirror. In contrast, a man personifies avarice and is depicted as a corrupt judge, taking money from both parties, rich and poor. The sin of lust is set in a Garden of Love, and in the depiction of hell in the same painting, lust is punished by the sinning parts of the body being bitten by serpentine dragons, whilst a toad sits on the vain woman's genitals.

Woman's preoccupation with ostentation was already lamented by

Tertullian (*c.* 160 – *c.* 225), who criticised early Christian converts for their pagan attitudes towards dress and appearance.[11] He chastised women for using sewn and woven wigs, dyeing their hair blonde with saffron, rubbing their skins with creams, staining their cheeks with rouge and making their eyes seem larger with eye-liner. Medieval preachers equally denounced the wigs, the paint, and the 'horns', the long flowing trains, the rich furs and wasteful sleeve-lengths, as well as womanly pride and passion.[12] In art in the Middle Ages, the most potent symbol of vanity was the horned headdress, to such an extent that it remained an object of criticism and satire long after it had become unfashionable. In medieval literature, too, it was a good target: for example, Lydgate in his poem 'A Dyte of Women his Hornys' describes woman as being 'hornyd like a kowe'.[13] Even if preachers had persuaded women to get rid of their finery and horned headdresses, their repentance would not last long, and although 'like snails in a fight they had drawn in their horns', they 'shot them out again as soon as the danger was over'.[14] A misericord in Ludlow, St Lawrence, of the bust of a woman, shows her in a horned headdress and with a bridle in her mouth, to keep her from gossiping, and rein her in generally. Not only did the horns immediately conjure up devils' horns, but the devil himself could nestle between them, and thus gain direct access to women's ears, as seen on misericords such as one in Minster-in-Thanet, *c.* 1410. One of the best-known misericords, depicting the scum of womanhood, vain, proud and deceitful, is *Ale-wife Taken to Hell* in Ludlow, St Lawrence (Pl. 36). Totally naked exept for her horned headdress, she is carried into hell over the back of a devil, while another devil welcomes her with bagpipes, and hell's mouth awaits her. She clutches in her hand the tankard with which she used to give false measure. Tutivillus is present in the left supporter noting down all her sins on a scroll of parchment. In literature, the alewife first appears in the Last Judgement scene of the Chester miracle plays, where she is considered to be so evil that she is the only soul left in hell after the harrowing of hell by Christ, and only Secundus Demon is prepared to marry her. The apex of misogynist satire is the so-called *Ugly Duchess* by Quentin Massys, *c.* 1513.[15] This is a satirical half-figure portrait of an old woman in a horned headdress; her skin is flabby and her breasts, in a low-cut bodice, are shrivelled up. Nevertheless, she is hopeful of attracting a suitor, for she holds a flower, an engagement symbol, although hers is a bud that will never blossom. In ridiculing the engagement portrait, it becomes a cruel caricature of women, probably based on Erasmus's scathing remarks in his *In Praise of Folly*: 'Yet it's even more fun to see the old women who can scarcely carry their weight of years and look

like corpses that seem to have risen from the dead.... They're for ever smearing their faces with make-up and taking tweezers to their pubic hairs, exposing their sagging, withered breasts and trying to rouse failing desire with their quavery whining voices.'[16] It was this type of old woman, in particular, who was feared to ensnare the souls of men. A topic which gained great popularity between *c.* 1470 to 1535, in particular in German prints, was the theme of Unequal Couples, where money is exchanged for love between couples of widely differing ages.[17] The satire affects old men as much as old women, for it is the foolishness of the old which causes them to offer their money for the love of the young. A large number of examples portray the men as old and foolish and the women as young, mercenary and deceitful. The theme was very popular in the drypoints of the Master of the Housebook and the paintings of Lucas Cranach and Quentin Massys, showing decrepit old women forcing bags of money on young men to gain their love, or vice versa. In one of Quentin Massys's versions,[18] a fool is included pointing at the foolishness of people, for the bag of money is passed on to him. The theme was very much a reflection of marriage practices at a time when marriages were based on economic considerations, so that women often had to marry old men. There was also the fear that widows or widowers might choose young and unsuitable partners who would squander their inheritence. The Unequal Couple could be extended into a Love-triangle, where the money changed from

35 *Tutivillus*, misericord, Ely Cathedral. Tutivillus is a devil who records those women gossiping during mass and reports their sins to God on the Day of Judgement. In the centre, he sits between two women, and in the left supporter, he is trying to stretch the scroll with his teeth, in order to add more names to the register

old man to young girl to young man, and where the old hag was the procuress, as in woodcuts by Erhard Schön and Lucas van Leyden (Pl. 37). Depictions of this theme are very similar to those of the Prodigal Son, where several young women entice a wealthy young man with food, drink and love.

Although both men and women are castigated in the Unequal Couple, women usually got the brunt of satirical criticism, for again and again the insatiability of their love was made apparent and they were portrayed as disgusting. An engraving by Frans Huys of the *Lute-maker* makes this clear (Pl. 38).[19] An old woman comes to have her lute repaired, as its strings have gone, i.e. she is really too old for love-making but wants to be rejuvenated. The lute lying on the ground is a simile for the female body, and the stringing and playing of the lute stands for the sexual act. The cat is a symbol of lechery; the small cock by the door is associated with adultery, i.e. cuckolding; and bellows incite lust or the flame of passion. The text says: 'Master John Bad Faith, will you string my lute? I will do so Dame Long Nose. But leave me in peace because I must keep it for Mother Mule who would also very much like to have her lute fixed.'[20] Such biting prints with their increasing emphasis on phallic symbols demonstrate that, although love had been denounced through the ages, never before had it been so cruelly satirised. The advent of printing in the second half of the fifteenth century played a large part in extending profane themes, of which

36 *Ale-wife Taken to Hell*, misericord, St Lawrence, Ludlow. Carted over the back of a devil, she is welcomed into hell by another playing the bagpipes; in the right supporter she is seen disappearing into hell's mouth, and in the left supporter Tutivillus records the sinners

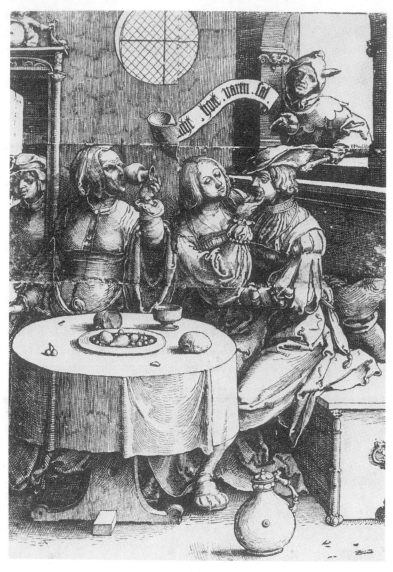

37 *Love-triangle*, by Lucas van Leyden. This scene in a brothel resembles that of the Prodigal Son. It shows a young woman enticing a man to part with his money which passes via the drinking procuress to the young man in the doorway. The fool in the window points out their foolishness

satire on women's role in the Garden of Love became a popular one. The change in the treatment of the Garden of Love can be seen in the engravings by the so-called Netherlandish Master of the Garden of Love, *c.* 1450; the lovers move around sedately, and although the garden contains symbols of foolishness, the atmosphere is reminiscent of harmonious, happy togetherness.[21] This, however, changes with the engravings by the Master E.S. In his *Small Garden of Love, c.* 1460, the young couple on the right sit on either side of a walled spring in which a flask of wine is left to cool. Behind and between the couple, a fool, as the commentator, demonstratively plays the bagpipes, a symbol of lust. The young man holds the hilt of his dagger, which is strategically placed between his legs. On the left stand a couple, the woman in very pointed horned headdress, looking out at the viewer lasciviously, her breast tightly clasped by her embracing lover. They all wear very pointed shoes, and the men very short, tight jerkins, all symbols of vanity.[22] In another example by the Master E.S., the *Game of Chess in a Garden of Love* (Pl. 39), the idyllic atmosphere is deceptive once more. Three young couples are assembled in an enclosed garden; the couple in the centre play chess standing on either side of a table, the woman sitting in the grass on the left is making a wreath of pearls for her lover next to her, and the couple standing on the right are singing from a sheet of notes. However, the singing lover on the

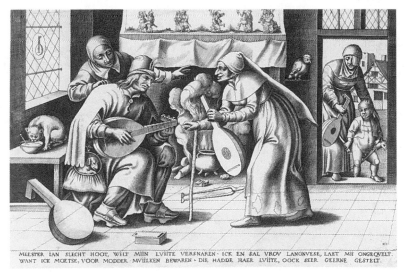

MEESTER IAN SLECHT HOOT, WILT MIIN LVIITE VERSNAREN · ICK EN SAL VROV LANONVESE, LAET MII ONGEQVELT.
WANT ICK MOETSE, VOOR MODDER MVIILKEN BEWAREN · DIE HADDE HAER LVIITE, OOCK SEER GEERNE GESTELT.

38 *Lute-maker*, by Frans Huys. An old woman comes to have her lute repaired.
This is a satire on old women looking for love

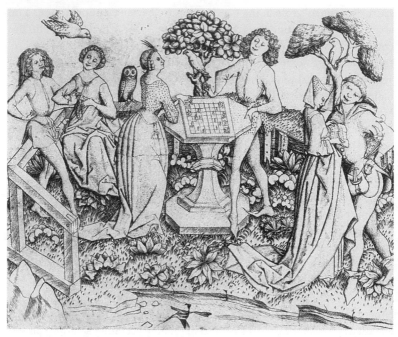

39 *A Game of Chess in a Garden of Love*, by the Master E.S. Here, the power of women over men is the meaning behind the innocent-looking dalliance of the three young couples in a lush garden

right has a tonsure, symbol of a fool, and is in fool's costume; also, his dagger is fastened over his purse and points upwards, just opposite the woman's vagina. The game of chess, which had been a metaphor of love, has become a symbol of woman's power over man, for it is now a contest in which the woman will win. Furthermore, on the fence behind the woman sits an owl, symbol of darkness and evil. The same ideas are developed to the verge of obscenity in another engraving by the Master E.S., called *The Large Garden of Love* (Pl. 40). Three couples are inside a Garden of Love, strewn with flowers, the flask of wine cools in a walled spring, and food and drink are laid out on a table. A servant is about to enter the garden with more drink. Again, the idyll is deceptive, for lust not love is the theme. The man sitting on the right of the table grasps his partner's breast and eyes her lecherously. The second couple sitting at the table look innocent, but the man offers his lady a large beaker of wine and that alone is an incitement to sexual love. Worst of all are the couple skipping towards the viewer. The woman wears a horned headdress; the man is tonsured and in fool's dress,

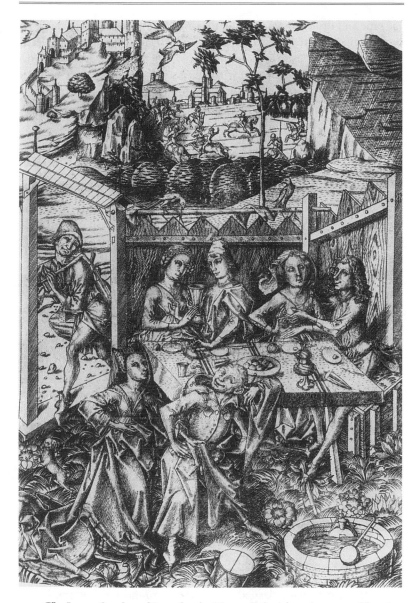

40 *The Large Garden of Love*, by the Master E.S. A bawdy scene of feasting and love-making is played out in a fenced-off garden, while a hunting scene goes on in the background

his pipe and drum, instruments of the devil and of bawdy behaviour, are on the ground before him. His coat has opened and his genitals are clearly visible between his legs, and it is the woman who has lifted his coat in order to expose them. Thus the engraving is a perfect parody of the Garden of Love, depicting sexual obsession and sinfulness to the extreme. As D. W. Robertson, Jr says: 'The garden of love is the garden of the Canticum turned upside down for purposes of ironic comedy.'[23]

Similar in concept is the Fountain of Love/Youth, which stands in contrast to the Fountain of Life as the expression of carnal love. Here, both old women and old men are rejuvenated, although most of the illustrations are of old women carted piggy-back or in wheelbarrows to the fountain by their husbands, and tipped into the youth-giving waters. This is illustrated in an engraving by the Master of the Banderolles, c. 1460–70. Old husbands throw their wives into the walled pool of water, and there they stand, now young and naked, accompanied by young men wearing minimal pants who fondle their breasts and genitals. Outside the fountain on the other side, they are dressed again but the love-making continues; the couples, including the fool from the *Small Garden of Love* by the Master E.S., have been copied and placed on the top right, and another couple in the foreground shows a woman's legs exposed as her lover lifts her dress and puts his hand up her skirt. Other figures, inscriptions and dogs all add to the sinful behaviour. The same theme is treated in a woodcut by Erhard Schön, c. 1535, where the figure of a fool crowns the fountain and urinates into the basin below (Pl. 41). His penis, organ of sexual desire, is in the shape of a cock, an ancient phallic symbol.[24] Lucas Cranach, at the beginning of the sixteenth century, was the first to translate the theme into a painting where the pool with its naked figures resembles a swimming pool with its activity; rejuvenated, the nudes disappear into bushes and tents to enjoy each other's lusty company, on the far side.[25]

The Master of the Housebook is known for his sense of humour, even in religious scenes. Several scenes in his so-called *Housebook*, c. 1475–85, poke fun at people playing games of love: for example, on a double page of an *Ill-defended Castle*, women are busy seducing and ensnaring men.[26] A couple walking away from the viewer in the foreground are embracing, while another woman, clasped by her lover around her bottom, herself pulls his head towards her. Yet another woman holds a birdcage, the symbol of a man trapped and of prostitution, while another woman tries to take it from her. In the background a peasant dangles head downwards from an animal trap. In another drawing a woman beckons a young man feeding a goose to come inside the well house, and on the chimney a stork

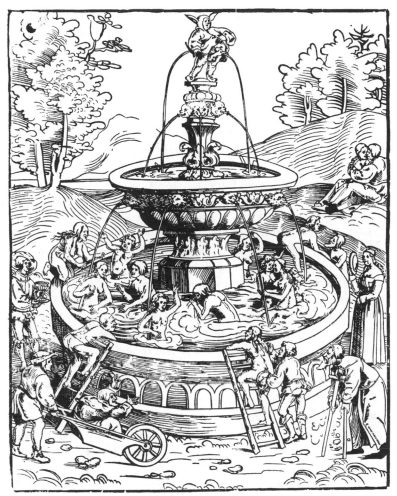

41 *Fountain of Love or Youth*, by Erhard Schön. Old people are thrown into the rejuvenating waters of the fountain, to be transformed into young lovers. The figure of a fool crowns the fountain, water spouting from his enormous cock

rears its young.[27] Another double page depicts a pond house where young men are trying to catch ducks, symbolic of catching a woman, and in a boat a woman ducks a man over the edge.[28]

As already seen in examples of fifteenth-century Gardens of Love, the fool often pointed out the moral, referring to folly and sin, and being himself implicated as the lover. He is the opposite of a good citizen,

because he is ruled by his passions in sexual matters, and he is haughty, greedy, lazy and gluttonous. Foolishness stood for sinfulness, and especially the humanists preached that sin was caused by foolishness and lack of knowlege of self, best expressed in Brant's *Ship of Fools*. In engravings such as the *Fool and the Naked Woman* by the Master E.S., sinfulness is made even more titillating: the fool in his typical dress plays the flute which points at the woman's vagina, while the woman plays the lute and looks out at the viewer. Although she is naked, she wears excessively pointed shoes. Making music incites to lust, and this couple quite clearly embody sinful sexual desire. An anonymous woodcut from the first half of the sixteenth century shows a *Fool Lying at the Feet of a Nude Woman*, tickling her genitals with a flower while blowing into a small horn. The woman, wearing only a wide-brimmed hat and chains around her neck, holds a captured bird that flaps its wings and is attached to her right hand by a string with bells. Thus, the fool has been ensnared like a bird, but his intention is to 'deflower' the woman, so that both are prisoners of their sexual passions and fall victim to sin. The situation becomes quite ridiculous when the pair are an *Old Woman and Old Fool*, as in an engraving by the Master bxg.[29] The old woman has advanced on the old man in fool's costume, and he puts out his tongue, trying to catch her mouth. He plays a lute, she holds a jar and spoon, all of which allude to sex and foolishness, so that the print once more shows up the co-existence of lust and folly which are to be condemned. The popularity of the theme of The Woman and Fool was immense, and is found in a great number of variations, not only in engravings but also in carvings. A good example is the carved and painted towel-rail by Arnt van Tricht from Kalkar, *c.* 1540.[30] A young woman in middle-class dress but with her breast bulging out of her bodice is tightly clasped and fondled by a fool. Sitting on their shoulders are two miniature fools playing the bagpipes and drum, and a third appears from the slit in the fool's sleeve. Thus, more little fools result from the relationship between woman and fool. Towel-rails with pure white towels are often found in paintings of the Annunciation, and refer to the purity of the Virgin and the fresh waters of baptism. The carved towel-rail, therefore, is a profanation: spiritual purity has been turned upside-down into carnal love, and the towel-rail may have been used in association with prostitutes in a brothel.[31] At the beginning of the sixteenth century, Hans Sachs in Nuremberg was well known for his verses ridiculing women, often based on the visual material already in existence. Thus, Erhard Schön made the *Distribution of Fools' Caps*, *c.* 1538, into a triumphal procession to which Hans Sachs added the verses (Pl. 42).[32] At

the beginning, women are seen handing out wagon loads and baskets full of fools' caps to men clamouring for them. The triumphal procession follows, headed by fools carrying placards that name their individual follies which make them eligible for fools' caps. There are two triumphal wagons, one pulled by horses with fools' ears and mounted by a woman with a whip, the other dragged along by fools and spurred on by a woman swinging a club. A woman sits in the centre of the first wagon facing outwards, and holds out fools' caps with both her hands, while another woman at the back of the wagon puts a fool's cap on a man eager to mount the wagon. The second wagon contains women cutting out fools' caps and sewing them up, and also hammering out metal bells. The finished products are put on view on the bare branches of a tree. The texts refer to false love, to the power of women putting fools' caps on men, and ends with a lament by the women that there are so many fools that they can hardly cope. In another woodcut by Erhard Schön, c. 1530, a woman sows fools' caps in a field, and while she does so, little fools are already sprouting up in the background. In fact, a beautiful woman could create as many fools as she desired, as a drawing of the *Tree of Fools*, c. 1526, illustrates, where a well-dressed woman shakes down fools like overripe fruit.[33] Some of the fools are not even fully grown, but only have heads with fools' caps that thud to the ground. The iconography here is based on the Tree of Knowledge which can turn into the Tree of Vice, or as here into

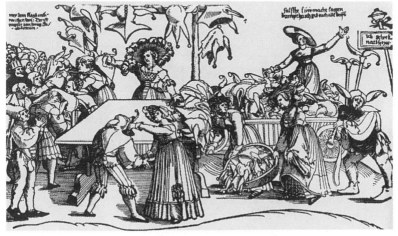

42 *Distribution of Fools' Caps*, by Erhard Schön. Powerful women are handing fools' caps to all classes of men eager to receive them

the Tree of Fools, and the woman is Eve.[34] Thus, foolishness is always related to sinfulness, and woman is at the root of all evil. That is why she is also painted as Mother of Fools on the Ambras Plate of 1528.[35] She is the central figure standing on the lower rim of the plate, enclosed by a fence which is open on the viewer's side, and her arms are extended in welcome. She is very fat, wears a bright red dress, a sparkling diadem with fool's ears, the badge of a fool's head, and shoes with yellow tops which signifies a prostitute. Jumping and agitating around her are her seven sons of different ages, all in fools' costumes, except for the baby who is naked. As already seen in the text of the woodcut of Adam and Eve in the Ship of Fools (Pl. 33), Eve was the mother of all foolishness; consequently, the Mother of Fools is also Eve. Furthermore, the text on the right-hand fence of the Ambras Plate indicates that she earns her money as a prostitute, and her seven sons may symbolise the seven deadly sins or vices.

The power of women over men was frequently expressed in scenes of men captured in nets, as in a woodcut by Niklas Stör, *c.* 1534, where men of all classes and ages are caught by women in a large net into which they come flying; the devil in a hide helps the women by pulling the strings. Men could also be caught in cages, as in a woodcut by Erhard Schön, *c.* 1530, where they are made to sing to the women's tune (Pl. 43). This again illustrates the fatal attraction of women who are in league with the devil, and above all their craftiness. Another variation on the power of women to lead men astray is found in an engraving by an anonymous German master of the mid-fifteenth century, possibly from Cologne, which shows men in

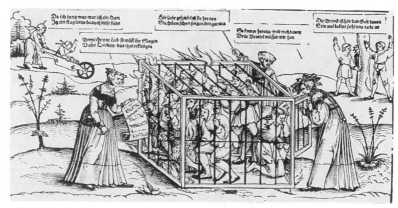

43 *Men Caught in Cages*, by Erhard Schön. Men in fools' caps are being locked inside a cage, full of flaming desire for the women, who teach them to sing their tunes

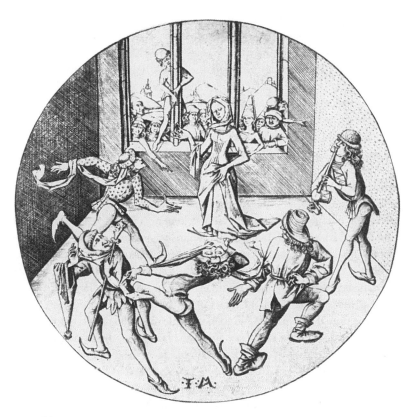

44 *Men Dancing Around a Woman*, by Israhel van Meckenem. The woman holds out a ring as a token of her favours. Other men desperately try to reach her through the window

fools' caps and apes led by Dame Folly, riding on an ass and carrying a cuckoo.[36] The inscription with it reads: 'An ass I ride whene'er I will / A cuckoo is my hunting bird / With it I catch many a fool and apes.' The cuckoo is an apt reminder of adultery, for it lays its eggs in other birds' nests. The ape, like the fool, stood for foolishness, and it too was associated with sexuality and seen as an unclean beast in the Middle Ages. In sixteenth-century England it had the reputation of being the embodiment of male sexual rapacity.[37] Likewise, on a misericord in Bristol Cathedral, a nude woman pulling apes, i.e. her foolish lovers, in tow is welcomed into the jaws of hell by the devil.

Foolish men in their passion not only allowed themselves to be led by a

woman but they also competed for her favours. This theme is exploited by Israhel van Meckenem, among other artists, at the turn of the fifteenth/ sixteenth century. In an engraving of *c.* 1480 by that artist, male dancers move around in wild abandonment and contortions, incited by a woman who tempts them with a ring, i.e. a token of her love (Pl. 44). Among the men is a dancer with flute and tabor, and a jester with his bauble. Dancing in the round was considered pagan and an enticement to lust because the dancers would touch each other and the devil was thought to be in their midst, as St Eligius had preached as early as the seventh century,[38] a view still held by moralists in the fifteenth and sixteenth centuries, who criticised dancing, in particular at country fairs, because of the dancers' wild abandonment, as though they were possessed by the devil. A similar engraving of *c.* 1490 by Israhel van Meckenem is found in the form of an ornamental frieze, with dancers, musicians and jester gyrating within the prickly tendrils of a tree that encases a temptress who holds an apple, symbol of carnal pleasure. Thus, again the men are fools, fighting over the woman, as indicated by the prickly growth and the inclusion of a dog by her feet, fiercely guarding a bone.[39]

Apart from the temptress, woman was known as the virago who, unable to get men into her clutches through craftiness or through sexual temptations alone, would use brute force. Even the devil was powerless against the onslaught of such women, as expressed in the Netherlandish saying 'to tie the devil to a cushion', meaning to make the devil impotent, powerless, tie him down. This was a theme of great popularity in the art of the sixteenth century, as for example on a misericord in Aarschot Parish Church, Belgium, *c.* 1515, where the struggling devil is fastened down on a cushion and thus immobilised by a woman. On a misericord in St Martin-aux-Boix, a woman saws a devil in half, and in a woodcut by Barthel Beham, *c.* 1532, which is an illustration to a carnival play of the same theme, an old woman fights the devil; she has grabbed him by the wrist, beats him with a stick, and demonstrates her power and supremacy by the bulging purse tied to her waist.

The situation of women ruling over men belongs to the genre of The World Upside-down or Topsy-turvy World. As an image it is best expressed by the Master of the Housebook in his drypoint of a coat of arms of *c.* 1485 showing a peasant actually standing on his head; on the helm above him, a peasant woman rides on a man who is made to hold her distaff while she spins on it (Pl. 45). In creating this image of peasants on a coat of arms, symbol of the aristocracy, the Master of the Housebook is poking fun at the old chivalrous order, and he is also reversing the accepted

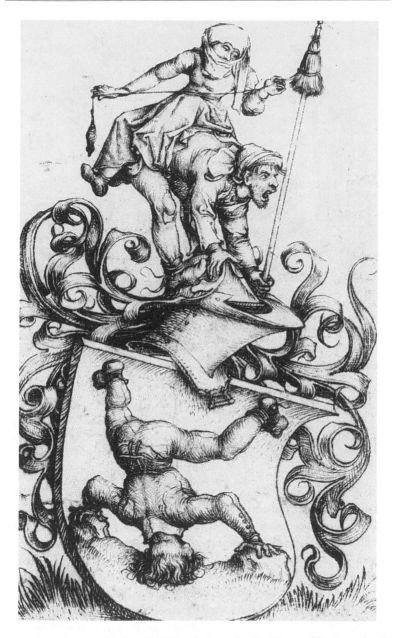

45 *Coat of Arms with the World Upside-down*, by the Master of the Housebook. The world upside-down is expressed by the peasant standing on his head, and by the peasant woman riding on a man who is made to do women's work

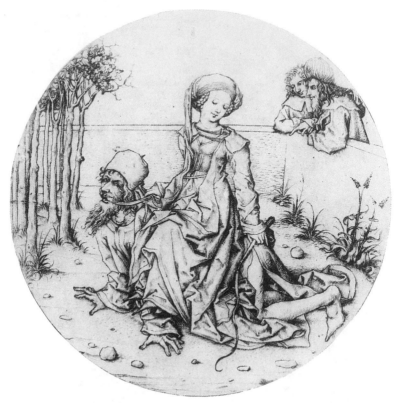

46 *Phyllis Riding Aristotle*, by the Master of the Housebook. This shows that even the wise Greek philosopher Aristotle succumbed to the wiles of a woman, and allowed himself to be bridled and ridden. Phyllis is in contemporary German dress

situation by making the man subservient to the woman. This expression of female sexual supremacy and therewith the overturning of the socially recognised sexual hierarchy became one of the most popular iconographic themes of this period, often illustrated as *Phyllis Riding Aristotle* (Pl. 46).[40] The story is told in the *Lai d'Aristote* by Henri d'Andeli which was widely known in the Middle Ages throughout Europe. Aristotle the philosopher and tutor of Alexander the Great had chastised the latter for his infatuation with Phyllis, whereupon Aristotle himself succumbed to her wiles, and was saddled and bridled by her, in order that she could ride on his back.[41] The drypoint of this subject matter by the Master of the Housebook, *c.* 1485, is a companion piece to *Solomon's Idolatry*. The aged Aristotle is

down on all fours in a secluded garden and a smiling young woman sits on top of him, holding his bridle and a whip. In this case, two onlookers observe the ridiculous situation. This scene is found in prints and drawings, carvings, metalworks and tapestries, and artists like Hans Baldung Grien, or the carver of a misericord in Straelen, 1440–50, have underlined the sexual passions by portraying both Aristotle and Phyllis in the nude. Another variation on the theme of the reversal of roles is in the Henpecked Husband, which above all shows up the woman as the virago. The distaff, the housewife's tool and symbol, has now become a weapon with which to beat the husband into submission. Thus, Master bxg depicts a violent peasant woman, her bare leg exposed and lifted high in order to kick her husband who has already collapsed on the ground. The purse and a dagger, signs of power, are around her waist and she lifts high the mighty distaff to beat her husband with, because her aim is to make him wind the wool for her, i.e. do her work, woman's work. In a woodcut by Hans Schäufelein, 1536, the husband is the *Nappy-washer*, alias the henpecked husband, seen beating the washing with a washing beetle, while the wife stands over him with a stick, and has purse and keys prominently displayed. The role reversal becomes more apparent in an engraving by Israhel van Meckenem, where man and woman are sitting next to each other, he holding the winding frame, trying to wind the wool, while looking fearfully across at his wife, who not only holds an enormous distaff high above her shoulders, but is also putting on her husband's breeches (Pl. 47).[42] The woman is therefore taking over the man's role; she is putting on the trousers, while he is doing the household chores. The history of this theme of the Battle for the Breeches must be one of the most long-lived, for 'the woman wears the trousers' is a saying still known nowadays. It was first mentioned as a thirteenth-century fabliau by Hugues Piaucelles describing the fight between Dame Anieuse and her husband Sire Hains.[43] The cause is Dame Anieuse's refusal to cook the desired titbits for her husband. The wife thus refuses obedience, she is the unruly housewife, and the man tries to meddle in the affairs of the kitchen. In order to decide who is the boss, the man takes off his trousers and puts them down to be fought over. After a lengthy violent battle, the woman's energy begins to flag and she has to admit defeat. In the story, the beating has reformed her and she is an obedient, pliant wife ever after. A real-life judicial fight is supposed to have taken place in Germany around 1400 to decide matters between husband and wife, and again the man eventually got the upper hand.[44] Yet, in contrast to the outcome in these stories, in art in general it is the wife who is victorious. There, the woman is seen to be

115

putting on the trousers and the man is handed the distaff. An engraving by Israhel van Meckenem gives a vivid illustration of the victorious woman (Pl. 48): her fingers have locked around the young man's wrist, and he is down on one knee in the position of the dying Orpheus in a drawing by Dürer which is based on dying classical heroes; her distaff is lifted high, and with one of her very pointed shoes she stands on the man's foot, thus subjugating him. Her long hair flutters wildly, indicating undisciplined passions and sexual freedom, her breasts are no longer contained by her dress, and the devil with serpent's tail inspires her from above. The breeches, the cause for dispute, lie on the ground. Another engraving by Israhel van Meckenem, entitled the *Acrobat and his Wife*, is less violent. The woman looks away from her young man, who holds on to her extended hand while standing on one leg, twirling around and balancing a double-conical object on his head. While she carries keys, purse and what looks like a knife[45] around her waist, his bag has been untied and lies on the ground. He is probably eager to dance to her tune, and do everything to please her. The Battle for the Breeches was also very popular in the Netherlands, both in prints and on misericords. On an early-sixteenth-

47 *Henpecked Husband*, by Israhel van Meckenem. The woman is putting on the trousers, while the man has to do women's work

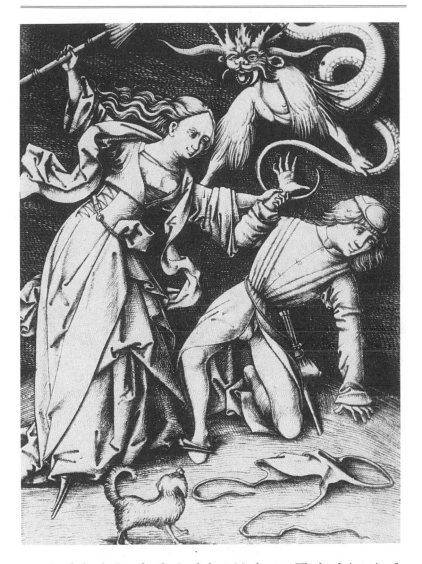

48 *Battle for the Breeches*, by Israhel van Meckenem. The battle is raging for the pants lying on the ground, and victory seems certain for the woman inspired by a demon

century misericord in Hoogstraten, a man and woman are tugging furiously at a pair of long trousers between them. On another misericord in Hoogstraten, the satire on women is even more biting, for there are several women fighting over a pair of trousers, meaning that the women are no

49 *Battle for Supremacy in the Kitchen*, misericord, Bristol Cathedral. The woman has grabbed the man by his beard, seat of his virility, after he tried to help himself to food from the large pot

longer fighting for domestic authority but are competing with each other for possession of a man. This scene is also found in a fifteenth-century German engraving, where the women, in horned headdresses, thump each other and scratch each other's eyes out, fighting over one pair of breeches held high.[46] Two fools accompany the scene, one playing the bagpipes, the other a drum.

It is interesting to note that the misericords in the Netherlands usually depict the tug-of-war over the trousers, whereas in England the fighting is carried out over a cooking pot. On a misericord in Bristol Cathedral, the woman grabs the man by the beard and has already thrown a dish at him

50 *Woman Beating a Man*, misericord, St Mary's, Fairford. She has thrown him to the ground, pulling him by his beard, making him totally subservient to her

51 *Joust between a Woman and a Man*, misericord, Bristol Cathedral. The man on a sow and the woman on a goose jousting is a satire on the battle between the sexes

for trying to lift the lid off the cooking pot to get at the food (Pl. 49). Similar kitchen scenes take place in Manchester Cathedral where the marital discord has resulted in a broken pot, allowing its broth to spill over, whereas in Beverley Minster the dog takes advantage of the situation and dives for the contents of the cauldron while the man is being caught by the hair. The English carvers must therefore have chosen that part of the story of Dame Anieuse and Sire Hains where he is trying to meddle in domestic affairs, the kitchen being the woman's domain. A very large number of

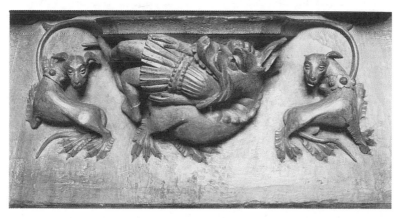

52 *Bigorne Swallowing a Good Husband*, misericord, Carlisle Cathedral. This mythical monster got very fat, because it fed on good husbands of which there was an abundance

choir-stalls include the scene of the woman beating the man, either with distaff or washing beetle, and taking hold of the man by his hair or beard, which signified the greatest of humiliations, because his hair stood for his strength and virility, e.g. Lincoln and Chester Cathedrals, 1370s and 1380s, where the man has been lifted off his feet by the beard, or Tewkesbury Abbey, c. 1430, and Fairford Parish Church, c. 1500, where he is dragged along the ground by his beard and belaboured with a washing beetle (Pl. 50). Sebastian Brant in his *Ship of Fools* says that to grab someone by the beard is an unforgivable offence. The aggressive attitude of women as depicted on misericords and in prints gives a picture of their short temper and a violent world of which Lawrence Stone writes: 'The extraordinary amount of casual inter-personal physical and verbal violence, as recorded in legal and other records, shows that at all levels, men and women were extremely short-tempered. The most trivial disagreements tended to lead rapidly to blows and most people carried a potential weapon, if only a knife to cut their meat.'[47]

Battles between the sexes are also pictured as jousts, often on most unsuitable animals, for increased ridicule, as on a misericord in Bristol Cathedral where a man comes charging on a sow with a broken-off staff, possibly originally a hay-fork, while the woman rides on a goose, armed with a broomstick and another standing upright behind her (Pl. 51). Other, more subtle forms of the battle of the sexes are found in scenes of card-playing, as in Israhel van Meckenem's engraving of a *Couple Playing Cards*. The man and woman are sitting on opposite sides of a table, enclosed by the backing of a bench, and the wine in its cooler is by their feet, reminiscent of couples playing chess in a Garden of Love. They are fashionably dressed and wear long pointed shoes; the woman has just produced the trump card, which she holds up to her opponent with a triumphant look, while he lifts his arm in shock-horror. Thus the game of cards is another of the favourite occupations of lovers, where they compete for power and where the woman, once more, is usually the winner.

The negative image of the housewife was kept alive and popular in art and literature and perpetuated the misogynist attitude of men. Even in 1541, Sebastian Franck included a proverb in his collection of popular German proverbs that went back to St Jerome defending the single life: 'If you find things going too well, take a wife.' Franck paired this with: 'If you take a wife, you get a devil on your back.'[48] Thus, the bad wife remained a favourite subject for all seasons, and the mythical monster Bigorne (Fillgut) was obese because he fed on obedient husbands, whereas Chichefache (Pinchbelly), who fed on obedient wives, was quite

emaciated (Pl. 52). There are examples of Bigorne, an enormous dragon-type monster, swallowing up husbands on misericords in Carlisle, Worcester, Gloucester and St David's Cathedrals.[49]

The perfect picture of the unruly busybody of a wife is found in the character of Metz Unmuss (Metz the Restless), pictured in an Upper Rhenish woodcut from the first half of the fifteenth century. Metz is riding on a donkey led by her insignificant-looking husband. Not only is Metz trying to spin with her distaff while riding along, but she has all her kitchen utensils slung around her neck in a sheet, carries a chicken in a basket on her head, and her baby in the cradle tied to her body. A cat with a mouse is trying to hold on to the back of the donkey, and pigs and geese wander under the feet of the donkey. This is a satirical personification of the housewife who can never sit still, who must always be doing something, however senseless, and who takes her whole household to market.

Man's greatest fear was loss of potency and the humiliation of being cuckolded, for women, especially married women, were viewed as potential sexual harpies, and even the most pious of them were thought to lust for power over men once they had experienced sexual intercourse.[50] Sebastian Brant treated the subject of adultery in his *Ship of Fools* (chapter 33), where the woodcut shows a woman tickling her husband in fool's dress with a thin twig, while he looks between his fingers; in the foreground, a cat catches mice (Pl. 53). The man, therefore, knows of his wife's adultery but refuses to see it, because once it is in the open he will be mocked by and lose his standing in the community. And just as the cat cannot leave off mousing, so the wife cannot stop committing adultery. This composition is repeated in a sixteenth-century woodcut by Georg Pencz, where the wife tickles the husband with a fox's tail, symbol of deceit, for she is pretending to ingratiate herself with him.[51] Such woodcuts demonstrate that, although German reformers had raised the status of marriage as an institution, the satirical portrayals remained most popular, blaming women for frustrated and often violent marriages. Although married women had always been satirised, as seen all along, the most famous example being Chaucer's *The Wife of Bath's Tale*, prints specifically dealing with the faithlessness of wives became a popular theme in Protestant cities of Germany, e.g. Nuremberg and Augsburg. The great emphasis on chastity before the Reformation had been replaced by very high moral expectations of family life after the Reformation, and thus, more than ever, women had to be seen to be perfect housewives. This is explained by Lynda Roper, who uses the Discipline Ordinances of 1537 in Augsburg to give a picture of the new situation after the transfer of control

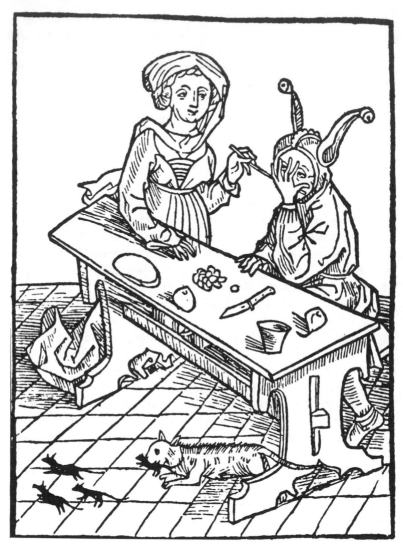

53 *Adultery*, from *The Ship of Fools*, by Sebastian Brant. The woman taunts the man, who knows what she gets up to. He is a fool who does not want to face up to reality, which would mean his loss of honour in the community

over marriage and morals from the Church to the civic council.[52] As a result of this, sin after the Reformation was seen as a public offence, an affront to civic decency, and marriage was made the corner-stone of the moral and religious universe.[53] The prints which took up this discussion

on marriage, many of them by Erhard Schön, were often accompanied by the texts of Hans Sachs, and they were published as broadsheets – an early form of news-sheets. Not only did these allow for a wide circulation, but they also made the whole discussion more public. A woodcut by Erhard Schön, the *Allegory of the Faithlessness of Women*, c. 1530, shows a woman committing adultery even before her husband has got out of sight of the house. While the husband is seen riding away from the house, a young lover is already awaiting a sign from the wife to be subsequently received into the house. There were bitter complaints about the misbehaviour of wives and instructions to men on how to nip any disobedience in the bud, to beat it out of them if necessary. A broadsheet by Barthel Beham, *Marital Discord*, c. 1530, with text by Hans Sachs, proclaims the evils of bad wives in 'The Nine Lives of a Bad Wife', where a man tells of his wife's disobedience which he counteracted with blows, only to be repaid by her.[54] The woodcut shows the woman on the ground, her distaff raised, while the man grips her by the hair and swings a stool at her. Hans Sachs's advice is to treat a young wife kindly, but use blows if nothing else works, i.e. the carrot-and-stick technique. What will happen if the wife is not kept in her place, if the husband fails to control her, is illustrated in a woodcut by Erhard Schön of 1533, of the *Husband Who Does Not Rule*.[55] The wife has taken over her husbands's sword, purse and trousers, thus having gained control over the man, even sexually. He is on all fours, pulling a butter cart while she whips him on. A young couple, a woman-fool and an old man follow, and comment on the scene; the accompanying verses underneath the illustration have a speech for each character: the wife points out how difficult it is for a beautiful young woman to put up with poor clothes, hunger and housekeeping; if the man wants a pious wife, he should stay at home and not carouse about; if he will not work to support his wife, he will be forced with a whip to wash, spin and draw the cart. The husband bewails his fate and warns those who marry before they have mastered a trade and possess money; his life is a misery and his wife has made off with his purse, sword and codpiece. The young man from the couple following is worried by what he sees, but the virgin by his side reassures him that if he is a man in all things, then she wants no such power over men. The woman-fool advises the man to avoid marriage altogether, to live it up and to take a concubine; the old man, however, warns against the wiles of such women. The full extent of evil in a wife is brought out in the woodcut by Erhard Schön, the *Evil Wife*, c. 1530, with verses by Hans Sachs (Pl. 54).[56] Here, all the husband's attempts to chastise his wife have failed. The couple are seen before a kitchen in chaos: he has raised a stick

but she is already taking hold of his hair; the two children, unkempt and dressed in rags, are up in arms. In an inset, the couple are seen standing before a judge; the wife has taken the husband to court and accuses him of all the sins that she has committed. In the end, the husband despairs, and in the background right, he is seen walking into the river.

Young women and old spinsters who had not found a man were also made fun of in woodcuts by Erhard Schön, created to go with farcical text by Hans Sachs, based on ancient carnival customs. One of these, from 1532, shows the women harnessed to a plough, whipped along by men. In this custom, known since c. 1450, a ploughman would walk in front, symbolically sowing men for these spinsters.[57] A woodcut of 1533 is closely related. Here, a carver with all his tools on the ground is hewing away at a large wooden block with his adze, and already the outlines of a man are visible. This is to be the man who will be forced on the spinsters; he is a 'block', the German for a large, thick and uncouth fellow.

The dissatisfaction of both sexes with one another found expression in two broadsheets, again by Erhard Schön. The husbands complaining about their wives are shown as seven men and the poet sitting in a public beer cellar, all dressed differently as representatives of different social classes or professions. They are all numbered: (1) A young man who has an 80-year-old wife who wants him to be thrifty and stay at home and keeps telling him off. (2) An old man who has a young wife, who pretends that he doesn't belong to her. She spends much of her time in front of the mirror, making herself up, and she then looks out of the window to attract young men. She complains that he is always trying to tell her what to do for her own good. (3) A man who has a lazy wife who won't bother about the household. She forgets to bring cabbage from the market for lunch, the peas get burnt, and the house is like a pigsty. (4) A heavy man whose wife is the master. He failed to keep her in tight reins, so she took charge of his money and he has taken to drink. (5) A wild fellow whose wife is a drunkard and spends all the money on drink. (6) A bearded man whose wife is the devil incarnate. She is always scolding and arguing, and he can't do anything right. He beats her up, then leaves the house for two to three days, but she often comes after him and gets him out of the pub. (7) An honourable man whose wife is fat and heavy. She used to be thin. They both agreed to do what they pleased, be friendly to each other and keep the peace. This man advocates punishment with good sense, and that every man should educate his wife to ensure a peaceful life together.

Seven women oppose the seven men with their complaints, and they sit in an enclosed garden with a fountain, reminiscent of the *hortus conclusus*

of the Virgin or the Garden of Love. Thus, the women are once more associated with love, whereas the meeting place of the men is one where 'serious business' is discussed, and from which good women are excluded. Like the men, the women are stereotypes with the same complaints, though talking to others about private affairs, making them public, is contrary to a good woman's behaviour: (1) The oldest woman, whose young husband has become faithless. She has made a gentleman out of him, but he now despises her. He goes whoring and sleeps with the maid, and spends all her savings. (2) A young woman who has an old, grey husband. She married him for his money but he turned out to be a miser. He is suspicious of her and keeps an eye on her. Her passions are not satisfied and she is afraid that she will die. (3) A poor woman whose husband is lazy and refuses to work. He cares nothing about his business, borrows money which he can't repay, and so is brought before the court. Nor can he pay the rent, so everything is pawned. (4) The husband is a drunkard, always found in the wine cellars. He only comes home to throw up, so everything stinks. He is always hungry and the children suffer and

54 *Evil Wife*, by Erhard Schön. In the foreground, a couple are fighting, while their children are up in arms. All this is seen as a result of the wife's belligerency and total neglect of her family

there is nothing to live on. (5) The husband is a gambler who spends all his money at cards, and when his wife chides him, he beats her up. He chases the servant and maid out of the house. All the clothes are pawned, including his good clothes, and in the end she has nothing but straw to lie on at night. (6) A weeping woman who complains that her husband whores, drinks and loses at cards; he tells lies, is lazy and steals; is rough, obscene and curses like a heathen; fights, and she often has to flee at night. She hopes that he may hang by the gallows. (7) A stout, honourable wife whose husband is often away for a long time to fairs and abroad. She gives the advice to persuade a husband to give up his bad habits with sensible words, and to help him reform, because otherwise the wife will be dishonoured with him.

In all these prints created around the theme of marital rebellion, women were, as always, viewed with suspicion because of their dangerous seductive properties, and once they had beguiled men into marriage, they would become master of the house. Once again, in real life the situation was rather different, and the extremes of beatings could only have been applied by husbands to wives, because they had the right to do so by law. The early-sixteenth-century Swiss artist Urs Graf, known for his depictions of women as temptresses, is an example of this; he is known to have beaten his wife so badly that he was sentenced to several terms of imprisonment in Basle gaols. The most even-handed depiction of men and women is in the last two prints by Erhard Schön, where the faults on both sides are enumerated by text. However, more popular prints would certainly be the exaggerated ones, especially the titillating ones for men. This can be illustrated by two prints: an engraving of the *Peasant Woman Pushed in a Three-wheeled Barrow*, c. 1475–80, by the Master bxg (Pl. 55), and a woodcut of the *Spinning Room*, c. 1527–30, by Barthel Beham. The peasant woman in the wheelbarrow wears a large hat, and clutches a flask in one hand and a barren twig in the other. The same composition occurs in the bottom margin of a French Book of Hours depicting the Labours of the Months where the woman carries a flail; this explains that, originally, she was being taken to the fields by force in her drunken stupor.[58] In the print the flail has been replaced by the barren twig, which was used at carnival as a symbol of foolishness. The print became extremely popular and was widely disseminated: it can be found on a misericord in Ripon Cathedral, 1489–94, on a side panel to the choir-stalls in Baden-Baden, and on a stone frieze on Breslau (Wroclaw) Town Hall. As for the print of the *Spinning Room*, it is true that these existed in reality. They were places where the rural youths came together, usually on winter afternoons and

55 *Peasant Woman Pushed in a Three-wheeled Barrow* by the Master bxg. As her bottle indicates, she is quite incapable of walking

evenings in order to converse and work together. These get-togethers, however, are depicted as examples of excessive erotic behaviour and lack of discipline. Couples are sitting around lazily by the tiled stove or cavorting lustfully. There is much groping and tumbling, exposing bare bottoms, and the women's distaffs are very prominent as phallic symbols; the cabbages and parsnips scattered on the ground were known as aphrodisiacs, and associated with the female womb and male genitalia. Thus, prints were part of the tradition of the marginal arts, where amusing subject matter of the topsy-turvy world was the norm, which did not exclude a moral message, but where real-life situations were spiced up.

Prostitutes

Women beyond the realm of the family home were the prostitutes and bath attendants, who were mostly one and the same. Their biblical predecessor was the Babylonian Whore in St John's Revelation (Chapter 17), who tempts humanity, and in particular men, to perdition. In Albrecht Dürer's woodcut from his series of the *Apocalypse*, 1498–1511, she rides triumphantly on a seven-headed beast, offering her golden cup filled with the wine of iniquity. Before her, people look at her in admiration and a monk has gone down on his knees to venerate her, while Babylon burns in the background, often identified with Rome and the corruption of the Church

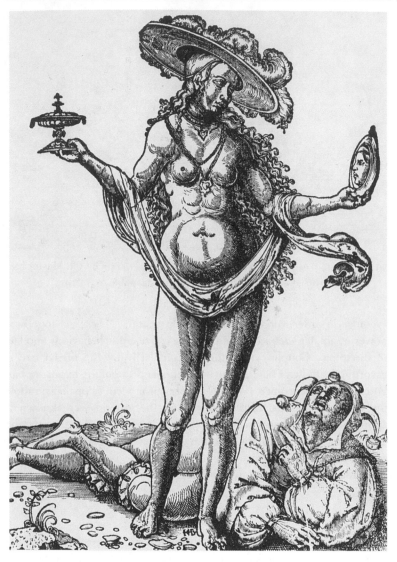

56 *A Whore Venerated by a Fool*, by Hans Brosamer. The nude, holding chalice and mirror, is in the image of the Babylonian whore, and the fool is representative of all men

at that time. The eroticism of this theme is intensified in the prints of the sixteenth century. Hans Brosamer, *c.* 1530, depicts a whore wearing but a fluttering piece of drapery and a wide-brimmed hat, and holding a chalice

in one hand, while looking at her reflection in the mirror held in the other; a man in fool's costume lies transfixed at her feet and looks up at her long-ingly (Pl. 56). In an engraving of a *Brothel*, the Master of the Banderolles, from the Northern Netherlands, active in the second half of the fifteenth century,[59] shows a young man, wearing the Order of the Maltese Cross, as he caresses the breast of a nude woman sitting at his side, while she touches his thigh from which his coat has slipped. Another nude woman stands in the room holding a beaker, and a fool entering the room looks through his fingers, not wishing to see what he sees. Drink stands on a small table in the room. Food and drink, in particular wine and ale, were always associated with brothels; alehouses, too, because of the drinking and gambling that went on, were considered houses of ill repute. Likewise, bath-houses had the reputation of brothels,[60] and many fifteenth-century manuscripts show people taking baths, women and men sitting together in a tub, a tray with love food and drink between them. After the bath, the couples proceed to beds standing at the ready. Most explicitly, the sin of *luxuria* rules in these baths, and in many of the prints, the women are ac-tively tempting men, often dressed as fools, into the water, as in another engraving by the Master of the Banderolles, *c.* 1470. There, the women are pulling a fool who is trying to get away into the canopied bath-tub, above which is seen a bed with a couple about to get into it. The popularity of such subject matter can be judged by the fact that the same motif is used on a clay model.

Prostitutes are also shown accompanying armies of soldiers on their campaigns, e.g. in the work of Albrecht Altdorfer, dressed in low-cut gowns with wide slit sleeves and wide-brimmed feathered hats. The exposure of their breasts and parts of their legs indicate their indecency. The Swiss artist Urs Graf, who was a soldier himself, created many provocative engravings of the relationship between whore and soldier, the soldier violently groping underneath the woman's skirt and Death lurking, ready to pounce. Such works by Urs Graf give a picture of the precariousness of the life of a real prostitute, who was exposed to infectious diseases, such as syphilis, or death in childbirth. As Lynda Roper says, economic pressures forced these women to keep working because brothels were shut on many days, such as holy days, when the women would earn no income. The situation would be aggravated by illness, and many would get into a cycle of debt, borrowing from the brothel keeper.[61] Once in debt, they were unable to leave and reform in the St Magdalene convents provided for the salvation of their souls. In Hieronymus Bosch's painting of the *Vagabond*, the dilapidated half-

timber brothel probably tells more realistically of the poverty and baseness of such an abode.[62] A man urinates against the side of the building, and in the doorway a prostitute and soldier embrace, while another dowdy-looking woman peers longingly past her mirror out of the window towards the pedlar. The pedlar was one of the most despised members of society, because he would sell his wares, such as combs, ribbons and belts, to the prostitutes and get them into everlasting debt, to be repaid by their services.

Dürer's first drawing from life of a nude woman, made in 1493, is of a bath attendant, i.e. a prostitute, as deduced from her turban-type headdress, which has partly unwound, and the slippers she is wearing.[63] Thus, at this time, only a bathmaid could have been available to stand for Dürer in the nude. He also made a drawing of the *Women's Bathhouse* which looks realistic, but on closer observation is a study of women of all ages and in varying positions as they wash themselves. Also, Dürer added the *frisson* of having the taste of a forbidden view, by including a Peeping Tom who peers in through a hole in the facing wall!

Little remains of the secular decoration of houses and castles, such as bathrooms, due to their destruction, but the fragments and design of the entrance wall to the Regensburg baths may give an insight. The paintings for Regensburg baths were commissioned from Albrecht Altdorfer, c. 1535, by Johann, Count Palatine of the Rhine, 1488–1538, in his function as administrator of the Regensburg Episcopacy. His lifestyle at that time was compared to that of the Roman Lucullus because of its extravagance. Altdorfer's design shows illusionistic spaces with a staircase in Renaissance style; women are washing themselves, combing their hair, and lovers are playfully embracing; a woman in gorgeous dress and hat, probably a prostitute, carries flasks of wine upstairs, where spectators watch the bathers below from a balustrade. Thus, again there is the voyeuristic element, and the manner in which the nudes are painted and look at each other or touch each other is very erotic. There was therefore a tradition of bath-house scenes, which in emphasising the erotic aspects were really didactic, intent on warning people of the temptations of the flesh, for in such a relaxed and humid atmosphere one sin could lead to another, and the woman as prostitute was the main instigator.

The attitude to brothels before the Reformation was much more lax and they were part of a town's ceremonial resource, catering to the needs of such visitors as Emperor Maximilian I and his retinue.[64] Also, it is thought that they contributed to the preservation of social order and protected decent women from male demand for a sexual outlet.[65]

Protestant reformers, however, preached against prostitution and Luther, in 1520, argued that there should be no brothels in Christian society.[66]

Witches

There was an even darker side to women conjured up by men's obsessive fears, which associated them with demonic powers and knowledge of the occult; in short, women were seen as witches, whose insatiable sexual appetites could only be satisfied by the devil with whom they would enter into a pact. All through the ages there had been the belief in women who were able to use magic powers for good or evil, but these sorceresses were differentiated from the 'modern witches' referred to in the *Malleus Maleficarum* (The Witches' Hammer), published in 1487.[67] This handbook on how to detect witches was written by Jacob Sprenger and Henricus Institoris, who believed that these witches who flew off to the witches' sabbath for orgies of copulation with the devil were a new phenomenon, for they owed their powers to this pact with the devil. Most horrendous of all, it was said that they would murder new-born babies and boil their bones in order to make an oil which, rubbed on their bodies, would allow them to fly to these satanic meetings. Not to believe in such heinous witches was heretical in itself according to Church dogma.[68] The hunt was therefore on for these women outside the control of the Church and in the clutches of the devil.

Superstitious beliefs could make witches out of those women who were in particularly vulnerable positions, such as midwives, who could easily be blamed for the death of a new-born child. Witches could even kill the embryo in the mother's womb, it was thought; and only a witch would cause a man's impotence or sterility, a belief that played an important part in arguments used for divorce in the Middle Ages. Also, women's knowledge of herbs and their medicinal properties could be suspect, resulting in accusations of sorcery, of casting spells and mixing magic potions. In an age when plagues and famines kept recurring, natural disasters could only be explained as God's punishment for a sinful life on earth, and in an attempt to find scapegoats all sorts of superstitions were stimulated. Sudden and unexplained illnesses and deaths could only be the result of a witch casting an evil eye. Witches created hailstorms that would ruin the crops. There were major European grain crises in 1437–39 and 1481–83 which, combined with fear of an apocalyptic end of the world in the form of a deluge on 25 February 1524, already announced in 1499 by a German astrologer,[69] may have contributed to a widespread belief in

witchcraft at the end of the Middle Ages. This could effectively escalate into a witch craze with the help of the printing press, which was full of reports of strange misshapen births of humans and animals. The *Malleus Maleficarum* itself was only illustrated with a decorative frontispiece and had no representations of witches. The first tract on witches to be illustrated, 1489–94, was written by the lawyer Ulrich Molitor from Constance in 1484. He actually argued against the persecution of witches because he was sceptical of the value of confessions under torture. He did, however, believe that they were heretics and should be punished with death. In the illustrations, the witches are not characterised by any special dress or undress, implying that all women were capable of being witches. They look like ordinary housewives except in the *Flight to the Witches' Sabbath*, when they have changed into animal shapes. Although the text speaks of the witches' evil activities being figments of their imagination, delusions inspired by the devil, the illustrations portray the effects of their malignant and harmful magical spells as real enough, e.g. a witch shooting at a man who tries to jump away, or witches making a brew, using a rooster and a serpent as ingredients, while hailstones come crashing down from the sky. Molitor certainly believed in the reality of their sexual intercourse with the devil. In the woodcut, the woman and devil are standing closely embracing, the devil dressed in the short waistcoat typical of young men of the time and a hat, his clawed foot and tail visible to the viewer.

The artist best known for his depictions of witches is Hans Baldung Grien. His drawings, woodcuts and paintings show voluptuous, sensuous women brewing magical potions, flying on pitchforks or creating disastrous weather. They are in tune with the demonic forces of nature, their fleshy bodies lithe and elongated, their hair streaming wildly. In a clair-obscure woodcut of 1510, preparations are being made for a *Witches' Sabbath*, and the use of light and dark increases the demonic atmosphere (Pl. 57). Two witches sit in the foreground, one facing, the other seen from the back, between them a pot with a magical inscription which lets off surging streams of steam that propel toads into the air. There is no fire under the pot, but according to the *Malleus Maleficarum*, demons turn into steam through condensation. The mirror lying in the foreground refers to the association between witchcraft and looking into the future. Pitchforks and skeletal remains are scattered over the ground, and on the left sausages hang over a pitchfork, in reference to male organs that have been bewitched away, thus causing impotence. (The association between male organs and sausages was usual in the language of that time.) A third witch, an old hag, faces and lifts high a dish of satanic fowl, while a fourth

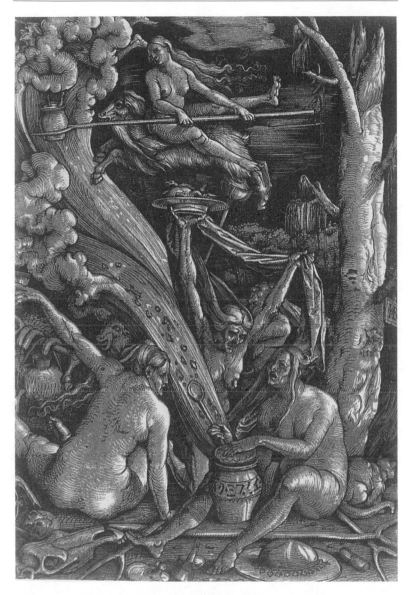

57 *Witches' Sabbath*, by Hans Baldung Grien. The nude witches secretively go about their dubious tasks, surrounded by ghostly apparitions and creatures of the night

flies, riding backwards on a goat and balancing a pot on her pitchfork that seems to contain human remains. The dead tree on the right characterises the usual place of assembly for witches, designating it as a place of the dead, of ghosts or forest demons. In the case of the Virgin, sitting on the ground means humility, but when witches crouch on the ground it indicates their union with nature and earth, and it was this association with earth that men feared in women, believing them to be in league with the demonic in nature and out of men's reach and rational influence.

A drawing of 1514 by Baldung Grien[70] depicts three witches, two young and one old, again with wildly streaming hair, climbing over each other, the one nearest the viewer bent over and glaring through her legs, her bottom towards the spectator. White highlights increase the smoothness of their skin and the fieriness of their hair, like the surging flames in the pot held up by the witch furthest back. Most astonishing is the inscription to this rather obscene drawing, which identifies it as a New Year's greeting to a cleric. How is this to be understood, and in what spirit did the cleric thus addressed take the message? The clergy were often satirised for their pleasure-loving and womanising lifestyle, and the drawing may be a dig by Baldung Grien at one easily bewitched by women, yet conscious of his own weaknesses as a sinful human being, and therefore capable of receiving this rude gift with a sense of humour.

How can Baldung Grien's great preoccupation with witches be explained, given that he never saw any persecutions of them? Strasburg, of which he had been a citizen since 1509, had no persecutions of witches till the seventeenth century, and there were only two cases of religious persecution between 1525 and 1550, concerning blasphemy and bigamy. However, in 1508 the theologian Johannes Geiler von Kaisersberg was actively preaching his lenten sermons in that city, many of which dealt with the deeds and nature of witches; these were published in the *Emeis* (*The Ants*) in 1517.[71] Baldung Grien very probably knew the sermons, because the woodcuts in the *Emeis* are based on Baldung Grien's woodcuts of witches. Baldung Grien came from an academic family and frequented the humanist circles of Strasburg, known for their interests in classical literature and law. Religious questions were not uppermost in the minds of the educated class, and Baldung Grien's patrons came from the nobility and people in very influential positions. Among the hotly debated topics of discussion at the time, indeed, were witches' ability to fly and the validity of witch-hunting methods. Hans Baldung Grien's main interest lay in the extent of evil and the force of amoral sensuality in human beings equated with animal passions; this was exemplified through his style, creating

bodies and movements of great erotic potency. The theme had thus become an artistic and intellectual problem for Baldung Grien, balancing the eroticism of the witches with the aesthetic quality of their nudity. Artists found different visual solutions according to their beliefs. This can be illustrated by examining the interpretations of *Melancholy* by Lucas Cranach the Elder and Albrecht Dürer.[72] Cranach's figure of Melancholy is copied from Dürer's engraving *Melancolia I* of 1514; but whereas Dürer follows humanist thinking in depicting Melancholy as the thwarted genius under the influence of Saturn, bowed down and inactive, Cranach's Melancholy looks out at the viewer and is busy sharpening a stick. The dog on the ground, curled up and asleep in Dürer's work, is here being teased by cherubs, and on a table are a bowl of fruit and glasses of drink. The room opens up into a landscape, where a dark cloud carries a horde of witches in flight, on horse, ox, goat, boar and stag. Cranach here follows Luther's concept that all sadness and melancholy derive from Satan, not from Saturn. To combat melancholy, he advocates prayer, religious songs and a sensible, non-ascetic lifestyle – food and drink, and the company of God-fearing people. It is devilish temptation which appears like a dream-vision in Cranach's painting, yet the impression given is one of light-heartedness, in contrast to Dürer's engraving, which does not contain witches but has a threatening, depressive quality. In Cranach's painting, the witches are more like an irritation; they blow past in the sky without long-lasting effect.

The *Malleus Maleficarum* had stimulated much preoccupation with and questioning of witchcraft, but it remained very much a scholarly theme for artists and humanists; witch-burning itself was isolated and the climax of the witch craze was not reached till the seventeenth century. Women had always been an easy prey because of Eve's temptation at the Fall. There was a long tradition of misogyny and preaching associating women with the vanities of the world, and with lust. Because of their inherent traits of indiscipline, disobedience and sexual straying, women could easily be accused of heresy. Thus, the mechanisms leading to persecution were all in place, and women far outnumbered men as victims of the witch craze.

As seen in the illustrations throughout this chapter, women were depicted as stereotypes, their main aim being to upset the norm of life; the housewife was the virago, always doing battle with the man, and being victorious; even the devil was no match for women. Carnal love and vanity were highlighted as women's main driving forces, and the Garden and Fountain of Love were filled with phallic symbols. Old age did not bring

wisdom, either to men or to women, but always more blame was apportioned to women. Men were fools succumbing to women's wiles, and foolishness was the major theme of the prints of this period; the increased production of prints coincided with the age of humanism, when human foolishness as the cause of sin was much discussed. The best-known examples were Sebastian Brant's *Ship of Fools*, where the whole world consists of fools, and Erasmus's witty *In Praise of Folly*. Depictions of The Woman and the Fool proliferated, the woman often in the nude, as a prostitute; always, women would lead the men on, would ensnare them, their powers of temptation coming naturally to them, and allowing them to command men with ease. They were held up as bad examples, requiring male surveillance to keep them on the straight and narrow path, and in illustrated books like The Book of the Knight of La Tour-Landry, foolish women are severely punished. The pictured women, however, resisted all control, and made men's tasks impossible.

Notes

1 Illustration to a booklet by the Flemish humanist Josse Bade from Ghent, printed in Paris, *c.* 1500. The title of the booklet, *La Grant Nef des Folles*, is borrowed from Sebastian Brant.

2 The Ship of Fools has its counterpart in 'la nef divine', rowed by the Pope and the Fathers of the Church, in the centre of which is Christ on the Cross with Mary and St John; the Foolish Virgins have been left behind on the banks.

3 The cope has scenes of the life of St Magdalene, and this particular one may be a powerful warning to celibate priests.

4 Roper, L., 1989, p. 202.

5 Compiled in English in 1303.

6 Description from Jacques de Vitry: XIX, fol. 20r, and CCXXXIX, fol. 138v, in Crane, 1890.

7 ll.255–77.

8 O'Reilly, 1988, pp. 384, 385, fig. 33b. Vanity is part of pride, and lust is a sin committed together with man.

9 Karras, 1992, pp. 237, 239.

10 Madrid, Prado.

11 Quintus Septimius Florens, *The Appearance of Woman* (De Cultu Feminarum).

12 Owst, 1926, p. 123.

13 Owst, 1961, p. 431.

14 Owst, 1926, p. 190.

15 National Gallery, London. She is so called because of John Tenniel's drawing of her for the Ugly Duchess in Lewis Carroll's *Alice in Wonderland*.

16 Massys's painting is related to drawings of caricature heads by Leonardo da Vinci, and there is also a connection with a drawing by Hollar of this woman and a man in profile, side by side. Quentin Massys was acquainted with Erasmus, for he painted

a portrait of him. Quote from Erasmus, 1971, p. 109.

17 Stewart, 1977. Chaucer's *The Merchant's Tale* tells of old January marrying young May, and being deceived by her and her lover Damian up in a pear tree.

18 Washington, National Gallery.

19 After Cornelis Massys.

20 'Meester Jan Slecht Hoo(i)t, Wilt miin Luiite Versnoren.
Ick En Sal Vrou Langnuese, Laet Mii Ongequelt,
Want Ik Moetso Voor Modder Musiiken Bewaren,
Die Hadde Haer Luiite Oock Seer Geerne gestelt.'
Moxey, 1989, p. 50.

21 Lehrs, M., 1969, fig. 102.

22 Munich, Staatliche Graphische Sammlung. The print is now a fragment, and the two couples cut apart.

23 Robertson, 1980, p. 49.

24 Mezger, 1991, p. 273. The motif of the male member in the shape of a cock has a long tradition that goes back to classical antiquity, as well as the connection between the cock and sexuality.

25 Berlin Staatliche Museen, Preussischer Kulturbesitz Gemäldegalerie.

26 The Master was probably working for a noble family, for his Housebook, in Waldburg-Wolfegg Collection, Germany, deals largely with military matters. It consists of drawings, some of them in colour.

27 The stork was associated with the Annunciation because, as the stork announces the coming of spring, the Annunciation to Mary indicated the Advent of Christ. Ferguson, 1961, p. 25.

28 In the Netherlands, a man fondling a duck was a 'Hennetaster', i.e. having sex with a woman.

29 German artist, active in the last quarter of the fifteenth century; close to the Master of the Housebook; his name derives from the signature *b x g*.

30 House Koekkoek, Cleves.

31 Mezger, 1991, p. 146.

32 Woodcut in four parts.

33 Coburg, Kunstsammlung der Veste; attributed to Hans Weiditz or the Master of the Petrarca Illustrations.

34 Mezger, 1991, p. 347.

35 Innsbruck, Castle Ambras; made of wood in the Upper Rhine region; Mezger, 1991, pp. 325–7.

36 Lehrs, M., 1969, fig. 30, who attributes it to the 'School of the Master of the Playing Cards'.

37 Janson, 1952, p. 208.

38 Geisberg, 1953, p. 35; and van Scheltema, 1938, p. 55.

39 The same ornamental pattern is used by the artist for a Tree of Jesse, where the tendrils are without thorns and bear fruit.

40 The theme is also called Women's Wiles.

41 Reid, 1958, no. 11; and Heron, A. (ed.), Henri d'Andeli, *Le Lai d'Aristote*, Rouen, 1901.

42 Lehrs, 1969, no. 649; Geisberg, 1974, no. 395.

43 Wright, 1865, pp. 125–8.
44 Wright, 1865, pp. 129–31. The couple faced each other with the woman standing above the pit into which the husband was placed up to his waist. The wife had as a weapon a stone wrapped in an elongation of her sleeve, while the husband had one arm tied to his side and a short staff in the other.
45 People used to carry cutlery around with them, and a woman needed a knife for her housework.
46 Possibly by the Master of the Banderolles. Ill. in Wilberg-Schuurman, 1983, pl. 16.
47 Stone, 1977, p. 93.
48 Ozment, 1983, p. 3.
49 Taylor, 1980.
50 Roper, 1989, p. 85.
51 Geisberg, 1974, no. 827; also attributed to Flötner.
52 Roper, 1989, p. 56.
53 Ibid., pp. 64–6.
54 Mende, *Die Welt des Hans Sachs*. Exhib. Cat., Nürnberg, Stadtgeschichtliche Museen, 1976, no. 65.
55 Roper, 1989, pp. 258–9, pl. 11.
56 *Die Welt des Hans Sachs*, 1976, no. 67.
57 Mezger, 1991, pp. 353 and 384.
58 Paris, Bibliothèque Nationale, Ms. lat. 1173, fol. 4 (August), Book of Hours of Charles d'Angouleme, probably from the workshop of Jean Bourdichon.
59 So called because of his characteristic use of scrolls.
60 The mistrust of bath-houses goes back to St Jerome; P. Scaff and H. Wace, eds., p. 378.
61 Roper, 1989, p. 95.
62 Also called the *Pedlar*; Rotterdam, Boymans-van-Beuningen Museum.
63 Bayonne, Musée Bonnet.
64 Roper, 1989, chapter 3.
65 Reeves, 1995, p. 205.
66 Ibid., p. 106.
67 See Dresen-Coenders, 1987, p. 59. The *Malleus Maleficarum* did not affect England, and was only translated from Latin in modern times, whereas it was issued sixteen times in Germany before 1700; Thomas, 1971, p. 523.
68 New doctrine in edicts of Papal Bull 'Summis desiderantes affectibus' of Innocent VIII, 1484; Thomas, 1971, p. 521, and J. W. R. Schmidt (ed.), 1982, p. 5.
69 Gibson, 1973, p. 52.
70 Vienna, Albertina.
71 Davidson, J. P. 1987, p. 21.
72 Cranach's painting of 1528, Private Collection; Koepplin and Falk, 1974, I, cat. no. 171, p. 292.

4

The ages of woman

In the Middle Ages, life was divided into different ages, varying from three to ten, Aristotle for example considering youth, middle period and age, and Isidore of Seville advocating six ages according to the six Ages of the World. Seven Ages was very popular because of the great symbolic significance of seven, the number of planets, days of the week, sacraments, liberal arts, etc. The Ten Ages were more often used in German-speaking areas in the fifteenth and sixteenth centuries. Usually, however, the ages of men rather than the ages of women are represented in art, and the main difference is that the men rise to a professional and active public life and descend into inactivity and senility, whereas it is women's sexuality which matures and declines. The artist most interested in the ages of women was Hans Baldung Grien. His *Seven Ages of Women*, 1544, stand before a blue sky with white clouds and begin with a child, about two years old, sitting in the foreground left and playing with a silver chain; it wears coral beads with an amulet around its neck to protect it against all harm.[1] Next to the child on the ground is a parrot, which has been variously interpreted: as associated with Eve, as a symbol of longevity or as the continuously recurring ages of life, due to its ceaseless chatter.[2] The first standing figure is a young girl, framed by climbing grapevines and a stem of fig leaves. The women, who can be considered as nude, link arms and are placed on a diagonal upwards towards the right of the picture, the oldest woman turning the movement backwards again by standing between the fifth and sixth Ages and looking down towards the left. Although all placed next to each other, the first three standing young women are grouped together, are lightly draped with flowing hair and stand on green grass, whereas the last three stand on sand, their drapery is darker and heavier, and the oldest woman has her head totally covered in a hood. The fifth Age wears the ring of a married woman and is the first to

have her head covered. Their bodies become fuller as they age, and as the breasts of Age six are beginning to sag, the woman looks out at the viewer longingly, realising the onset of old age. All, however, look healthy, and it is thought that the women are depicted at seven-year intervals and that the oldest is about fifty years old.³ A painting of the *Three Ages of Death* is considered to be a copy of a lost original by Hans Baldung Grien, and possibly once formed a pair with the painting of the *Seven Ages of Women*.⁴ Here, three women seen against a night sky are taken away by skeleton Death who points to a yawning grave. A magpie, skull and bones are on the ground. The magpie can be seen as the bird announcing death, or be compared to cantankerous old age. The woman on the left stands upright and her head and lower body are covered by drapery. The second woman is in the nude and, although younger, is bent over and looks haggard and very ill; she has a wreath on her head and clasps a crucifix, while a small child sits on the ground, and may belong to her; the third, old woman, nude and walking on a stick, is being dragged forcibly by Death into the black grave. The grave, however, is not empty but in it lies Christ, who has thus preceded humanity into death and gives hope to Christians following.

In depictions of the Children of the Planets, a deity rules over both men and women, and influences their characteristics and lives. Six ink drawings by the Master of the Housebook, *c.* 1475–85, show six planets ruling over the activities of their 'children'. Women goddesses are Luna and Venus; but in all the occupations of the children, the women are subsidiary to the men, and only figure more prominently as children of Venus. Saturn's children who are characterised as pale, hard, cold, sad and old, include an old crippled woman on crutches. The children of Mars are marauding soldiers, but while one woman throws up her arms in despair, the other two women vigorously attack the mounted soldiers with distaff and water-jug. Mercury was the planet which ruled the visual arts before Albrecht Dürer, following Aristotelian ideas under the influence of Italian Neoplatonic thought, introduced melancholy as the characteristic of artistic genius, associated with Saturn. In the representation by the Master of the Housebook, the artist painting a small altarpiece of the Madonna with Child and St Catherine is inspired by his sweetheart leaning over and putting a hand on his shoulder, and the master's wife, sitting at a well-stocked table with him, hands a beaker with wine to the sculptor against the wishes of her husband who is trying to restrain her.

The death of woman

The late Middle Ages were obsessed with the thought of death, fearing the battle for the human soul at the hour of death between the devil and St Michael. A sinful, unrepentant life would end in everlasting hellfire, and visual imagery was produced to warn human beings of the sudden appearance of Death, and of their total impotence in his grip. In cloisters and on

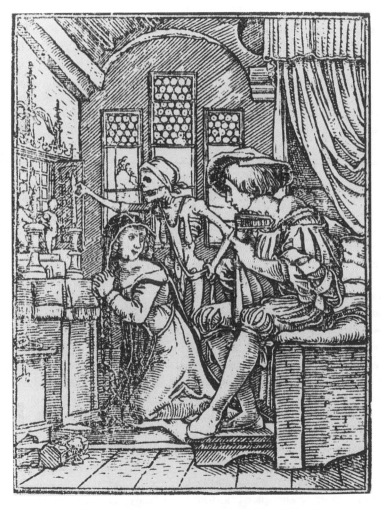

58 *Death of a Nun*, from the *Dance of Death* by Hans Holbein the Younger. The nun kneeling before the altar does not notice Death approaching. She has eyes only for the young tempter

church walls in the fifteenth century, the Dance of Death gave a vivid illustration of the equalising power of death; each person from emperor and pope down to the peasant is taken by the hand by a skeleton, and made to dance to his bidding, the living and the dead figure thus alternating.[5] In 1485 Guillot Marchant produced a series of woodcuts of the *Dance of Death of Men* based on that in the Cemetery of the Innocents in Paris, 1425,[6] which was followed by a *Dance of Death of Women* in 1486. Whereas men were defined by their status or occupations in public life, e.g. the emperor, the cleric, the usurer or the labourer, women were represented according to their marital and sexual status. Forty different states of feminine life are thus lined up with Death taking them by the hand, such as the virgin, the beloved bride, the newly-wed, the woman with child and the nun, as well as different ranks such as the empress, the queen or the duchess. In this manner the Dance of Death, like the passing of years, also included an aspect of regret for lost beauty, giving an additional feminine characteristic. Most haunting are the skeletons which have wisps of hair attached to their skulls, to give them a feminine air. The Three Living and the Three Dead was another variation on the theme of death, introduced as a French poem, *Le Dit des Trois Morts et des Trois Vifs*, in the thirteenth century. Three skeletal corpses meet three young and wealthy men and warn them of the vanities of this world, pointing out that 'we once were as you are now; you will be as we are now'. Visual depictions began with the figures standing stiffly but progressed in movement until horses were introduced in the fifteenth century and the warning became an aggressive hunt for the living. On one rare occasion, a woman is depicted being hunted by the Three Dead, and she is no other than Mary of Burgundy, who died in 1482 as a result of a riding accident. The miniature was added to her Book of Hours after her death, and shows her trying to flee on horseback from the pursuing skeletons armed with javelins.[7] From *c.* 1500 there was more emphasis on individuality, and Hans Holbein the Younger not only breaks up the *Dance of Death*, 1538, into separate woodcut illustrations but also individualises Death, relating his actions closely to the status or personality of the character about to follow him. The women he includes are all of higher status: empress, queen, abbess, nun, countess, lady and duchess. In the case of the empress, a female Death with thin, sagging breasts takes her by the arm and sedately walks her along as would her lady-in-waiting. The queen is dealt with less ceremoniously: Death in fool's dress grabs her violently by the hand to make her skip along, while she resists, and a young man tries to hold Death at arm's length. A female Death in headscarf and apron snuffs out the candle on the altar before

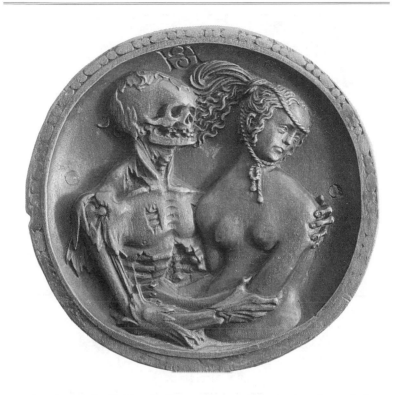

59 *Death and the Maiden*, by Hans Schwarz. The carving shows skeleton Death cruelly embracing a nude woman, whose resistance proves pointless

which kneels the nun whose thoughts, however, are turned towards the young man enticing her with his lute-playing (Pl. 58). The countess is concerned with her finery at the hour of her death, and Death helps to adorn her neck with a necklace of bones.

Although there are depictions of Death warning young dandies against pride and vanity, the most poignant portrayals are of Death and the Maiden, and none more so than those of Hans Baldung Grien, who explored the erotic nature and vulnerability of the nude woman in this gruesome encounter. In a painting of 1517,[8] a young woman stands in a wooded landscape, gazing into her mirror, oblivious to the approach of Death, who is seen by the baby boy sitting on the grass with his hobby-horse, and by the old woman who is trying to prevent Death from taking the young woman, thinking it should be her turn; Death, however, will not act logically but by stealth and surprise. In another painting of 1517,[9] Death

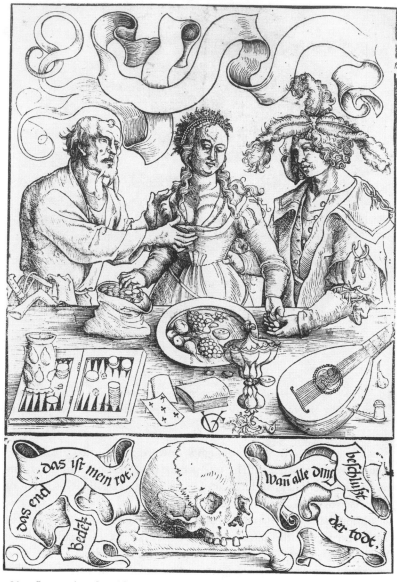

60 *Love-triangle with Memento Mori*, by Urs Graf. A young woman takes money from an old man who fondles her breasts, and passes it on to her young lover; the objects of worldly pleasure on the table before them are contrasted with warnings of death in the register below

grabs the young woman by her hair and points to the black grave to which an inscription directs her; her begging hands and tears are of no avail. The white, smooth flesh of the woman contrasts with the rotting dark skeleton, as also in a further painting,[10] where Death sneaks up from behind, digs his nails into her soft white skin and gives her the kiss of death, before she realises who her lover is. Death as a lover is most effectively depicted on a circular relief wood carving with a raised rim, by Hans Schwarz, c. 1520 (Pl. 59).[11] A half-length rotting corpse grips a half-length, softly curved, nude woman, and presses her to his chest; she looks away and with her hands begs him to let her go, but he looks at her intently from hollow eye-sockets, and his jaws are locked and thrust towards her with unyielding determination. Thus, life and death are joined together, and Death in his activity takes on a macabre life. The circular rim of the carving is much worn, indicating its use as an object held in the hand for contemplation. The sensuality of a nude woman as the victim of Death was to be contemplated not only with the eyes but even with the mouth, as gleaned from the existence of a baker's model on the theme of Death and the Maiden used as an imprint on bread or biscuits.[12] A nude woman stands in a landscape, while skeleton Death lunges out at her from a grave at her feet; she half turns back towards him and lifts the veil that drapes one side of her body towards her face, probably to hide the view of Death.

Death in the service of misogyny is found in a woodcut by Urs Graf, from the beginning of the sixteenth century, which portrays the typical *Love-triangle*, where money is exchanged for love, but below, a skull and bone as *memento mori* have been added (Pl. 60). A young woman, her breasts bulging out of her bodice, takes money from an old man who fondles her breasts, and hands it to the young man on her other side. On the table before them are objects known for their associations with love-making and a life of worldly pleasures, as found in brothels: fruits on a platter, gameboard and playing cards, beaker and chalice, and a lute. In contrast, the text accompanying the skull and bone warns of the transience of life: 'Consider the end – that is my counsel: when everything finishes with death.'[13]

As seen the presence of Death became ever more dramatic and awe-some, culminating in the creations of Baldung Grien at the beginning of the sixteenth century. A profusion of frightening renderings of the theme was allowed to excite the popular imagination, and in general, although Death was an equaliser and men were thought as sinful as women, it was women's lust that took centre-stage and which blinded them in the face of Death.

Notes

1 Leipzig, Museum der Bildenden Künste. A coral was a common amulet for children to keep away the evil eye.

2 Osten, 1983, p. 249.

3 Ibid., p. 250.

4 Rennes, Musées des Beaux-Arts. Possibly a late-sixteenth-century French copy; ibid., pp. 253 and 254.

5 It is conventionally called a Dance of Death but is correctly a Dance of the Dead. The origin of the French *Danse Macabre* is controversial.

6 The verses accompanying the woodcuts are found in two manuscripts of St Victor: Paris, BN, Ms. lat. 14904 and Ms. fr. 25550; he also copied the verses for the Danse Macabre of the Cemetery of the Innocents.

7 Hours of Mary of Burgundy, c. 1482, Flemish; Berlin, Staatliche Museen, Preussischer Kulturbesitz, Kupferstichkabinett, MS. 78.B.12, fol. 220v.

8 Vienna, Kunsthistorisches Museum.

9 Basle, Kunstmuseum.

10 Basle, Kunstmuseum.

11 Berlin, Staatliche Museen, Preussischer Kulturbesitz.

12 German, *c.* 1500; Vienna, Museum für Angewandte Kunst.

13 Bartrum, 1995, p. 216, cat. no. 22.

CONCLUSION

When looking back over the representations discussed, women, apart from their role as donatrix, are rarely seen alone, without male company; from the time of the Creation, Adam needed Eve, and woman existed in relationship to man. Thus, they were usually seen together, for better or for worse, but if women behaved badly, their behaviour was less excusable, more despicable, than the same in men. In art, representations of 'ordinary' women with an evil disposition are more varied and dramatic, with all negative qualities exaggerated. Good women are usually associated with religious works; they try to get as close as possible to holy personages in their conduct of life as in their visual representations; also, they are all from the aristocracy or the upper middle class, who can afford illuminated manuscripts and painted panels. Even after the Reformation, these women sit at dinner tables which have all the associations of the Last Supper, and lead a most virtuous life. They look passive and move sedately with restrained gestures. Evil women, on the other hand, give the artists much more scope, because bad, sinful characteristics can be more imaginatively represented in chaotic, violent scenes, just as hell with its devils is always a more interesting place visually than heaven with its angels. These are the scenes one remembers best.

As already seen, many of the illustrations are quite obscene, especially those of The Woman and the Fool, e.g. *The Large Garden of Love* by Master E.S. (Pl. 40), or *Fool with Woman Holding a Child*, a pen-drawing by Urs Graf where the fool lifts the woman's skirt and exposes his own genitals.[1] In the same vein, the relationship between priests and women was and had been a popular topic for satire; in that case the clergy came under attack for their disregard of the vows of chastity, poverty and obedience, although woman remained the temptress. Much of the obscenity was related to carnival, the period of revelry before Lent when the Fool was allowed to rule. Folly was the order of the day, the world was turned upside-down, and customs of foolish, boisterous behaviour were instituted. Unmarried and widowed women were publicly mocked, because they had failed to catch a husband by carnival time as illustrated in woodcuts by Erhard Schön of *Spinsters Harnessed to the Plough*, 1532, and

Hewing at the Block, 1533. The first shows the women pulling the plough through the streets, driven by the men with whips, and the second has a large block being roughly hewn into the shape of a man for these women. The Mother of All Fools, too, was a carnival figure, and in France in particular, societies of fools with *Mère Folle* at their head were instituted at the end of the fifteenth century, societies that organised grotesque plays and all kinds of carnival activities. One of the sixteenth-century banners from such a society in Dijon, the Infanterie Dijonnaise,[2] has a picture of Mother Folly on one side and on the back two fools with bare bottoms, one holding the other upside-down, so that their bottoms fart into each other's faces. What is interesting in connection with women is that Mother Folly has taken the mask off her face, to expose a full-moon face framed on one side by the sickle of the moon; this symbolises the fickleness and changes in mood, comparable to the waxing and waning of the moon, believed to be characteristic of women (Pl. 61).

All these illustrations, of foolish behaviour and of profane themes generally, are from what are called the 'marginal arts': from the margins of illuminated manuscripts, from woodcuts and engravings, and from misericords and the decorative arts. Here, on the margins of what was official art, satire and laughter were allowed to take hold, and, like carnival, it was here that built-up tensions could be allowed to explode. Women were not the only ones to be lampooned, but they were a satisfying target like peasants, who could not successfully fight back.[4] But why did men produce such satirical prints of women with seemingly ever greater relish? The artisan's wife had to be a reliable helpmate, and any middle-class housewife had to be wise and thrifty, in order for the family and business to succeed. Portrayals of foolish wives, spendthrifts, shrews and adulterers could, therefore, be used as warnings, and exaggerations would not only increase the humour but also amplify the didactic purpose. Thus, as in *exempla* used in preaching, there was usually a moral message included, made more palatable through dramatic imagery. The production of prints at affordable prices greatly expanded the audience for profane subject matter, and because many engravings were used as patterns, their life-span was extended in time and into other media, ensuring the afterlife of a stereotype. The pattern of the *Love-triangle with Memento Mori* by Urs Graf, for example (Pl. 60), lived on well into the sixteenth century.[5] What can also be determined is that many of the prints, in particular the bawdy ones, were attached to the walls and over the fireplaces of taverns, as seen in prints by Frans Huys (Pl. 38) and Pieter Aertsen, who depict prints within prints.

61 *Carnival Banner* from the Infanterie Dijonnaise. This shows Mother Folly unmasked, exposing her ever-changing moon-face

With a greatly enlarged audience, did these prints add to the negative attitude towards women? Did women have any chance, being faced by this propaganda? Prints of evil, battling housewives and lecherous nudes, certainly, cannot have improved the standing of women, and could only have given men more proof of women's failings and sinfulness. They

would have reinforced men's inclination to keep women out of serious business, to mistrust them, and to see a 'good' woman as a near-impossibility. As with any opinion or accusation, when repeated often enough, it begins to stick, one begins to believe in it, and think there might be a grain of truth in it. Thus, misogyny continued to the detriment of women in general.

As I have said, satire had long reigned in the marginal arts, but were there any changes as a result of the advent of printing and the Reformation? Prints, too, combined humour and moral teaching, and therewith a didactic purpose, but had the manner of depiction changed? In manuscripts and on misericords, the bawdy scenes could always be seen in opposition to religious scenes, set in an overall holy environment; they seemed as playful additions, balancing on ledges and tendrils, in combination with grotesque monsters; and misericords were even sat on. Once such scenes moved into prints, they gained independence, but with this new concentration came a more hard-hitting, even belligerent attitude. The satire became more vicious, attacking women in particular. For example, in a Flemish manuscript from *c.* 1300, a nun has caught a young man in a net; he is ensnared by Venus, but although given to his passionate longings, the scene looks very peaceful, and the young man is reclining thoughtfully. In contrast, the same iconography in woodcuts by Niklas Stör and Erhard Schön, in the first half of the sixteenth century, has much commotion, and there seems to be cruel compulsion in the actions of powerful, dominating women who threaten the men (Pl. 43).

The Reformation was introduced in Germany by Luther, but it did not take root everywhere, nor at the same time. Where it was accepted, Books of Hours, with their marginal drolleries, and misericords were abolished. Also, with the dissolution of monasteries, women unwilling or unable to marry could no longer opt for an alternative life in a nunnery, where they had had a chance of achieving positions of authority. Female saints and chastity no longer merited veneration, and saints and the Virgin Mary were no longer allowed to give comfort as intercessors. The production of cheap woodcuts of saints, available to all, was halted. A woman had to be the perfect housewife, without the myriad of human saints to counteract every ill. Life had become barer, concentrated on the earthly family and on salvation through Christ only; although the honour of the family had always been paramount, this was now reflected more forcefully in the prints and paintings showing a serious, God-fearing family life. It is interesting that the woodcuts most concerned with the evil housewife and her effect on the family were published in Nuremberg and Augsburg after

these cities had become Protestant, and many of the prints have texts by Hans Sachs of Nuremberg, known for his support of Protestant moral values.

62 *The Life of Jan de Wasser and Griet*, cartoon strip. The loving Griet turns into a virago after her marriage to Jan de Wasser. She puts on the trousers and reduces him to subservience: their relationship has been turned upside-down

The Reformation coincided with the Renaissance introduced by Albrecht Dürer in Northern Europe, and many of the changes can be attributed to a new style, new philosophical movements, new concerns and, in particular, the influence of Italy. The female nude came to be of special interest for artistic study, based on classical goddesses rather than on medieval female saints. Fashion of dress progressed with the changing ideal of the human figure, from an elegant, vertical line to one heavier and more horizontal. Thus, trailing gowns, funnel-shaped headdresses and exceedingly pointed shoes became angular, with straight hemlines, broad, square shoulders, flattish bonnets and rounded shoes, and the colours, too, became less garish and showy. Men's fashion of the first half of the sixteenth century, in particular, emphasised male dominance: broad, powerful shoulders and large codpiece, legs apart and hand on hip, best exemplified in portraits of Henry VIII created by Hans Holbein the Younger. Was this an indication of men attempting to assert themselves over women, parallel to the virulent prints attacking women? A woman, Margaret of Austria, governed the Netherlands at the beginning of the sixteenth century, and she brought up the later Habsburg Emperor Charles V; she was followed by two further governesses: Mary of Hungary and Margaret of Parma; at the end of the sixteenth century, Elizabeth I ruled in England and Mary was Queen of the Scots. However, whatever the religious or political developments, misogyny lived on, and the all-powerful nagging housewife resurfaced in Pieter Bruegel the Elder's painting of the *Dulle Griet* (Mad Meg), 1562,[6] striding in full flight to attack hell itself. Pieter Bruegel is known for his reworking of medieval iconography, and transmitting it into the higher medium of paintings for the first time. Thus, the medieval virago has been lifted from her marginal position and becomes a monumental image. She wears breastplate and helmet, is armed with a sword and already laden with loot. Behind her and subsidiary to her, other women are busy tying devils down on cushions. The Dulle Griet's warpath did not stop at Bruegel, but she fought her way right through to the present century. She can still be seen fighting for the breeches and asserting her position, as she did in the sixteenth century when Griet married Jan de Wasser. In the *Jan de Wasser* strip cartoons,[7] Griet, the minute she is married to Jan, turns the roles of man and wife upside-down and wears the pants. The name 'de Wasser' was added at the end of the seventeenth century, meaning that Jan's work, which was really woman's work, was connected with water, e.g. washing up, scrubbing etc. In an early print, from the end of the seventeenth century (Pl. 62), the story develops in eight pictures: (1) Griet is very loving towards Jan and tempts

him into marriage. (2) Jan and Griet are married in church before the minister with the Bible in a pulpit. (3) Jan returns home, expecting a meal to be ready for him, but his wife stands before him in an aggressive attitude, ready to oppose him. (4) Jan gets hold of the tongs and a ladle to beat her with and she is seen falling to the ground. (5) Griet now gets into a rage, grabs the tongs and beats the husband to the ground. (6) She makes Jan take off his trousers and holds them up as her trophy while all Jan can do is hold his head. (7) She threatens Jan with a stick and forces him to rock the cradle and to spin with her distaff. (8) In the end, returning home from a good time out, she grabs Jan by the hair and beats him for having burned the buns. The story could be expanded at will into a greater number of comic-strip pictures, but the basic story remained that once Griet was married, Jan had to do all the work around the house and look after the child, while Griet would go out. And this is how Griet, the well-known virago from the turn of the fifteenth/sixteenth century, afraid of neither man nor devil, will live on for ever.

From the time of Adam and Eve, man's main preoccupation has been his relationship to woman, or rather, that of woman to man, expressed in the indestructible, universal theme of woman and love, that runs through art and life. Was this love virtuous and spiritual, geared towards the well-being of the family, or was it carnal and lecherous, designed to disrupt all order and corrupt all reason? All through the Middle Ages, including the time of chivalrous romances, and the Reformation period, undisciplined passion and carnal desires were strongly criticised, and the famous lovers of the romance stories were severely punished, and held up as tragic examples. Always, the question of love was seen as a moral problem that affected the whole of life, and art became the helpmate of Church and public authority, showing up woman's bad behaviour towards her mate, when she turned help into destruction.

Notes

1 Basle, Kunstmuseum, Kuppfer Kabinett; Mezger, W., 1991, p. 153, fig. 65.
2 Mezger, W., 1991, p. 383, fig. L, and p. 352, fig. 192.
3 Dijon, Musée de la Vie Bourguignonne.
4 There was a peasant revolt in Germany in 1525 which was put down.
5 Bartrum, 1995, p. 216.
6 Antwerp, Mayer van den Bergh Museum.
7 Dresen-Coenders, 1988, pp. 41–5.

ANNOTATED BIBLIOGRAPHY

One of the major books to supply background information on women as viewed by men, their social conditions and daily experiences from the sixth to the fifteenth century is *A History of Women in the West* edited by Christiane Klapisch-Zuber. In part II of this book, entitled: *Silences of the Middle Ages*, twelve authors write on women's place in society, men's opinions on their sexuality and emphasis on chastity, and the power of Church and State, all male-orientated and trying to control women's lives. The book is especially useful in tracing the created image of women back to antiquity and the early Church Fathers. In spite of all moral admonishments and misogynistic dictates by men, however, a picture is created of women's accomplishments in daily life and, in particular, as artists, poets and mystics. The index is extremely detailed, giving easy access to important information.

As part of the series Women in Culture and Society, edited by Catharine R. Stimpson, Margaret L. King's book on *Women of the Renaissance* (1991), is comparable to *A History of Women in the West* in examining the literature on the condition of Western European women, in this case from 1350 to 1650. The book is divided into parts entitled 'Daughters of Eve', 'Daughters of Mary' and 'Virgo et Virago', taking into account women of all classes, and considering both their accomplishments and their limitations. King looks in detail at women within the Church, the nunnery as allowing freedom from marriage, and the differing effects of Catholicism and Protestantism on women, and also touches on the fear of heresy. She ends with the lives of specific women who exerted power and influence, and asks the question: 'Did women have a Renaissance?'

Women in the Middle Ages and the Renaissance, edited by Mary Beth Rose (1986) contains eleven articles that range from women's public role in general to individual cases, such as Margery Kempe, and discuss women in the writings of men like John Foxe and Shakespeare, spanning the Middle Ages to the seventeenth century. The first essay by Mary E. Wiesner, 'Women's Defence of their Public Role', is most relevant to the period covered in my book and charts the changes in attitudes to women and regulations concerning their lives and professions *c.* 1500.

Angela M. Lucas divides her book *Women in the Middle Ages* into three parts: 'Women and Religion', 'Women and Marriage' and 'Women and Letters', and uses medieval literature such as wills, charters, and medical, theological and philosophical treatises, as well as sermon literature and proverbs, in her examination of attitudes to women. She, too, argues that women's role was significant in the social and intellectual life of the period.

Margaret Wade Labarge, in *Women in Medieval Life* (1986), looks at women and society, divided into classes and occupations, such as those who ruled, those who prayed and those who toiled, and reflects on their contributions to medieval culture.

Very useful and informative is the well-illustrated book edited by George Duby (translated from the French by Arthur Goldhammer), *A History of Private Life, vol. II: Revelations of the Medieval World* (1988). Although it is not a book about women only but covers both sexes, and all ages, classes and professions, from the eleventh to the fifteenth century, information on women as an integral part of society can be gained using the detailed index.

There are a number of books that concentrate on the laws regulating women's lives. James A. Brundage, in *Law, Sex, and Christian Society in Medieval Europe* (1987), looks at how the law generally handicapped women, in particular concerning cases of sexual behaviour. He takes the period 1348 to 1517 (the Black Death to the Reformation), and compares the law as laid down and as in practice in marriage and in cases of adultery; also the management of prostitution. Sex and the clergy is another topic debated, in particular the question of celibacy and marriage before and during the period of the Reformation, with reference to the Lutheran view of woman's place in God's creation. Brundage also considers the changes in literature and art, and argues that with increased silent reading in the fourteenth and fifteenth centuries, erotic and even pornographic tales and illustrations became more common.

Shulamith Shahar, in *The Fourth Estate: A History of Women in the Middle Ages* (1983), examines the treatment of women from the time of their births to their role as mothers, as well as their part in public life and under the law in Western Europe, except Scandinavian countries, Scotland and Ireland, from the early twelfth century to about the second quarter of the fifteenth century. In this wide-ranging study of women from those of the nobility to peasant women, and from nuns to witches, Shahar, while attempting to give a general picture, reminds the reader that the great differences in customs and laws for various countries and even districts must be kept in mind. She has examined a large number of feudal records, manuals for the education of women, and possibly all texts that might throw light on women's rights in medieval society.

Many books concentrate on the early sixteenth century, because of the far-reaching changes that were brought about by the Reformation. Steven Ozment, in *When Fathers Ruled* (1983), considers family life in Reformation Europe, when married life was placed above a life of celibacy. Now respect for women was closely tied to their devotion to home-making, yet the authority of the man remained undiminished. The nature of children is discussed, and how to mould them into rational human beings. However, even in this period, mothers were considered too indulgent to be able to discipline their offspring, and therefore fathers were to take over the child-rearing role once a child was 6 or 7 years old.

A novel approach to the social and religious history of women is taken by Caroline Walker Bynum in *Holy Feast and Holy Fast* (1987). Here, the importance of food to women, and spiritual food in particular, is highlighted, and female piety in the Middle Ages is examined from a new angle. Bynum explores the importance of Eucharistic food in the lives of women saints and the writings of women mystics, the deeper meaning of food, the relationship between women's bodies and food, and how, in particular, the theological and devotional traditions influenced women's lives and behaviour.

Books more overtly concerned with representations of women in art in the Middle Ages stress the polarities between the Virgin and Eve, the good and the bad woman. In

her book *Women, Art and Society* (1990), Whitney Chadwick devotes one chapter to the Middle Ages, where she discusses the importance of the economic situation for the position of women. She considers the role of women in the early Church and under the feudal system, concentrating on well-known ecclesiastical women and the restrictions on them from the time of the late-eleventh-century Church reforms. Her chapter entitled 'The Renaissance Ideal' deals with Italy, where the prosperous bourgeois society pushes women back into the private, domestic sphere. Her chapters on women artists are primarily on those from the late sixteenth to the eighteenth century. Chadwick's overall concern is the relationship between women, the visual arts and art history. The visual arts are central to *Saints and She-Devils*, edited by L. Dresen-Coenders (1987), and researched by an interdisciplinary study group whose essays formed the basis for an exhibition in Nijmegen (Nov. 1985 to Jan. 1986). The edition translated by C. M. H. Sion and R. H. J. van der Wilden (1987) contains essays only, while the Dutch book (*Tussen heks en heilige*) also has a catalogue section. The essays concentrate on the antithesis between good and bad women, the descendants of the Virgin and those of Eve, as represented in the visual arts. Thus, the Holy Family, saints and good women of antiquity oppose the evil housewife, the virago, the prostitute and the witch. The virtues and vices, the civic morals, and the socio-economic structure of towns are discussed. The emphasis is on the transitional period from the Middle Ages to the Modern era, 1400–1600, a period of great fear of the 'power of women', which is thought to have led to belittlement, ridicule, persecution and ultimately the restriction of women's role. Although not, strictly speaking, addressing art-historical concerns, because the illustrations were added for the Cambridge University Press edition of 1975, Eileen Power's book *Medieval Women*, based on her lectures of 1926 and edited by M. M. Postan, gives a valuable insight into the life and representations of women. It is a short book with a concise overall introduction and general picture of women of all classes and of their activities in the Middle Ages. It is divided simply into chapters dealing with 'Medieval Ideas about Women', 'The Lady', 'The Working Woman in Town and Country', 'The Education of Women' and 'Nunneries'.

A short and succinct article by Veronica Sekules, entitled 'Women and Art in England in the Thirteenth and Fourteenth Centuries' (1987), looks at representations of women in that period, and discusses art and life, the negative and the positive, and reasons for the shortcomings of women. Alison G. Stewart studies a specific theme found in the visual arts in *Unequal Lovers* (1977). This theme of love between the old and the young has been popular since antiquity, and had a revival in Germany *c.* 1470–1535 as an independent subject. Stewart discusses the reasons for this popularity and discusses the meanings and significance of the representations, as well as their audience. A classified list of unequal couples is included at the end of the book.

Misogyny specifically, with emphasis on Northern Europe, is addressed in a number of books concentrating on the late fifteenth and early sixteenth centuries. Katherine M. Rogers, in *The Troublesome Helpmate: A History of Misogyny in Literature* (1966), tackles the problem of trying to distinguish between literary jokes and real hostility, which is equally relevant for the visual arts. The influence of the Church pontificating on women and marriage from the pulpit is explained, aggravating the antithesis between the Virgin and Eve with her human descendants. Misogyny remained a

popular theme in Renaissance pamphlets, and debates on women's worth persisted. Rogers does, however, see a change in English Renaissance drama, where misogyny was no longer presented as an acceptable attitude, and notices that by the seventeenth century misogynists had become cynical villains. In chapter 8, the reasons for misogyny are addressed. Lyndal Roper, in *The Holy Household: Women and Morals in Reformation Augsburg* (1989), uses early-sixteenth-century woodcuts to illustrate points for discussion on good and mainly bad housewives. Many of these woodcuts had text added by Hans Sachs, the Nuremberg moralist, in the early sixteenth century. Thus, although the illustration is the source for the text, it also highlights the new emphasis on the word at the time of the Reformation. Roper speaks of the laws regulating life and woman's position within the family, sexual offences, discipline and prostitution. Furthermore, the controls exerted by councils, marriages as bargains, and property laws are examined, and, above all, the effect of the Protestant Church on women not wanting to marry and previously in convents. Roper finds that the Reformation encouraged patriarchy to the detriment of women's freedom, and, as the prints show, the attacks on women who did not toe the line became more serious, leading Roper to the conclusion that the boundaries between the sacred and the profane were more clearly marked. *The Crooked Rib* by Francis Lee Utley (1944) traces the origin of misogyny in the writings of classical authors and early Christian Church leaders who had their roots in the classical world. He sees bourgeois culture as favourable to women for economic reasons. He introduces the book written by Geoffrey, Knight of La Tour-Landry, in the late fourteenth century for the guidance of his motherless daughters (several copies of which were illustrated). He ruminates on the question of jest and satire, the nature and rationale of both, equally applicable to the visual arts, and concludes that satire and defence are both eternal and in a state of perpetual flux. In literature and art women's worth was always measured against the Virgin Mary, whose virtuous nature could never be equalled by ordinary women who were instead associated with Eve. A most informative, scholarly and readable book on the Virgin is Marina Warner's *Alone of All her Sex*, subtitled *The Myth and the Cult of the Virgin Mary* (1976). The Virgin is seen in her different natures: Virgin, Queen, Bride, Mother and Intercessor. The reasons for the cult are examined, going back to the Gospels; its many-sidedness and growth are traced; and the moral, social and emotional implications are revealed. Warner's knowledge is extremely wide-ranging, and her arguments most convincing. At the end of the book a very useful chronological table is given, from the time of the Gospels to the Second Council of the Vatican (1963–65), and divided into 'Historical Background', 'Cult of the Virgin' and 'Arts and Letters'. Joy Wiltenburg, in *Disorderly Women and Female Power in the Street Literature of Early Modern England and Germany* (1992), uses street literature, ballads, broadsheets, song pamphlets and chapbooks of the sixteenth and seventeenth centuries to differentiate between the images created of women in these two countries. She also considers the real-life situation, and the effects of social conditions on popular literature. She focuses on the similarities and differences, for example on the level of literacy, types of heroines, marital love, and views on children and their upbringing. Thus, within the general image of women as disruptive, as shrews, a fine distinction is brought to light between Germany and England. All quotations given have translations. Although this

book deals primarily with the later sixteenth and seventeenth centuries, when pamphlets and broadsheets were more widespread, there are still many points of contact with earlier German prints. What seems to be the case, and is pointed out by Wiltenburg, is that the earlier shrews, temptresses and disorderly women are all much more powerful and active than their successors. In the literature examined by the author, the male is usually victorious in Germany, whereas that is not the case in late-fifteenth-century and early-sixteenth-century prints that are shown in this book. Also, prints cannot be compared in the early period, because at that time Germany was in the forefront in the field of printing and England had not yet established an individual approach.

The books so far cited concentrate on the woman debate, and many of them have some illustrations. For pure visual material, however, books should be consulted which are on the art of the period, and from which specific depictions of women have to be extricated. Thus, examples of women in the margins of manuscripts can be looked up in the index of the profusely illustrated book by Lilian Randall, *Marginal Illuminations in Gothic Manuscripts* (1966). For examples of evil women, the virago, and the world upside-down, books on engravings and woodcuts are most useful, because prints carry on the tradition of low, humorous art from the margins of manuscripts. *The Illustrated Bartsch,* edited by Walter Strauss (1981–), is a large series of reproductions of engravings, still in the process of being republished. There are volumes on anonymous engravers, on those with monograms, and on known artists, such as Dürer, Baldung Grien and Lucas van Leyden (and women in extremely bawdy situations in illustrations of playing cards, by such artists as Flötner and Schön). There is also a volume on profane art. The text has been reduced to titles and numbering. Max Geisberg's *The German Single-Leaf Woodcut, 1500–1550* (4 vols, 1974) contains woodcuts relevant to the Reformation period, including those to which Hans Sachs added texts. *Livelier than Life* by J. P. Filedt Kok (1985) is a catalogue based on the exhibition of the so-called Master of the Housebook, held in the Rijksmuseum, Amsterdam, in 1985, and includes engravings on such themes as unequal couples, the power of women and the world upside-down. Max Lehrs, *Late Gothic Engravings of Germany and the Netherlands* (1969), is a condensed edition of the multi-volume German work; and A. Shestack, *Fifteenth Century Engravings of Northern Europe*, is the catalogue of an exhibition held at the National Gallery of Washington in 1967–68.

Many of the women as viragos are found on misericords, which are carvings underneath the seats of choir-stalls; here, above all, the topsy-turvy world finds expression. English misericords have been catalogued by L. Remnant in *A Catalogue of Misericords in Great Britain* (1969); and F. Bond, in *English Woodcarvings in English Churches, Vol. I: Misericords* (1910) treats them in themes. Dorothy and Henry Kraus have written on French and Spanish misericords in: *The Hidden World of Misericords* (1976), and *The Gothic Choir-Stalls of Spain* (1986), respectively. My own book, *The World Upside-down: English Misericords* (1997), contains a profusion of illustrations.

Peasants and labourers could not afford to commission paintings and have themselves portrayed. This was the prerogative of the upper middle class and nobility, who can be seen portrayed in single portraits or, as part of altarpieces commissioned by them, in the company of holy personages. Lorne Campbell's book on Renaissance portraiture (1990) gives insight into these groups of people; and Shirley Blum's *Early-*

Netherlandish Triptychs (1969) concentrates on donors and donatrixes kneeling in association with religious events in fifteenth-century Netherlandish altarpieces.

For an overall view of religious art – the Virgin, the saints and the patrons – in Northern Europe, *Northern Painting* by Charles Cuttler (1968) should be consulted. It covers artists from Pucelle to Bruegel, and thus the fourteenth, fifteenth and sixteenth centuries. Similar is James Snyder's *Northern Renaissance Art* (1985), except that it is not restricted to paintings. It does, however, exclude the lesser known-painters and more emphasis is put on iconography.

GENERAL BIBLIOGRAPHY

Alexander, J. and Binski, P. (1987), *The Age of Chivalry: Art in Plantagenet England 1200-1400*, London.

Amt, E. (1993), *Women's Lives in Medieval Europe*, New York and London.

d'Andeli, H. (1974), *Oeuvres*, introd. Héron, A., Geneva.

Aries, P. and Duby, G., eds (1988), *A History of Private Life, vol. II: Revelations of the Medieval World*, Cambridge, Mass.

Augustine, *City of God* (1972), Knowles, D. (ed.), transl. Bettenson, H., Harmondsworth.

Barber, R. and Baker, J. (1989), *Tournaments, Jousts, Chivalry and Pageants in the Middle Ages*, Woodbridge.

Bartrum, G. (1995), *German Renaissance Prints 1490-1550* (exhib. cat.), London.

Bayrische Staatsbibliothek, Munich (1970), *Der Ritter vom Turn*, Unterschneidheim.

Bennett, J. M., 'Mysogyny, Popular Culture, and Women's Work', *History Workshop*, Issue 31, Spring 1991, pp. 166-88.

Bernheimer, R. (1952), *Wild Men in the Middle Ages: A Study in Art, Sentiment and Demonology*, Cambridge, Mass.

Blamires, A., ed. (1992), *Woman Defamed and Woman Defended: An Anthology of Medieval Texts*, Oxford.

Blum, S. (1969), *Early Netherlandish Triptychs*, Berkeley.

Bond, F. (1910), *Wood Carvings in English Churches, vol. I: Misericords*, London, New York, Toronto and Melbourne.

Brant, S. (1971), *The Ship of Fools*, transl. W. Gillis (with original woodcuts), London.

Braswell, M. Flowers (1986), 'Sin, the Lady, and the Law: The English Noblewoman in the Late Middle Ages', *Medievalia et Humanistica*, n.s. 14, pp. 81-101.

Brereton, G. and Ferrier, J., eds (1981), *Le Ménagier de Paris*, Oxford.

Brietzmann, F. (1912), *Die böse Frau in der deutschen Literatur des Mittelalters*, Berlin.

Brooke, C. (1989), *The Medieval Idea of Marriage*, Oxford.

Brown-Grant, R. (1994), 'Rhetoric and Authority: Christine de Pizan's Defence of Women', Ph.D. thesis, Manchester.

Brundage, J. A. (1987), *Law, Sex, and Christian Society in Medieval Europe*, Chicago and London.

Bruyn, L. de (1979), *The Woman and the Devil in Sixteenth-Century Literature*, Tisbury.

Bullough, C. W. (1973), 'Medieval Medical and Scientific Views on Women', *Viator*, 4, pp. 485-501.

Buri, A. Rapp and Stucky-Schürer, M. (1990), *Zahm und wild: Basler und Strassburger Bildteppiche des 15. Jahrhunderts*, Mainz.

Bynum, C. Walker (1987), *Holy Feast and Holy Fast: The Religious Significance of Food to Medieval Women*, Berkeley, Los Angeles and London.

Camille, M. (1992), *Image on the Edge: The Margins of Medieval Art*, London.

Campbell, L. (1990), *Renaissance Portraits: European Portrait-Painting in the Fourteenth, Fifteenth and Sixteenth Centuries*, New Haven.

Caviness, M. (1993), 'Patron or Matron? A Capetian Bride and a Vade Mecum for the Marriage Bed', *Speculum*, 68, pp. 333-62.

Chadwick, W. (1990), *Women, Art and Society*, London.

Crane, T. F. (1890), *Exempla of Jacques de Vitry*, London.

Cuttler, C. (1968), *Northern Painting: From Pucelle to Bruegel - Fourteenth, Fifteenth, and Sixteenth Centuries*, New York.

Davidson, J. P. (1987), *The Witch in Northern European Art, 1470-1750*, Science and Research, vol. II, Freren.

Defoer, H. L. M., introd. (1982), *Geschreven, gedrukt, versierd, verzameld: Boeken uit de bibliotheek van het Rijksmuseum het Catharijneconvent*, Utrecht.

Der Mensch um 1500: Werke aus Kirchen und Kunstkammern (exhib. cat.) (1977), Berlin.

Dinzelbacher, P. (1989), *Wörterbuch der Mystik*, Stuttgart.

Dresen-Coenders, L., ed. (1985), *Tussen heks en heilige*, Nijmegen.

Dresen-Coenders, L. (1987), *Saints and She-Devils: Images of Women in the Fifteenth and Sixteenth Centuries*, London (a collection of essays for an exhibition originally staged in Nijmegen, 1985-86, transl. Sion, C. M. H. and van der Wilden, R. M. J.).

Dresen-Coenders, L. (1988), *Helse en hemelse vrouwenmacht omstreeks 1500*, Nijmegen and Utrecht.

Duby, G., ed. (1988), *A History of Private Life, vol. II: Revelations of the Medieval World*, transl. A. Goldhammer, Cambridge.

Duchet-Suchaux, G. and Pastoureau, M. (1994), *The Bible and the Saints* (Flammarion Iconographic Guides), Paris and New York.

Eckenstein, L. (1896), *Women under Monasticism*, Cambridge.

Ennen, E. (1989), *The Medieval Woman*, Oxford.

Erasmus, *The Praise of Folly*, [1971] transl. B. Radice, Penguin.

Erickson, C. and Casey, K. (1975), 'Women in the Middle Ages: A Working Bibliography', *Medieval Studies*, 37, pp. 340-59.

Evans, J. (1969), *Life in Medieval France*, New York and London.

Eyb, A. von (1993), *Ob einem Manne sey zunemen ein eelichs weyb oder nicht*, Darmstadt.

Farmer, D. H. (1978), *The Oxford Dictionary of Saints*, Oxford.

Farmer, S. (1986), 'Persuasive Voices: Clerical Images of Medieval Wives', *Speculum*, 61, pp. 517-43.

Ferguson, G. (1961), *Signs and Symbols of Christian Art*, New York and Oxford.

Friedländer, M. and Rosenberg, J. (1978), *The Paintings of Lucas Cranach*, New York.

Geisberg, M. (1974), *The German Single-Leaf Woodcut, 1500-1550*, revised and ed. W. Strauss, 4 vols, New York.

Geisberg, M. (introd.) (1953), *Israhel van Meckenem*, Bocholt.

Gibson, W. (1973), *Hieronymus Bosch*, London.

Goody, J. (1983), *The Development of the Family and Marriage in Europe*, Cambridge.

Grössinger, C. (1989), 'Humour and Folly in English Misericords in the First Quarter of the Sixteenth Century', in D. Williams, ed., *Early Tudor England*, Woodbridge, pp. 73-85 and Plates 1-19.

Grössinger, C. (1997), *The World Upside-down: English Misericords*, London.

Hansen, W. (1984), *Kalenderminiaturen der Stundenbücher: Mittelalterliches Leben im Jahreslauf*, Munich.

Harbison, C. (1995), *The Art of the Northern Renaissance*, London.

Harthan, J. (1977), *Books of Hours and their Owners*, London.

Harvey, J. (1981), *Medieval Gardens*, London.

Hays, H. R. (1966), *The Dangerous Sex: The Myth of Feminine Evil*, London.

Herlihy, D. (1985), *Medieval Households*, Cambridge.

Heron, A. (1901), *Henri d'Andeli, Le Lai d'Aristote*, Rouen.

Hieatt (1983), 'Hans Baldung Griens Ottowa *Eve* and its Context', Art Bulletin 65, pp. 290-304.

Hogenelst, D. and Oostrom, F. van (1995), *Hand-Geschreven Wereld, Nederlandse Literatuur en Cultuur in de Middeleeuwen*, Amsterdam.

Holbein, Hans, the Younger (1971), *The Dance of Death*, introd. W. Gundesheimer, New York.

Husband, T. and Hayward, J. (1975), *The Secular Spirit: Life and Art at the End of the Middle Ages* (exhib. cat.), Metropolitan Museum of Art, New York.

Hutchison, J. (1972), *The Master of the Housebook*, New York.

Janson, H. W. (1952), *Ape and Ape-Lore in the Middle Ages and the Renaissance*, London.

Jezler, P. (1994), *Himmel Hölle Fegefeuer: Das Jenseits im Mittelalter* (exhib. cat.), Zurich.

Jones, M. (1990), 'Folklore Motifs in Late Medieval Art, II: Sexist Satire and Popular Punishments', *Folklore* 101:1, pp. 69-87.

Karras, R. Mazo (1992), 'Gendered Sin and Misogyny in John of Bromyard's *Summa Predicantium*', *Traditio*, 47, pp. 233-57.

Kempe Margery, (1985), *The Book of Margery Kempe*, transl. B. A. Windcatt, Harmondsworth.

Kempis, Thomas à, *The Imitation of Christ* (1978 [1963]), transl. B. Knott, Glasgow.

King, M. L. (1991), *Women of the Renaissance*, Chicago and London.

Klapisch-Zuber, C., ed. (1992), *A History of Women in the West, vol. II: Silences of the Middle Ages*, Cambridge, Mass. and London.

Koechlin, R. (1968), *Les Ivoires Gothiques Français*, vols I, II and Plates, Paris.

Koepplin, D. and Falk, T., eds, vol. I (1974), vol. II (1976) (exhib. cat.), *Lukas Cranach*, Basle and Stuttgart.

Koerner, J. L. (1993), *The Moment of Self-Portraiture in German Renaissance Art*, Chicago and London.

Kok, J. P. Filedt (1985), *Livelier than Life: The Master of the Amsterdam Cabinet or the Housebook Master, ca. 1470-1500* (exhib. cat.), Amsterdam.

Kraus, D. and Kraus, H. (1975), *The Hidden World of Misericords*, London.

Kraus, D. and Kraus, H. (1986), *The Gothic Choirstalls of Spain*, London.

Kühnel, H., ed. (1986), *Alltag im Spätmittelalter*, Graz, Vienna and Cologne.

Kurth, W., ed. (1963), *The Complete Woodcuts of Albrecht Dürer*, New York.

Lehrs, M. (1969), *Late Gothic Engravings of Germany and the Netherlands*, New York.

Loomis, R. S. (1938), *Arthurian Legends in Medieval Art*, Modern Language Association of America, London and New York.

Lucas, A. M. (1983), *Women in the Middle Ages*, Brighton.

Male, E. (1984 [1898]), *Religious Art in France: The Late Middle Ages*, Princeton.

Mende, M. (1976), introd., *Die Welt des Hans Sachs*, (exhib. cat.), Nürnberg.

Mezger, W. (1991), *Narrenidee und Fastnachtsbrauch*, Konstanz.

Morewedge, R. Thee, ed. (1975), *The Role of Women in the Middle Ages*, Albany.

Moxey, K. (1989), *Peasants, Warriors and Wives: Popular Imagery in the Reformation*, Chicago and London.

O'Reilly, J. (1988), *Studies in the Iconograpy of Virtues and Vices in the Middle Ages*, New York and London.

Osten, G. von der (1983), *Hans Baldung Grien: Gemälde und Dokumente*, Berlin.

Owst, G. R. (1926), *Preaching in Medieval England*, Cambridge.

Owst, G. R. (1961), *Literature and Pulpit*, Oxford.

Ozment, S. (1983), *When Fathers Ruled: Family Life in Reformation Europe*, Cambridge, Mass., London, 1983.

Paecht, Otto (1991), *Van Eyck and the Founders of Early Netherlandish Painting*, London.

Panofsky, E. (1971a), *Early Netherlandish Painting: Its Origins and Character*, 2 vols, New York.

Panofsky, E. (1971b [1943]), *The Life and Art of Albrecht Dürer*, Princeton.

Power, E. (1975), *Medieval Women*, ed. M. Postan, Cambridge.

Power, E. (1992 [1928]), *The Goodman of Paris* (Le Ménagier de Paris), The Folio Society, London.

Randall, L. (1966), *Marginal Illuminations in Gothic Manuscripts*, Berkeley.

Reeves, C. (1995), *Pleasures and Pastimes in Medieval England*, Stroud.

Reid, T. B., ed. (1958), *Twelve Fabliaux*, Manchester.

Remnant, L. (1969), *A Catalogue of Misericords in Great Britain*, Oxford.

Rigby, S. (1995), *English Society in the Later Middle Ages*, Basingstoke and London.

Ring, G. (1949), *A Century of French Painting 1400-1500*, Oxford.

Robertson, D. W., Jr (1969 [1962]), *A Preface to Chaucer*, Princeton.

Robertson, D. W., Jr (1980), *Essays in Medieval Culture*, Princeton.

Rogers, K. M. (1966), *The Troublesome Helpmate: A History of Misogyny in Literature*, Seattle.

Roper, L. (1989), *The Holy Household: Women and Morals in Reformation Augsburg*, Oxford.

Rose, M. Beth (1986), *Women in the Middle Ages and the Renaissance*, Syracuse, NY.

Rowland, B. (1981), *Medieval Woman's Guide to Health*, Ohio.

Scheltema, F. A. van (1938), *Die deutsche Volkskunst*, Leipzig.

Schmidt, J. W. R. (1982), *Der Hexenhammer*, Munich.

Schraut, E. and Opitz, C. (1983), *Frauen und Kunst im Mittlealter*, Braunschweig.

Sekules, V. (1987), 'Women and Art in England in the Thirteenth and Fourteenth Centuries', in J. Alexander and P. Binski, eds, *The Age of Chivalry: Art in Plantagenet England 1200-1400*, London, pp. 41-8.

Shahar, S. (1983), *The Fourth Estate: A History of Women in the Middle Ages*, London and New York.

Shestack, A. (1967a), *Fifteenth Century Engravings of Northern Europe* (exhib. cat.), Washington.

Shestack, A. (1967b), *Master E.S.* (exhib. cat.), Philadelphia.

Snyder, J. (1985), *Northern Renaissance Art: Painting, Sculpture, the Graphic Arts from 1350 to 1575*, New York.

Stadtgeschichtliche Museen, Nürnberg (1976), *Die Welt des Hans Sachs* (exhib. cat.).

Stewart, A. G. (1977), *Unequal Lovers: A Study of Unequal Lovers in Northern Art*, New York.

Stone, L. (1977), *The Family, Sex and Marriage in England 1500-1800*, London.

Strauss, W., ed. (1972), *The Complete Engravings, Etchings and Drypoints of Albrecht Dürer*, 2 vols, New York.

Strauss, W., ed. (1981-), *The Illustrated Bartsch*, New York.

Taylor, S. (1980), 'Monsters of Misogyny', *Allegorica*, 5, pp. 98-124.

Thomas, K. (1971), *Religion and the Decline of Magic*, Harmondsworth.

Utley, F. Lee (1944), *The Crooked Rib: An Analytical Index to the Argument about Women in English and Scots Literature to the End of the Year 1568*, Columbus.

Vavra, E. (1986), 'Ueberlegungen zum "Bild der Frau" in der mittelalterlichen Ikonographie', in *Frau und Spätmittelalterlicher Alltag*, Vienna, pp. 283-99.

Veldman, I. M. (1986), 'Lessons for Ladies: A Selection of Sixteenth and Seventeenth-century Dutch Prints', *Simiolus*, 16, pp. 113-27.

Verdiér, P. (1975), 'Woman in the Marginalia of Gothic Manuscripts and Related Works', in Morewedge, R. T. (ed.) (introd.), *The Role of Women in the Middle Ages*, Albany, pp. 121-63.

Wade Labarge, M. (1986), *Women in Medieval Life. A Small Sound of the Trumpet*, London.

Warner, M. (1976), *Alone of All her Sex: The Myth and the Cult of the Virgin Mary*, London.

Werd, G. de (1981), 'Een handdoekrek door de Kalkarse beeldhouwer Arnt van Tricht', *Antiek*, 16:1, pp. 33-55.

Wieck, R. (1988), *The Book of Hours in Medieval Art and Life*, London.

Wilberg-Schuurman, T. Vignau (1983), *Hoofse Minne en Burgerlijke Liefde in de Prentkunst rond 1500*, Leiden.

Willard, C. C. (1984), *Christine de Pizan: Her Life and Works*, New York.

Wiltenberg, J. (1992), *Disorderly Women and Female Power in the Street Literature of Early Modern England and Germany*, Charlottesville and London.

Wirth, J. (1979), *La Jeune Fille et la Mort*, Geneva.

Wölfflin, H., introd. (1970), *Drawings of Albrecht Dürer*, New York.

Wright, T. (1865), *A History of Caricature and Grotesque*, London.

Wright, T. (1868), *The Book of the Knight of la Tour-Landry*, Early English Text Society, London.

INDEX

Note: numbers in *italic* type refer to pages with illustrations on; entries in *italic* refer to illustrations and written works.